D

FAST FORWARD: Modern Moments 1913 >> 2013

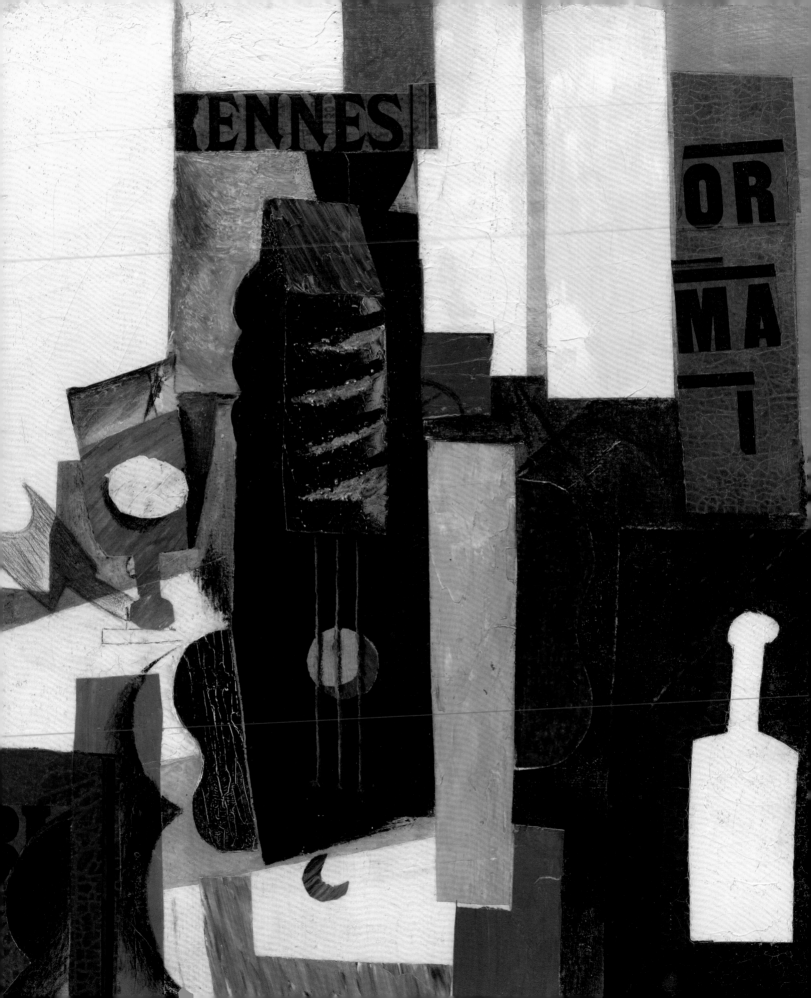

FAST FORWARD: Modern Moments 1913 >> 2013

Jodi Hauptman

with essays by
Samantha Friedman
and Michael Rooks

High Museum of Art, Atlanta
The Museum of Modern Art, New York

THE HENLEY COLLEGE LIBRARY

Published in conjunction with the exhibition *Fast Forward: Modern Moments 1913 >> 2013* (October 13, 2012–January 20, 2013), organized by Jodi Hauptman, Curator, Department of Drawings, The Museum of Modern Art, and Samantha Friedman, Assistant Curator, Department of Drawings, The Museum of Modern Art, in collaboration with Michael Rooks, Wieland Family Curator of Modern and Contemporary Art, High Museum of Art.

Fast Forward: Modern Moments 1913 >> 2013 is a collaboration between The Museum of Modern Art, New York, and the High Museum of Art, Atlanta. The exhibitions and programs of The MoMA Series are made possible by

Presenting Sponsor:
Bank of America

Lead Sponsors:

PORTMAN

The Gary W. and Ruth M. Rollins Foundation

The Coca-Cola Company

▲ DELTA

accenture

Turner
A TimeWarner Company

Planning Partner:
The Rich Foundation

The Modern Masters Circle of the High Museum of Art:
Louise Sams and Jerome Grilhot
Margaretta Taylor
Sue and John Wieland

Additional Support Provided by: Sandra and Dan Baldwin, Carey and Doug Benham, Dr. Robert L. and Lucinda W. Bunnen, Mr. and Mrs. Holcombe T. Green, Jr., Paul Hagedorn, Jane and Clay Jackson, Sarah and Jim Kennedy, Donald R. Keough, Michael Keough, Barbara and Sanford Orkin, Catherine N. Rawson, Sara and John Shlesinger, Joan Whitcomb, AVYVE, Corporate Environments, UPS, Atlanta Foundation, Massey Charitable Trust, Tull Charitable Foundation, Jane Smith Turner Foundation, Vasser Woolley Foundation, The Wish Foundation Fund of the Community Foundation for Greater Atlanta, and members of the High Museum of Art Board of Directors. Support also provided by the Alfred and Adele Davis Exhibition Endowment Fund, the Dorothy Smith Hopkins Exhibition Endowment Fund, the Estate of Barbara Dunbar Stewart, the Estate of Virginia Cook Wood, and an indemnity from the Federal Council on the Arts and the Humanities.

Produced by the Department of Publications, The Museum of Modern Art, New York

Edited by Nancy Grubb
Designed by Margaret Bauer
Production by Nerissa Dominguez Vales

Printed and bound by OGI/1010 Printing Group Ltd., China. This book was typeset in Minion Pro and Eureka Sans Pro by Duke & Company, Devon, Pennsylvania. The paper is 157 gsm Gold East Matte.

Published by The Museum of Modern Art
11 West 53 Street
New York, New York 10019

and

High Museum of Art
1280 Peachtree Street, N.E.
Atlanta, Georgia 30309

Distributed in the United States and Canada by ARTBOOK | D.A.P.
155 Sixth Avenue, 2nd floor, New York, New York 10013
www.artbook.com

Distributed outside the United States and Canada by Thames & Hudson Ltd, 181 High Holborn, London WC1V 7QX
www.thamesandhudson.com

Library of Congress Control Number: 2012936891

ISBN: 978-0-87070-836-7 (MoMA)
ISBN: 978-0-87070-837-4 (High Museum of Art)

Page 2: Pablo Picasso, *Glass, Guitar, and Bottle* (detail), early 1913 (plate 4). Right: Francis Bruguière, Untitled (detail), c. 1928–29 (plate 36). Page 7: Bradley Walker Tomlin, *Number 9: In Praise of Gertrude Stein* (detail), 1950 (plate 69). Page 11: Sonia Delaunay-Terk and Blaise Cendrars, *La Prose du Transsibérien et de la petite Jehanne de France (Prose of the Trans-Siberian and of the Little Jeanne of France)* (detail), 1913 (plate 2)

Printed in China

Bank of America and the Arts

Continuing our support of The MoMA Series at the High Museum of Art, Bank of America is pleased to sponsor *Fast Forward: Modern Moments 1913 >> 2013*. We look forward to working once again with two leading arts institutions — the High Museum of Art and The Museum of Modern Art. Each of these institutions is a world-class organization that consistently delivers incredible, groundbreaking exhibitions, as well as programming for the public, which is always an important consideration for us as we choose arts organizations and programs to support.

As a company with employees and clients in more than one hundred markets around the world, Bank of America is committed to a diverse program of cultural support that is designed to engage individuals, organizations, communities, and cultures in creative ways to build mutual respect and understanding; to strengthen institutions that contribute to local economies; to engage and provide benefits to our employees; and to fulfill our responsibilities as a major corporation with global reach and an impact on economies and societies throughout the world.

At Bank of America, we recognize that cultural resources contribute to stronger communities and bring people together through shared cultural experiences. We hope you enjoy *Fast Forward: Modern Moments 1913 >> 2013* and consider how art can transcend time and place to create meaningful human connections.

Directors' Foreword

MICHAEL E. SHAPIRO

Nancy and Holcombe T. Green, Jr., Director of the High Museum of Art

GLENN D. LOWRY

Director, The Museum of Modern Art

Fast Forward: Modern Moments 1913 >> 2013 is the fifth exhibition in a multi-year collaboration between the High Museum of Art in Atlanta and The Museum of Modern Art in New York. Since 2010 the High has presented four exhibitions drawn from MoMA's unparalleled collections. Consisting of both large-scale and more focused exhibitions, this program has been extraordinarily lively, representing modern art's diversity in approach, medium, and subject. The MoMA Series began in spring 2010 with *Monet Water Lilies*, a presentation of Monet's epic late canvases of textured plant life and shimmering ponds. The second, *Modern by Design*, told a history of twentieth-century design, demonstrating the influence and ubiquity of objects ranging from a Machine Age self-aligning ball bearing to an Eames folding screen. *Picasso to Warhol: Fourteen Modern Masters* showcased some of the most significant artists of the twentieth century, offering the High's audiences a close-up experience of such icons as Pablo Picasso's *Girl before a Mirror*, Henri Matisse's *Dance (I)*, and Andy Warhol's *Campbell's Soup Cans*. Just this past summer, visitors to the High viewed *Picturing New York*, a striking installation reflecting photographers' engagement with New York City; it was a wonderful chance to see examples from one of the world's most renowned collections of photography.

Each of these exhibitions marks a milestone in the long and fruitful relationship between our two institutions, an affiliation that dates back to 1936, when MoMA, still in its infancy, sent an exhibition of etchings by Otto Dix to the High. Since then, we have continued to develop partnerships, always working toward the same fundamental goals: to develop a broad understanding of modern art and to inspire and challenge our viewers.

Presenting about 160 objects made by more than 100 artists, *Fast Forward* reflects these same aspirations. This exhibition highlights key moments in the last century, revealing the distinguished artists, significant achievements, and important themes at work during six specific years. Setting aside the traditional survey's objective of comprehensive seamless coverage, *Fast Forward* focuses on slices in time, yielding a multifaceted picture of the multitude of activities, the variety of experiments, the range of mediums, the

sometimes-competing goals that occurred at each particular moment. We begin in 1913, the year of the opening of the Armory Show, the first presentation of advanced art in the U.S.—an exhibition that provoked enormous controversy and debate and that remains a landmark in the art history of this period. Viewers can then immerse themselves in 1929, 1950, 1961, and 1988. Each year is represented in the exhibition by great works created by celebrated artists, including Pablo Picasso, Salvador Dalí, Louise Bourgeois, Robert Rauschenberg, and Brice Marden; by important movements, including Cubism, Surrealism, and Pop art; and by stunning achievements, including the invention of abstraction and the ready-made, the explosion in the graphic arts, and the expanded use of photography and film. We end in 2013, the year the exhibition itself closes, to remind viewers that artistic efforts continue into our own time and that stories of invention from the last one hundred years are relevant to contemporary practice. We invited three contemporary artists to speak for the present moment: Aaron Curry, Katharina Grosse, and Sarah Sze. These artists express recent art's diversity of methods and challenges to long-accepted traditions—and, most of all, prove that modernism's spirit of innovation is alive and well. We are enormously grateful to these three for agreeing to participate and look forward to the compelling dialogues that are sure to occur between their contributions and the historical works on view.

Our talented and hard-working staffs also deserve our gratitude. A collaboration of this scale and ambition involves every department in our two institutions, and we have depended on the expertise, conscientiousness, and good humor of many, from our conservators who examined each piece for travel to our communications officers who shared our excitement with our public; from our educators who developed thrilling programs in the galleries and on the Web to our registrars who ensured the safe transport of these masterworks, and so many more. Among our staff, a core team has been working on this collaboration since the beginning: Jodi Hauptman, Curator, and Samantha Friedman, Assistant Curator, Department of Drawings, at MoMA, organized the exhibition in collaboration with Michael Rooks, Wieland Family Curator of Modern and Contemporary Art at the High. David Brenneman, Director of Collections and Exhibitions and Frances B. Bunzl Family Curator of European Art; Philip Verre, Chief Operating Officer; and Jody Cohen, Senior Manager of Exhibitions and Special Initiatives, all of the High, and Ramona Bronkar Bannayan, Senior Deputy Director for Exhibitions, Collections, and Programs, and Maria DeMarco Beardsley, Coordinator, Exhibition Program, at MoMA, have overseen the development and implementation of this exhibition, its catalogue, and The MoMA Series in general with camaraderie and aplomb.

A collaboration of this magnitude demands significant resources. We are profoundly grateful to our Presenting Sponsor, Bank of America; our Lead Sponsors: Portman, The Gary W. and Ruth M. Rollins Foundation, The Coca-Cola Company, Delta Air Lines, Accenture, Turner Broadcasting System Inc.; our Planning Partner, The Rich Foundation; and members of The Modern Masters Circle of the High Museum of Art: Louise Sams and Jerome Grilhot, Margaretta Taylor, and Sue and John Wieland. Crucial additional support has been provided by Sandra and Dan Baldwin, Carey and Doug Benham, Dr. Robert L. and Lucinda W. Bunnen, Mr. and Mrs. Holcombe T. Green, Jr., Paul Hagedorn, Jane and Clay Jackson, Sarah and Jim Kennedy, Donald R. Keough, Michael Keough, Barbara and Sanford Orkin, Catherine N. Rawson, Sara and John Shlesinger, Joan Whitcomb, AVYVE, Corporate Environments, UPS, Atlanta Foundation, Massey Charitable Trust, Tull Charitable Foundation, Jane Smith Turner Foundation, Vasser Woolley Foundation, The Wish Foundation Fund of the Community Foundation for Greater Atlanta, and members of the High Museum of Art Board of Directors. Support is also provided by the Alfred and Adele Davis Exhibition Endowment Fund, the Dorothy Smith Hopkins Exhibition Endowment Fund, the Estate of Barbara Dunbar Stewart, and the Estate of Virginia Cook Wood. And for crucial aid in making the public presentation of these groundbreaking works possible, we acknowledge with immense gratitude a generous indemnity from the Federal Council on the Arts and the Humanities.

Once Upon a Time . . .

JODI HAUPTMAN

Curator, Department of Drawings,
The Museum of Modern Art

In his book *A Little History of the World* — written to make history accessible to children — the famed art historian Ernst Gombrich deploys a series of metaphors to help his readers conjure the past: a tale that begins "once upon a time," a hall of mirrors, a bottomless well, a faraway journey, and a joyous return home.[1] Though seemingly plucked straight out of a fairy tale, each one nonetheless offers important history lessons for children and adults.

With "once upon a time," Gombrich emphasizes the importance of narrative to explaining the past — history is, first of all, a story. "Behind every 'Once upon a time,'" he points out, "there is always another. . . . And so it goes on, further and further back." He provides another emblem of the past's infinity as well: "A long line of shiny mirrors, each one smaller than the one before, stretching away into the distance, getting fainter and fainter, so that you never see the last." This journey back in time is, Gombrich writes, an opportunity to tour another era, with the return passage a "coming home." It is his "bottomless well," however, that most viscerally describes the depth of the past. To stress the well's

profundity, he asks his readers to imagine lighting a scrap of paper and dropping it down: "It will fall slowly, deeper and deeper," he writes. "And as it burns it will light up the sides of the well. Can you see it? It's going down and down. . . . It's getting smaller and smaller . . . and now it's gone."[2]

To look down into infinity, Gombrich acknowledges, "makes your head spin." Equipped with tools of inquiry and analysis, however, the historian ably restores balance by recording memories, deciphering scraps, and most of all, asking questions (note that the word *history* means inquiry). "*When* did that happen?" and "*How* exactly did that happen?"[3] are two that Gombrich specifically poses, pinpointing chronology and causality as key elements of any historical investigation. We can supply a host of others: What was the order of events? Who was involved? What provoked the action? What were the results? To ask, Gombrich insists, is to shout "Stop!" and thus momentarily halt time, thwarting the pull "back down into that bottomless well," alleviating the dizziness that looking into the past incites.[4]

C'est aussi un peu d'âme... car tu es malheureuse

J'ai pitié j'ai pitié viens vers moi sur mon cœur
Les roues sont les moulins à vent du pays de Cocagne

Et les moulins à vent sont les béquilles qu'un mendiant fait tournoyer

Nous sommes les culs-de-jatte de l'espace
Nous roulons sur nos quatre plaies
On nous a rogné les ailes
Les ailes de nos sept péchés
Et tous les trains sont les bilboquets du diable
Basse-cour
Le monde moderne
La vitesse n'y peut mais
Le monde moderne
Les lointains sont par trop loin

Et au bout du voyage c'est terrible d'être un homme avec une femme

« BLAISE, DIS, SOMMES-NOUS BIEN LOIN DE MONTMARTRE ? »

J'ai pitié j'ai pitié viens vers moi je vais te conter une histoire

Viens dans mon lit
Viens sur mon cœur
Je vais te conter une histoire...

Oh viens! viens !

Aux Fidji règne l'éternel printemps
La paresse

L'amour pâme les couples dans l'herbe haute et la chaude syphilis rôde sous les bananiers

Viens dans les îles perdues du Pacifique !
Elles ont nom du Phénix, des Marquises
Bornéo et Java
Et Célèbes à la forme d'un chat
Nous ne pouvons pas aller au Japon
Viens au Mexique !
Sur ses hauts plateaux les tulipiers fleurissent
Les lianes tentaculaires sont la chevelure du soleil
On dirait la palette et les pinceaux d'un peintre
Des couleurs étourdissantes comme des gongs,
Rousseau y a été
Il y a ébloui sa vie.
C'est le pays des oiseaux
L'oiseau du paradis l'oiseau-lyre
Le toucan l'oiseau moqueur
Et le colibri niche au cœur des lys noirs

Viens!
Nous nous aimerons dans les ruines majestueuses d'un temple aztèque
Tu seras mon idole
Une idole bariolée enfantine un peu laide et bizarrement étrange
Oh viens!

Si tu veux nous irons en aéroplane et nous survolerons le pays des mille lacs,
Les nuits y sont démesurément longues
L'ancêtre préhistorique aura peur de mon moteur
J'atterrirai
Et je construirai un hangar pour mon avion avec les os fossiles de mammouth
Le feu primitif réchauffera notre pauvre amour
Samowar
Et nous nous aimerons bien bourgeoisement près du pôle
Oh viens!

Jeanne JEANNETTE *Ninette nini ninon nichon*
Mimi mamour ma poupoule mon Pérou
Dodo dondon
Carotte ma crotte
Chouchou p'tit-cœur
Cocotte
Chérie p'tite-chèvre
Mon p'tit-péché mignon
Concon
Coucou
Elle dort.

Elle dort
Et de toutes les heures du monde elle n'en a pas gobé une seule
Tous les visages entrevus dans les gares
Toutes les horloges
L'heure de Paris l'heure de Berlin l'heure de Saint-Pétersbourg et l'heure de toutes les gares

Et à Oufa, le visage ensanglanté du canonnier
Et le cadran bêtement lumineux de Grodno
Et l'avance perpétuelle du train
Tous les matins on met les montres à l'heure
Le train avance et le soleil retarde
Rien n'y fait, j'entends les cloches sonores
Le gros bourdon de Notre-Dame
La cloche aigrelette du Louvre qui sonna la Barthélemy
Les carillons rouillés de Bruge-la-Morte
Les sonneries électriques de la bibliothèque de New-York

Les campanes de Venise
Et les cloches de Moscou, l'horloge de la Porte-Rouge qui me comptait les heures quand j'étais dans un bureau
Et mes souvenirs
Le train tonne sur les plaques tournantes
Le train roule
Un gramophone grasseye une marche tzigane
Et le monde comme l'horloge du quartier juif de Prague tourne éperdument à rebours.

The "once upon a time" of this exhibition begins just about one hundred years ago. Looking down into the century's well, we have followed Gombrich's lead, shouting "Stop!" not once, but six times, halting at 1913, 1929, 1950, 1961, 1988, and finally, at the very edge of our own time. For museum curators, "Stop!" is also "Look!" What constitutes the history we tell is not text—"old scraps of paper that people once wrote on," to borrow Gombrich's words (though they may play a role)—but objects that have been made.[5] As Neil MacGregor, director of the British Museum, succinctly puts it, "Telling history through things is what museums are for" (see fig. 1).[6]

Fast Forward: Modern Moments 1913 >> 2013 slices time into core samples: for each of the selected years, we extract synchronous artistic strategies, themes, subjects, and players. Each excavation yields a complex picture of that particular moment. As opposed to a survey honed by a sharp gaze used to precisely define masters and masterworks, *Fast Forward* offers an opening up: to diversity, to irresolution, to miscellany. In this way, our method also functions as a critique of tidy one-after-another sequencing, a rethinking of the familiar succession of key achievers, a comment on notions of linear progress and progression. Our account emphasizes the multiplicity of movements, events, and practices overlapping at the same time—an approach that observes the logic of confrontation, juxtaposition, and collision. Gombrich's well is less apt here; a better metaphor is montage, borrowed from another philosopher of history, Walter Benjamin.

For Benjamin, whose own project was a layered history of the nineteenth century, montage is both poetic and radical, allowing the historian to gather "materials of widely differing kinds in a new, intuitive relationship" while ridding "the image of history of any trace of 'development.'"[7] History, to Benjamin, is not a "cumulative, additive narrative in which the uninterrupted syntagm of time flows homogeneously from past to future, but rather a montage where any moment may enter into sudden adjacency with another."[8]

Benjamin's choice of montage as a mode of historical practice—with its suggestion of a cinematic method defined by the "rapid-fire juxtaposition of 'small, fleeting pictures'"—also implies a particularly imagistic view of the past.[9] "I need say nothing," he writes, "only show…I will not describe but instead exhibit."[10] Ultimately, though, Benjamin was a writer, and what he "showed" of the nineteenth century in what came to be called *The Arcades Project (Das Passagen-Werk)* were literary impressions composed of an enormous volume of notes, commentary, and citations copied directly from primary sources or contemporary thinkers, all ordered by topic into files or "convolutes."[11] These citations were "set up to communicate among themselves," resulting in, Benjamin hoped, "a world of secret affinities."[12]

The museum offers a visual counterpart to Benjamin's wide-ranging montage. We might think of its galleries as the equivalent of the historian's files, the works of art as fragments of a lost world. Our goals, like Benjamin's, are both macro and micro: to illuminate the century's achievements in art by spotlighting particular moments when innovative movements and radical strategies emerged. These stories are told through objects selected from the collection of The Museum of Modern Art. In choosing them, we abided by one strict rule: each work was created during the year in question.

Though we might think of texts as being the most eloquent transmitters of history, objects—here, works of art—communicate equally well; they "speak of whole societies and complex processes…and tell of the world for which they were made, as well as of the later periods which reshaped or relocated them."[13] To Benjamin, each object is a "magic encyclopedia" that encapsulates "the period, the region, the craftsmanship, the former ownership."[14] A lone object tells us much—articulating such specific details as medium, maker, strategic choices, provenance—and, when joined by others in pairs or groups, can convey a story significantly enhanced by debate and dialogue.

Look, for example, at *La Prose du Transsibérien et de la petite Jehanne de France (Prose of the Trans-Siberian and of the Little Jeanne of France)*, 1913, a collaborative visual/textual work by painter Sonia Delaunay-Terk and poet Blaise Cendrars (plate 2). Neither painting nor sculpture, this work

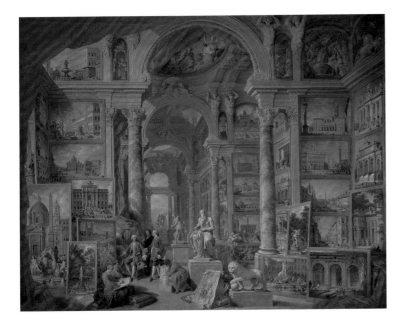

is an unusual accordion book, printed by pochoir (a stencil technique), and measuring more than six feet in length. Its medium and form tell us about the expansion of artistic activities during this period. The vibrantly colored and mostly nonrepresentational shapes running down the left side — among the earliest self-consciously abstract images made — and the text (a poem, in fact) printed in a variety of fonts, type sizes, and hues running down the right side speak to the importance of abstraction at this moment, the possibilities for collaboration, and the vitality of putting together pictures and words. The authors' own description of the work as a "*livre simultané*" (simultaneous book) (fig. 2) is not only a nod to the simultaneous presentation of word and image, but also situates *La Prose du Transsibérien* in contemporary debates about the term *simultaneity*. The word was deployed by artists and writers of the period to describe and encapsulate the collapse of spatial and temporal distance in what they felt was an increasingly sped-up, crowded, and spectacular world, while also reflecting a resultant radical shift in perception.[15]

Just as a single object tells many stories, when multiple objects are organized according to the six core years of *Fast Forward*, the groupings display a mix of practices, styles, and approaches, proving that movements (like Cubism, Abstract Expressionism, and Pop) or inventions (like abstraction or the readymade) do not emerge in a neat chronology, in one place, or in a single form. In 1913, for example, all of the major avant-garde movements of the early twentieth century are dramatically in force: Cubism, Futurism, German Expressionism, Dada. Moreover, these developments take place across Europe and the U.S., encompassing the experiments of Pablo Picasso, Henri Matisse, and Delaunay-Terk in France; Piet Mondrian in the Netherlands; Kazimir Malevich in Russia; Umberto Boccioni and Giacomo Balla in Italy; and Ernst Ludwig Kirchner and Oskar Kokoschka in Germany and Austria — to name just a few. We see artworks in many shapes and sizes, from bronze sculpture and oil on canvas to printed books and found objects. Of course, these activities did not emerge in isolation in different capitals but resulted from networks of friendships among artists, writers,

1
Giovanni Paolo Panini (Italian, 1691–1765). *Modern Rome*. 1757. Oil on canvas, 67¾ in. × 7 ft. 7¾ in. (172.1 × 233 cm). The Metropolitan Museum of Art, New York. Gwynne Andrews Fund, 1952

2
Envelope for Sonia Delaunay-Terk and Blaise Cendrars. *La Prose du Transsibérien et de la petite Jehanne de France*. 1913. See plate 2 and page 11

curators, and gallerists, facilitated by newly efficient modes of transportation and communication. Similarly, in 1929, activities associated with Surrealism and international Constructivism unfolded in multiple venues. Artists involved in these movements worked as far afield as Moscow, Barcelona, and Cologne, exploring a vast array of mediums and materials, including painting, photography, posters, and film.

Though our groupings foreground miscellany and mixture, there are also convergences within each year, indicating a common spirit, cultural climate, or zeitgeist. In 1913 we see the attempts of the early twentieth-century avant-gardes to make a new art for a new world. This new world was defined by dramatic shifts in experience, from the rapid growth of the city and industry to the invention of the airplane and the automobile to the expansion of visual spectacle in cinema and advertising. How does our vision change when we can look down from unprecedented heights or gaze out the window of a speeding train, when we see images projected on a screen or reproduced on billboards? How can we capture motion in still formats or make art without the figure? In answering these questions, artists turned to abstract (or almost abstract) visual languages. In 1929 we see efforts to understand and represent a new kind of vision, a pull between looking inward to investigate the workings of the mind and outward to depict an increasingly technological world. Though visually distinct — compare, for example, Salvador Dalí's little theaters (plate 21) to Aleksandr Rodchenko's *Chauffeur* (plate 55), one about desire, the other about the relations of photographer and subject to the outside world — there are commonalities in medium and in strategy: the increasing use of and dialogue with photography, especially the exploration of innovative points of view and the close-up, as well as an interest in juxtaposition and montage.

In our pantheon of years, 1950 is the most uniform in its preference for large-scale abstract painting that uses gestural mark making as a vehicle of expression. Though just a little more than a decade later, 1961 is a world away from the existential and material concerns of midcentury. With the incorporation of real-world objects into the space of art —

through assemblage or appropriated subject matter and through close attention to mass consumption and media culture — artists of this moment aspire to the integration of art and life. Appropriation is still a dominant method in 1988, but to different ends. Artists explore identity, showing how creators and their works are embedded in specific experiences of race, class, and sexuality. Without the benefit of hindsight, assessing the art of our own time is more difficult. Characteristics that we can identify are an impulse toward ever more diverse practices and expanded definitions of traditional forms. Our representatives of 2013 — Aaron Curry, Katharina Grosse, and Sarah Sze — offer a sense of the range and reach of contemporary art in their works installed at the High Museum.

An unanticipated benefit of our aim to illuminate artistic invention at particular moments has been the recognition of threads connecting chronologically distant efforts, whether in the echoes of form from one moment to the next or in the way that strategies prevalent in one era so clearly feed subsequent achievements (in this sense, historical development has not been completely abandoned). Some of these connections will be familiar to attentive students of the art history survey. Duchamp's readymade of a bicycle wheel and stool (plate 3), 1913, for example, paved the way for Robert Rauschenberg's Combine of a tire, license plate, and lightbulb (plate 91), 1961. (Is it a coincidence that the major element in both works is a wheel?) Bauhaus and Constructivist graphics, 1929, are the ancestors of Otl Aicher's midcentury posters. By renouncing gesture in 1961, Andy Warhol, Richard Hamilton, and Roy Lichtenstein are reacting against the Action Painting of Jackson Pollock and Willem de Kooning from 1950. By juxtaposing these moments, many other relationships become apparent. Move beyond the wheels of Duchamp and Rauschenberg — along with those of Alberto Giacometti's *Chariot* (plate 76) — to a chain of circles including Jean Arp's heads, his and Walter Cyliax's polka dots, Aicher's mosaics of colorful shapes, Lee Bontecou's ominous void, Jim Dine's beads and doughnut, Lichtenstein's beach ball, Kenneth Noland's graphic rings, David Wojnarowicz's spinning disk, and

Annette Messager's rounded assemblage. While admittedly this reduces art history to morphology, it is nonetheless fascinating to see artists from many generations stacking the building blocks of art in such different ways. We also see the use of words as messages, graphics, or pure form. René Magritte's arrangement of words and pictures (plate 23) is a progenitor of later combinations of text and image or text *as* image, including Jenny Holzer's *Laments* (plates 142–43), Glenn Ligon's *Untitled (There is a consciousness we all have…)* (plate 144), and Mona Hatoum's *Measures of Distance* (plate 145). The photograph is repeatedly exploited in new and radical ways: compare Alfred Stieglitz's *Equivalents* (plates 28–31) to Messager's *My Vows* (plate 139). And the body is deconstructed into its constituent parts, mechanized, and reconstructed; links in this chain connect Joan Miró's *Portrait of Mistress Mills in 1750* (plate 24) to de Kooning's *Woman, I* (plate 71) to Jeff Koons's *Pink Panther* (plate 152).

The identification of such links is itself another approach to history, one based on reassessment, rethinking, and reinvention: a reanimation of the past through the present.[16] From this perspective, the past is not remote — is not a foreign country, as the saying goes — but instead is in constant dialogue with the present.[17] Similarly, the museum is not, as sometimes claimed, a mausoleum where "we put the art of the past to death,"[18] but an arena for the lively combat of ideas and approaches. Art historian Erwin Panofsky contends that the humanities, of which museums and the stories they tell are a part, "are not faced by the task of arresting what otherwise would slip away, but of enlivening what otherwise would remain dead."[19] To sharpen this sense of history's ongoing function in the present, we might offer a reading of Allen Ruppersberg's poster *Nostalgia 24 Hours a Day* (plate 158). Rather than a critique of sentimental immersion in the past, it can be seen as a demand to pay vigilant attention to history. Only through the present can we access the past; only through the past can we understand the present. Traveling forward into the past, we might turn once more to Ruppersberg, who, in another poster from the same series (plate 159), offers an enthusiastic "Good Luck!"

1. E. H. Gombrich, *A Little History of the World*, trans. Caroline Mustill (1936; New Haven, Conn., and London: Yale University Press, 2008), pp. 1–4.

2. Ibid.

3. Ibid., p. 4.

4. Ibid.

5. Ibid., p. 2.

6. Neil MacGregor, *A History of the World in 100 Objects* (London: Trustees of the British Museum and the BBC; New York: Viking Press, 2011), p. xiii.

7. Walter Benjamin, "One-Way Street (selection)," in *Reflections: Essays, Aphorisms, Autobiographical Writings*, ed. Peter Demetz, trans. Edmund Jephcott (New York: Schocken Books, 1986), p. 69; and Benjamin, quoted in Richard Sieburth, "Benjamin the Scrivener," in *Benjamin: Philosophy, Aesthetics, History*, ed. Gary Smith (Chicago: University of Chicago Press, 1989), p. 23.

8. Sieburth, "Benjamin the Scrivener," p. 24.

9. Benjamin, quoted ibid., p. 23.

10. Ibid., p. 21.

11. See Walter Benjamin, *The Arcades Project*, trans. Howard Eiland and Kevin McLaughlin (Cambridge, Mass.: Belknap Press of Harvard University Press, 1999).

12. "Set up" from Eiland and McLaughlin, "Translators' Foreword," *Arcades Project*, p. x; "a world of secret affinities" is a quotation from Benjamin, ibid.

13. MacGregor, *History of the World*, p. xv.

14. Walter Benjamin, "Unpacking My Library," in *Illuminations*, ed. Hannah Arendt, trans. Harry Zohn (New York: Schocken Books, 1969), p. 60.

15. Stephen Kern, *The Culture of Time and Space: 1880–1918* (Cambridge: Harvard University Press, 1983), pp. 65–88. For a brief discussion of debates about the term *simultaneity* in relationship to *La Prose du Transsibérien*, see my essay on Sonia Delaunay-Terk in *Modern Women: Women Artists at The Museum of Modern Art*, ed. Cornelia Butler and Alexandra Schwartz (New York: The Museum of Modern Art, 2010), pp. 84–87.

16. Benjamin writes, "The past can be seized only as an image which flashes up at the instant when it can be recognized and is never seen again." Walter Benjamin, "Theses on the Philosophy of History," in *Illuminations*, p. 255.

17. Benjamin would call this dialogue a dialectic. See Walter Benjamin, *Arcades Project*, and Benjamin, "Theses on the Philosophy of History," pp. 253–64. See also Sieburth, "Benjamin the Scrivener," pp. 18–19.

18. Theodor W. Adorno, "Valéry Proust Museum," in *Prisms*, trans. Samuel and Shierry Weber (Cambridge, Mass.: MIT Press, 1983), p. 177.

19. Erwin Panofsky, *Meaning in the Visual Arts* (Garden City: Doubleday Anchor Books, 1955), p. 24. Discussed in Hal Foster, *Design and Crime* (London: Verso, 2002), p. 74.

1913

» In their "Rayonist Manifesto" of 1913, Mikhail Larionov and Natalia Goncharova extol the marvels of contemporary life: "We exclaim: the whole brilliant style of modern times — our trousers, jackets, shoes, trolleys, cars, airplanes, railways, grandiose steamships — is fascinating, is a great epoch, one that has known no equal in the entire history of the world."[1] This elated outburst reflects the love affair of these two artists — and their avant-garde colleagues — with new technologies of transportation. The forceful velocity of a rumbling train, the convenience of a city trolley, the sheer power of a large ship, and especially, the heights and distances made available via air travel sparked the imaginations of artists and writers, provoking what became a pervasive ambition: to represent these new subjects in radically new ways.[2]

The airplane provided perhaps the most dramatic shift in both experience and perception, inspiring many artists to make aviation a central element in their oeuvres. Following milestones such as Orville and Wilbur Wright's twelve-second flight at Kitty Hawk, North Carolina, in 1903, and Louis Blériot's first-ever air crossing of the English Channel in 1909, in 1913 Roger de La Fresnaye presented his take on "The Conquest of the Air" (plate 1). For him, it was a particularly French story: the tricolor flag presides over two men playing cards, who have been identified as the artist himself and his brother Henri, director of an aircraft manufacturing plant near Meulan, France.[3] Towering over the small Cubist houses that dot the landscape, the cardplayers

Plate 1

Roger de La Fresnaye. *The Conquest
of the Air.* 1913. Oil on canvas,
7 ft. 8⅞ in. × 6 ft. 5 in. (235.9 × 195.6 cm)

17

1

Kazimir Malevich. *Suprematist Composition: Airplane Flying.* 1915 (dated on reverse 1914). Oil on canvas, 22⅞ × 19 in. (58.1 × 48.3 cm). The Museum of Modern Art, New York. 1935 Acquisition confirmed in 1999 by agreement with the Estate of Kazimir Malevich and made possible with funds from the Mrs. John Hay Whitney Bequest (by exchange)

2

Robert Delaunay (French, 1885–1941). *Homage to Blériot.* 1914. Oil on canvas, 6 ft. 4½ in. × 50½ in. (194.3 × 128.3 cm). Kunstmuseum, Basel

have a larger-than-life monumentality. There is no airplane in the picture; instead, we see two other means of "conquering" the air: the yellow hot-air balloon in the upper center and the sailboat at center right.[4] La Fresnaye pays tribute here to France's early role in air travel: the invention of the hot-air balloon in 1783 by another pair of French brothers, Joseph-Michel and Jacques-Étienne Montgolfier. This reference, according to art historian Kenneth Silver, expresses "pride and confidence in the role that France was destined to play in the future of aviation."[5]

The experience of flight — whether in bodily, aural, visual, or perceptual terms — became a widespread symbol of the modern, appearing in paintings and drawings by Fernand Léger, poems by Guillaume Apollinaire, and musical compositions by Igor Stravinsky. Kazimir Malevich's landmark opera of 1913, *Victory over the Sun,* opens with the "growling of propellers," an airplane wing falls to the stage, and the aviator-protagonist makes an entrance as "the man of the future."[6] In subsequent years, even as Malevich's formal language became wholly abstract, the airplane continued to stand for dynamism and technological optimism in his paintings and works on paper. Composed of multicolored blocks placed diagonally across the canvas, *Suprematist Composition: Airplane Flying* (fig. 1) suggests the path of flight. Other artists created ever more ecstatic visions of the invention of the airplane and the experience of flying. In Robert Delaunay's *Homage to Blériot* (fig. 2), the rotating propeller seems to generate not only speed but what might be described as psychedelic perception, a prismatic vision of light and hue, spinning toward the viewer and back into the distance.

Many other works by artists, writers, composers, and architects embodied this fascination with the airplane and, in particular, its speed. Their rapturous belief in the transformative power of flight was paralleled by a conviction that our humanness would be altered so that we would ultimately function more like machines. Malevich looked forward to the day when the pilot would "graft onto himself this new-grown body, to use it inseparably with his organism,"

while the Futurist provocateur F. T. Marinetti held close a faith "in the possibility of an incalculable number of human transformations, and we say without smiling that wings sleep in the flesh of man."[7] Other artists and writers, however, were less optimistic about such new technologies, concerned that a machine might "enslav[e] humanity through its domination of the skies."[8] "For all that was being gained," historians Charles Harrison and Paul Wood have noted, "there was a sense that life was losing a depth, a dimension of freedom, and that human beings were becoming imprisoned in what German sociologist Max Weber saw as the 'iron cage' of modernity."[9]

Whether enunciating a utopian or dystopian view of the future, the rhetoric of this period favored analogies between artist and pilot, art making and flying.[10] The Russian poet Vasily Kamensky was especially eloquent on this point: "I wanted to participate in the great discovery not merely with words, but with deeds. What are poems and novels? The airplane — that is the truest achievement of our time.... If we are people of the motorized present, poets of universal dynamism, newcomers and messengers of the future, masters of action and activity, enthusiastic builders of new forms of life — then we must be, we have no choice but to be flyers."[11] Though Kamensky felt he had to choose between piloting and poetry, writing — specifically the manifesto — often took the airplane and other forms of transportation as its subject and found its syntax in the energy, vitality, and force of the new technologies. According to Marinetti, its most famous and most talented practitioner, the manifesto required "violence, *precision*," "a *precise* accusation, a well-*defined* insult."[12] He led the way with his own Futurist Manifesto of 1909, but by 1913 there was an outpouring of belligerent, fervent, violent, ecstatic proclamations representing every avant-garde ism, including Cubism by Apollinaire, Simultaneism by Robert Delaunay, Dada by Marcel Duchamp, Imagism by Ezra Pound, and Futurism in Italy and Russia by Carlo Carrà, Luigi Russolo, Velimir Khlebnikov, Alexei Kruchenykh, and Larionov and Goncharova. The era was infected with "manifesto fever."[13]

Though the manifesto had existed as a "public declaration or proclamation" as far back as the seventeenth century, the particular form it took in 1913 is rooted in Karl Marx and Friedrich Engels's *Communist Manifesto* of 1848. Marjorie Perloff explains: "In the wake of the French Revolution, the manifesto had become...the voice of those who are contra — whether against king or pope or ruling class or simply against the existing state of affairs.... Indeed, it is the curiously mixed rhetoric of the *Communist Manifesto,* its preamble itself something of a prose poem, that paved the way for the grafting of the poetic onto the political discourse that we find in Futurist, and later in Dada and Surrealist, manifestos."[14] This poetic and political *No* to authority, along with anticipation of an exhilarating new order, is the common language of the early twentieth-century manifesto. Consider, for example, a few declarations from Larionov and Goncharova's "Rayonist Manifesto":

We have no modesty — we declare this bluntly and frankly — we consider ourselves to be the creators of modern art.
We are against the West, which is vulgarizing our forms and

Eastern forms, and which is bringing down the level of everything. We are against art societies, for they lead to stagnation. We've had enough of this manure; now we need to sow.[15]

Similarly, in his 1913 manifesto "Destruction of Syntax — Imagination without Strings — Words-in-Freedom," Marinetti calls for the "acceleration of life to today's swift pace," "Dread of the old and the known. Love of the new, the unexpected."[16] He also calls for a complete overhaul of written language itself, a "typographical revolution" that would overthrow the harmony of the well-composed page. He writes, "By the imagination without strings I mean the absolute freedom of images or analogies, expressed with unhampered words and with no connecting strings of syntax and no punctuation."[17]

This assault on the verbal and the written extended to the visual as well. Rejecting aesthetic conventions, artists of 1913 set out on a quest for a new pictorial language. Many turned toward abstraction. In inventing an abstract grammar, Sonia Delaunay-Terk, Morgan Russell, Stanton Macdonald-Wright, and Larionov employed contrasts of color and fractured or splintered form (plates 2, 14, 15, and 10), while Piet Mondrian explored the structure of the grid (plate 11). Even without figuration, these works reflect the era's rapid pace, its simultaneity, its amplified spectacle. Pablo Picasso, Juan Gris, and Malevich drew close to abstraction during this period without losing their subjects entirely: all deployed Cubism to fragment traditional genres — flattening the planes of their pictures, reducing elements to simple geometries, and making vivid use of pattern and ornament (plates 4, 6, and 9). In devising methods to describe in static mediums what they perceived as the defining characteristics of modern life — movement and velocity — the Futurist Giacomo Balla repeated lines and forms in a staccato rhythm, while his compatriot Umberto Boccioni created winglike flares that extend beyond the body of his sculpted figure to make visible its path striding through space (plates 12 and 13). Similarly attuned to the new conditions of modern life, Ernst Ludwig Kirchner took on the subjects of the twentieth-century city, compressing and tilting his urban dwellers and their surroundings to create a sense of destabilization and anxiety (plate 18).

It was Duchamp, however, who formulated the most radical syntax of all. At New York's famed Armory Show, in 1913, the first exhibition of international advanced art in the United States, he was represented by the painting *Nude Descending a Staircase (No. 2)* (fig. 3). Borrowing from Cubism and Futurism, he splintered the figure and the stairs into discrete planes, creating an optical vibration and a sense of motion. As outrageous as this work may have seemed — one viewer mocked it as "an explosion in a shingle factory"[18] — it was soon surpassed by Duchamp's next step: turning away from painting entirely in favor of selecting a manufactured object and calling it a "readymade" work of art. The readymade subverted such principles of aesthetic appreciation as originality, authorship, skill, and taste. But for Duchamp, whether the artist "with his own hands made the . . . [work] or not has no importance. He CHOSE it. He took an ordinary article of life, placed it so that its useful significance disappeared under the new title and point of view — created a new thought for that object."[19] This act set out the terms of a new grammar far different from those we have already considered: not of gesture nor color nor speed nor dynamism, but of naming, what the artist called "pictorial nominalism." In 1913 Duchamp had "begun to construe *naming* art — that is nominating a given image or object as art — as tantamount to *making* art."[20] After that, what artists did would never be the same. — JODI HAUPTMAN

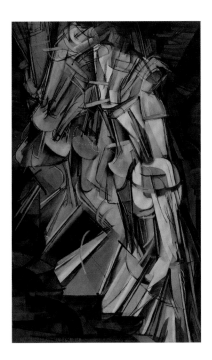

3

Marcel Duchamp. *Nude Descending a Staircase (No. 2)*. 1912. Oil on canvas, 57⅞ × 35⅛ in. (147 × 89.2 cm). The Philadelphia Museum of Art, The Louise and Walter Arensberg Collection, 1950

1. Mikhail Larionov and Natalia Goncharova, "A Manifesto," 1913, in Mary Ann Caws, ed., *Manifesto: A Century of Isms* (Lincoln: University of Nebraska Press, 2001), p. 242.

2. Charles Harrison and Paul Wood write: "It is hard retrospectively to capture the extent of the transformation that was taking place. In developing societies in Europe at the turn of the twentieth century the new was ousting the old at a pace for which there was no historical precedent." See Charles Harrison and Paul Wood, eds., *Art in Theory, 1900–2000: An Anthology of Changing Ideas* (Malden, Mass.: Blackwell, 2003), p. 128.

3. Helen M. Franc, *An Invitation to See: 150 Works from The Museum of Modern Art* (New York: The Museum of Modern Art, 1992), p. 52. For an alternative reading of the two men as another set of French brothers, Henry and Marcel Kapferer, see Laura Morowitz, "La Conquête de l'air: The 'right' brothers: les frères Wright ou les frères Kapferer?" in *Roger de La Fresnaye, 1885–1925: Cubisme et tradition,* ed. Françoise Lucbert (Paris: Somogy Éditions d'Art, 2005), pp. 83–93.

4. Discussed in Franc, *Invitation to See,* p. 52.

5. For Silver, the flag is the key to a reading of nationalism in the picture. His argument — originally presented as a paper, "Tricolorism Revisited," at Self and History: A Symposium in Honor of Linda Nochlin, Institute of Fine Arts, New York University, April 17, 1999 — is summarized by Mary Chan, "The Conquest of the Air," in John Elderfield et al., *Modern Starts* (New York: The Museum of Modern Art, 1999), p. 253.

6. For "growling": see Robert Wohl, *A Passion for Wings: Aviation and the Western Imagination, 1908–1918* (New Haven, Conn., and London: Yale University Press, 1994), p. 173. For "man of the future": ibid., p. 171. See also Wohl's discussion of *Victory over the Sun* and Malevich, pp. 157–79.

7. For Malevich, see Wohl, *Passion for Wings,* p. 175; for Marinetti, see Robert Wohl, "Messengers of a Vaster Life," in *Defying Gravity: Contemporary Art and Flight,* ed. Huston Paschal and Linda Johnson Dougherty (Raleigh: North Carolina Museum of Art, 2003), p. 19.

8. Velimir Khlebnikov, quoted in Wohl, *Passion for Wings,* p. 161.

9. Harrison and Wood, eds., *Art in Theory,* p. 126.

10. In their collaborative invention of Cubism, Pablo Picasso and Georges Braque compared themselves to Orville and Wilbur Wright. See Kirk Varnedoe, *A Fine Disregard: What Makes Art Modern* (New York: Harry N. Abrams, 1990), p. 271.

11. Kamensky, quoted in Wohl, "Messengers of a Vaster Life," pp. 19–20.

12. "De la violence et de la *précision,*" "l'accusation *précise,* l'insulte bien *définie*": Marinetti, quoted in Marjorie Perloff, *The Futurist Moment: Avant-Garde, Avant Guerre, and the Language of Rupture* (Chicago: University of Chicago Press, 1986), pp. 81–82.

13. This is Perloff's phrase; see ibid., p. 81. For a compilation of these manifestos, see Caws, ed., *Manifesto.*

14. Perloff, *Futurist Moment,* p. 82. For an extensive discussion of the manifesto, see Perloff's "Violence and Precision: The Manifesto as Art Form," ibid., pp. 80–115.

15. Larionov and Goncharova, "A Manifesto," 1913, in Caws, ed., *Manifesto,* pp. 240–43.

16. F. T. Marinetti, "Destruction of Syntax — Imagination without Strings — Words-in-Freedom" (1913), in Umbro Apollonio, ed., *Futurist Manifestos,* trans. Robert Brain et al. (Boston: MFA Publications, 2001), p. 96.

17. Ibid., p. 99.

18. Julian Street described the painting this way in an article in the *New York Sun.* Discussed in Joseph Masheck, *Marcel Duchamp in Perspective* (Cambridge, Mass.: Da Capo Press, 2002), p. 4.

19. Marcel Duchamp, "The Richard Mutt Case," *Blind Man* (New York) 2 (1917): 5. Reprinted in Kristine Stiles and Peter Selz, eds., *Theories and Documents of Contemporary Art: A Sourcebook of Artists' Writings* (Berkeley and Los Angeles: University of California Press, 1996), p. 817.

20. Hal Foster et al., "1914," in *Art since 1900: Modernism, Antimodernism, Postmodernism* (New York: Thames and Hudson, 2004), p. 128.

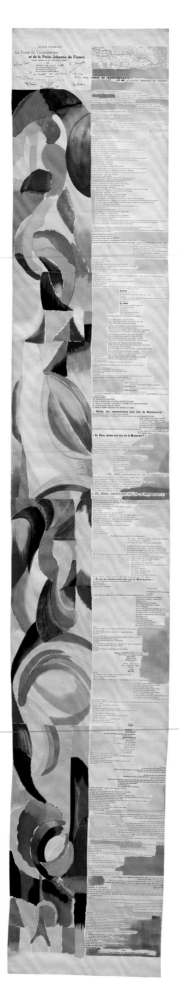

Plate 2

Sonia Delaunay-Terk and Blaise
Cendrars. *La Prose du Transsibérien
et de la petite Jehanne de France
(Prose of the Trans-Siberian and of
the Little Jeanne of France)*. 1913.
Illustrated book with pochoir,
sheet: 6 ft. 9⅝ in. × 14¼ in.
(207.4 × 36.2 cm)

Plate 3

Marcel Duchamp. *Bicycle Wheel*. 1951
(third version, after lost original of
1913). Metal wheel mounted on painted
wood stool, 51 × 25 × 16½ in.
(129.5 × 63.5 × 41.9 cm)

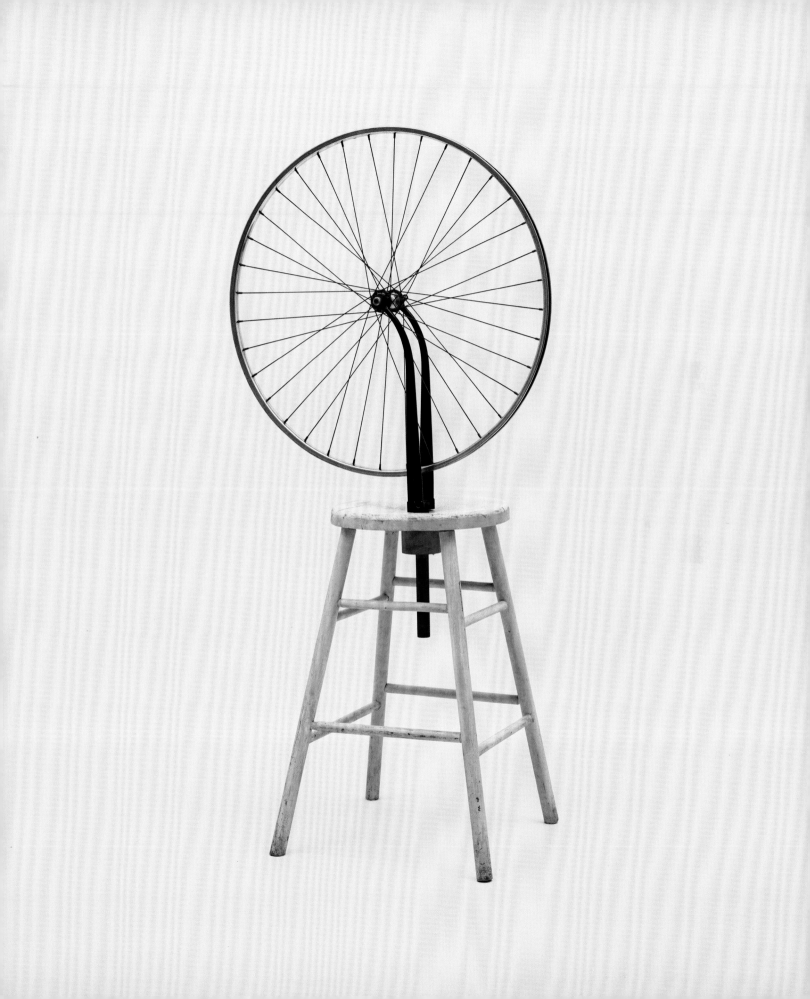

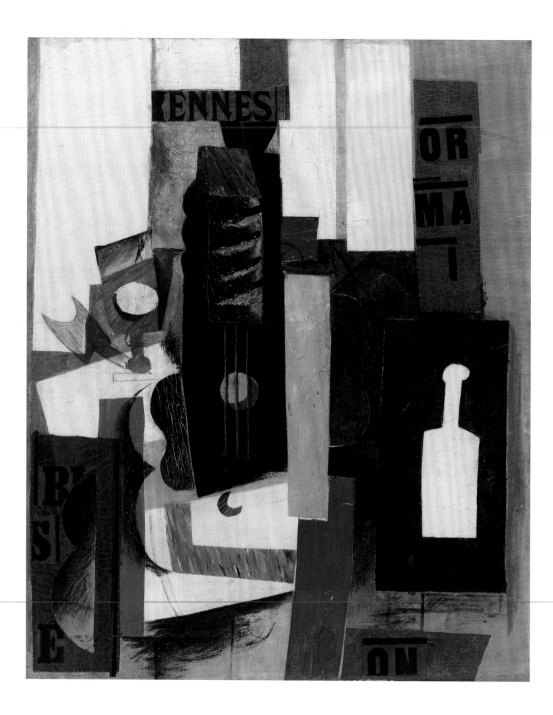

Plate 6

Juan Gris. *Grapes*. October 1913.
Oil on canvas, 36¼ × 23⅝ in.
(92.1 × 60 cm)

Plate 7

Pablo Picasso. *Card Player*.
Winter 1913–14. Oil on canvas,
42½ × 35¼ in. (108 × 89.5 cm)

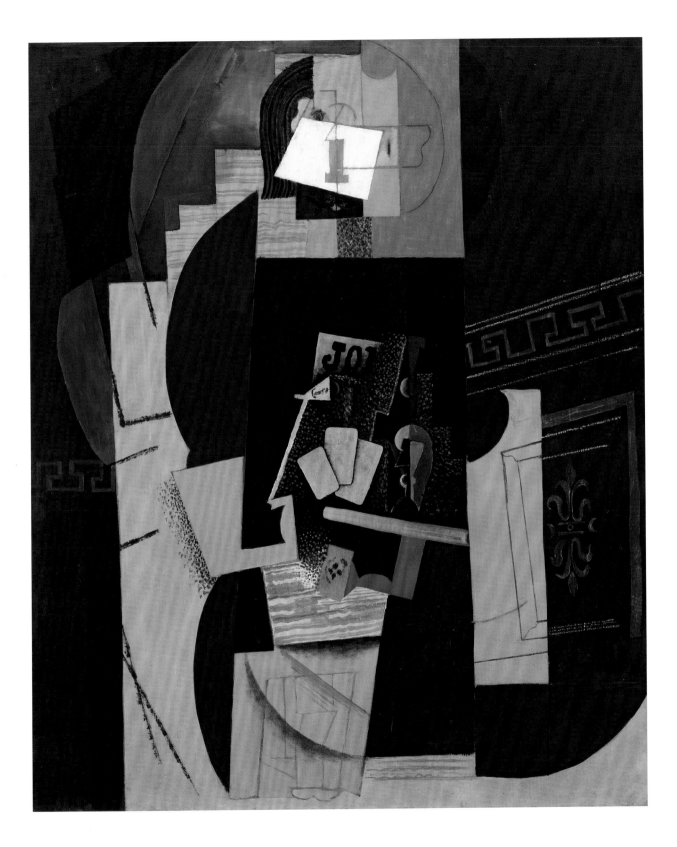

Plate 8

Olga Rozanova. *The Factory and the Bridge*. 1913. Oil on canvas, 32¾ × 24¼ in. (83.2 × 61.6 cm)

Plate 9

Kazimir Malevich. *Samovar*. 1913. Oil on canvas, 35 × 24½ in. (88.5 × 62.2 cm)

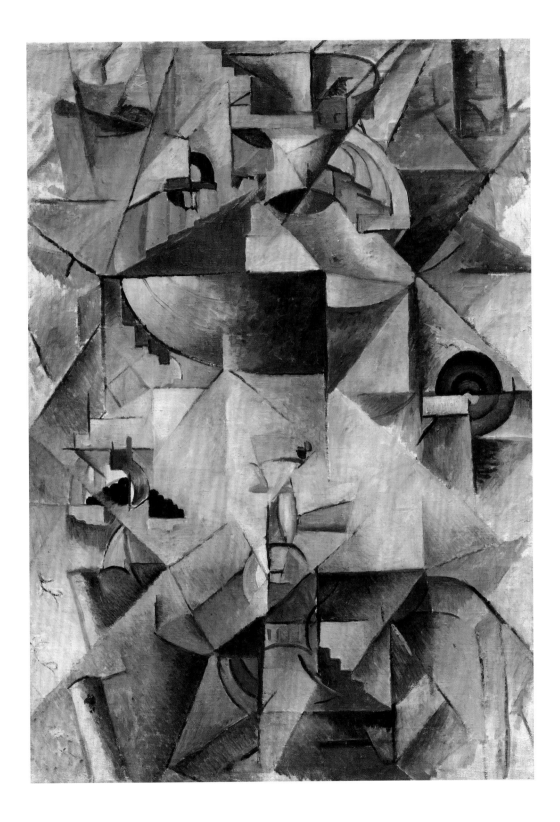

Plate 10

Mikhail Larionov. *Rayonist Composition.*
c. 1912–13. Oil on cardboard,
20 × 17⅛ in. (50.2 × 43.5 cm)

Plate 11

Piet Mondrian. *Gemälde no. II/Composition
no. IX/Compositie 5 (Composition in Brown and Gray).*
1913. Oil on canvas, 33¾ × 29¾ in.
(85.7 × 75.6 cm). © 2012 Mondrian/Holtzman
Trust c/o HCR International Washington, D.C.

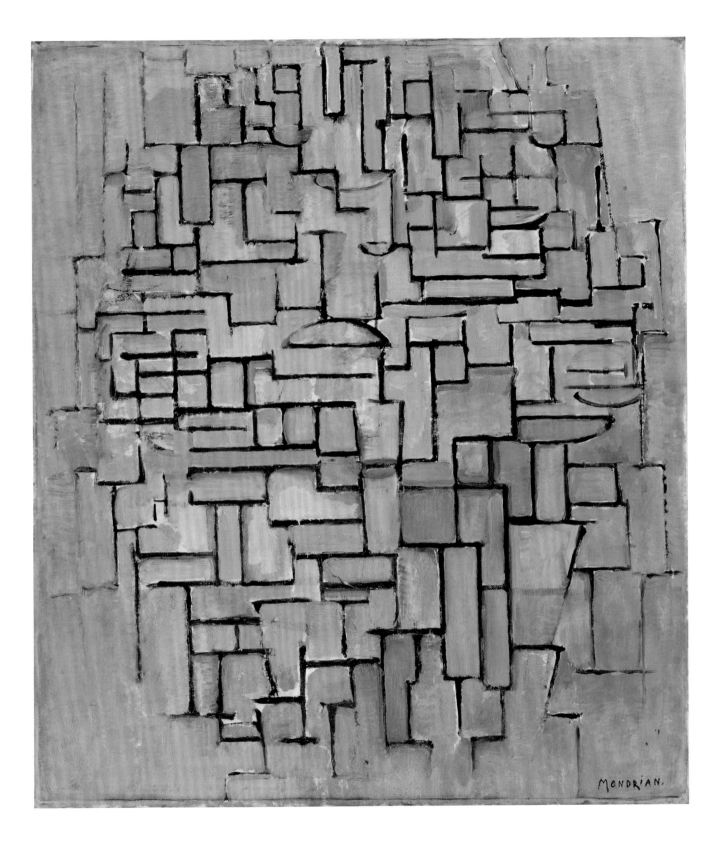

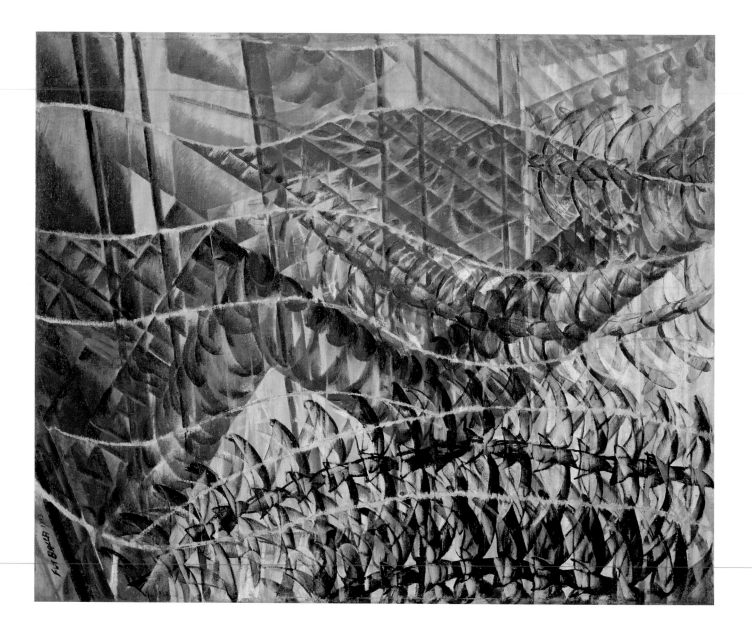

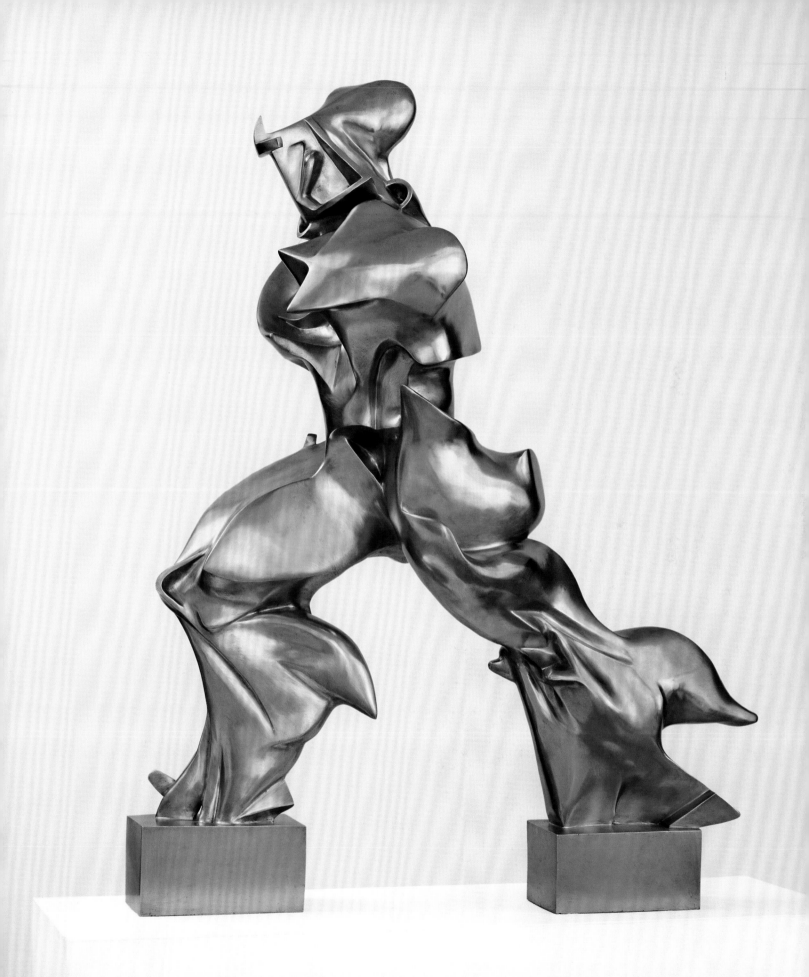

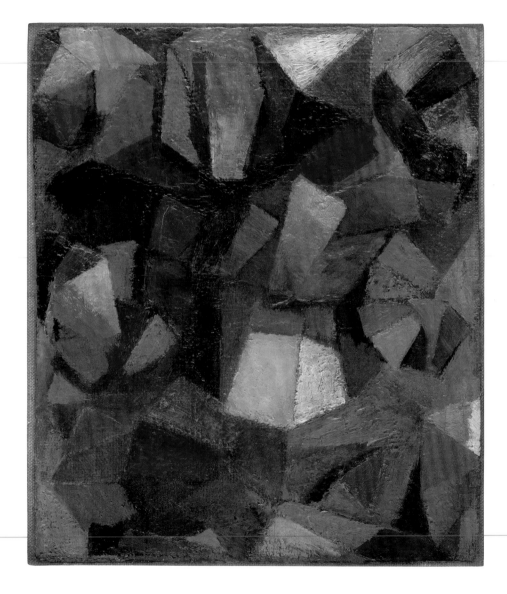

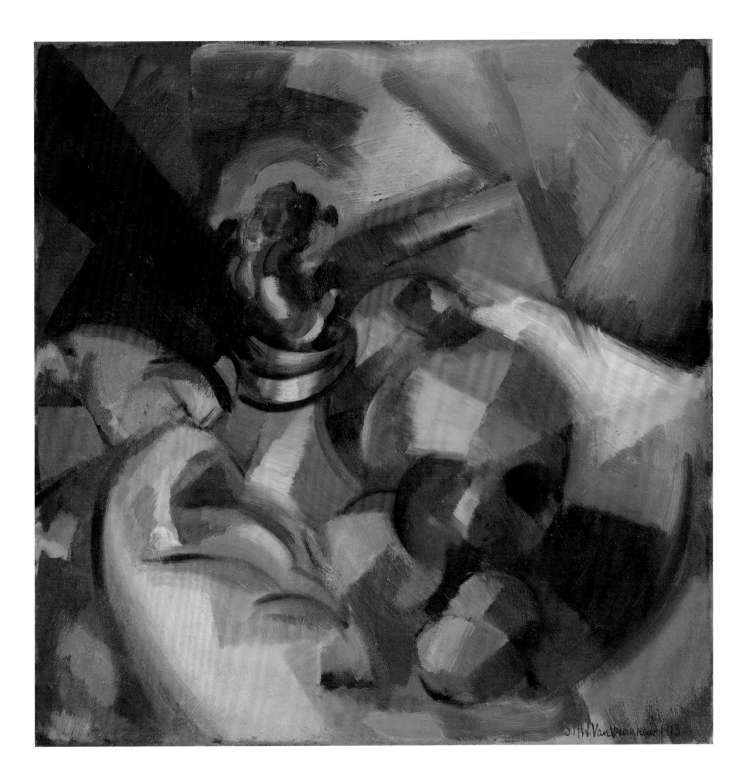

Plate 16

Erich Heckel. *Woman Kneeling near a Rock.*
1913 (published 1921). Woodcut, sheet
(irreg.): 24 3/8 × 20 3/16 in. (61.9 × 51.2 cm)

Plate 17

Erich Heckel. *Siblings.* 1913 (published
1921). Woodcut, sheet: 24 3/16 × 18 1/2 in.
(61.4 × 47 cm)

Plate 18

Ernst Ludwig Kirchner. *Street, Berlin.*
1913. Oil on canvas, 47 1/2 × 35 7/8 in.
(120.6 × 91.1 cm)

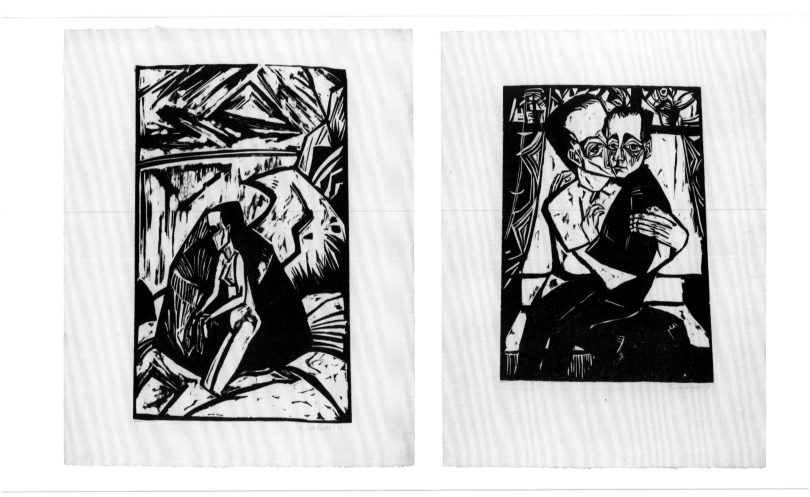

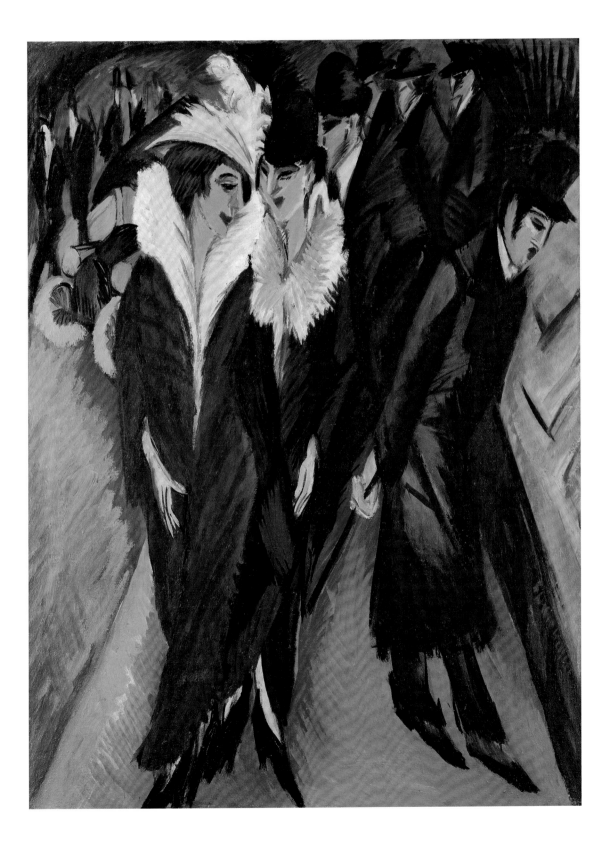

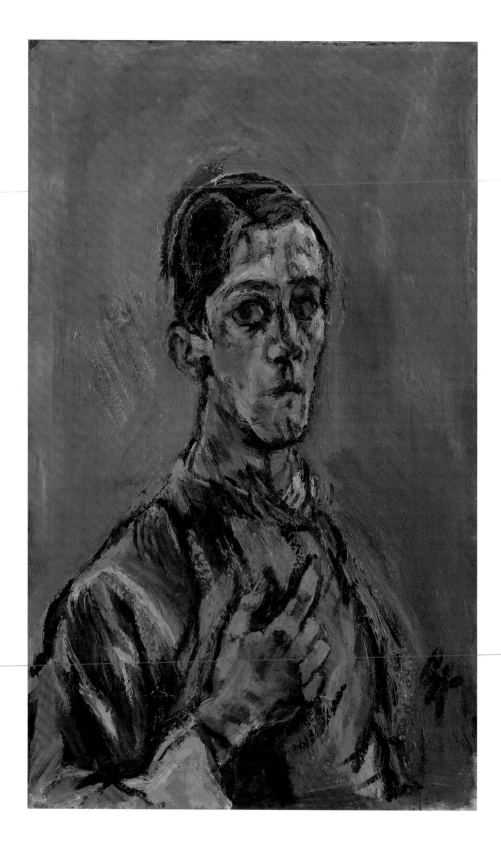

Plate 19

Oskar Kokoschka. *Self-Portrait*.
1913. Oil on canvas, 32⅛ × 19½ in.
(81.6 × 49.5 cm)

Plate 20

Franz Marc. *The World Cow*.
1913. Oil on canvas, 27⅞ × 55⅝ in.
(70.7 × 141.3 cm)

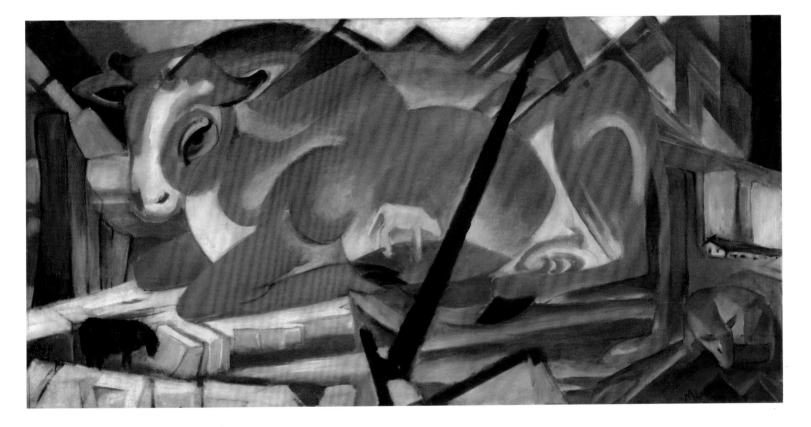

1929

» In 1929 the Catalan artist Salvador Dalí had his first Paris solo exhibition, at the Galerie Goemans. In the introductory essay to the show's catalogue, André Breton — ringleader of the Surrealist movement — declared, "It is perhaps with Dalí that for the first time the windows of the mind are opened fully wide."[1] While Breton was undoubtedly referring generally to the artist's ability to represent interior mental states with vivid clarity, he may also have been thinking more specifically of a particular painting in the exhibition. With its diorama-like boxes, lit up with fantastic dream scenes, *Illumined Pleasures* (plate 21) quite literally pictures the workings of the mind as a series of windows.

And yet, another important milestone for Dalí that same year compels us to consider the central forms of this painting not only as windows but also as cinematic screens. On June 6, 1929, Dalí's short film made in collaboration with fellow Spaniard Luis Buñuel, *Un Chien Andalou* (*An Andalusian Dog*), premiered in Paris. This time-based medium allowed Dalí and Buñuel to experiment with new visual techniques: the cut enabled disjunctions in narrative flow, the fade permitted unrelated objects to metamorphose into each other, and the close-up encouraged unsettling decontextualizations.[2] This cinematic logic would find its parallel in Dalí's painted compositions, as the juxtapositions and transformations of *Illumined Pleasures* demonstrate.[3] Rather than presenting a fluid narrative, the canvas is composed as a series of cuts between unrelated scenes: a man confronts an enormous egg that seems to have rolled in front of the facade of a church;[4] a mass of men ride bicycles with

Plate 21

Salvador Dalí. *Illumined Pleasures*. 1929.
Oil and collage on composition board,
9⅜ × 13¾ in. (23.8 × 34.7 cm)

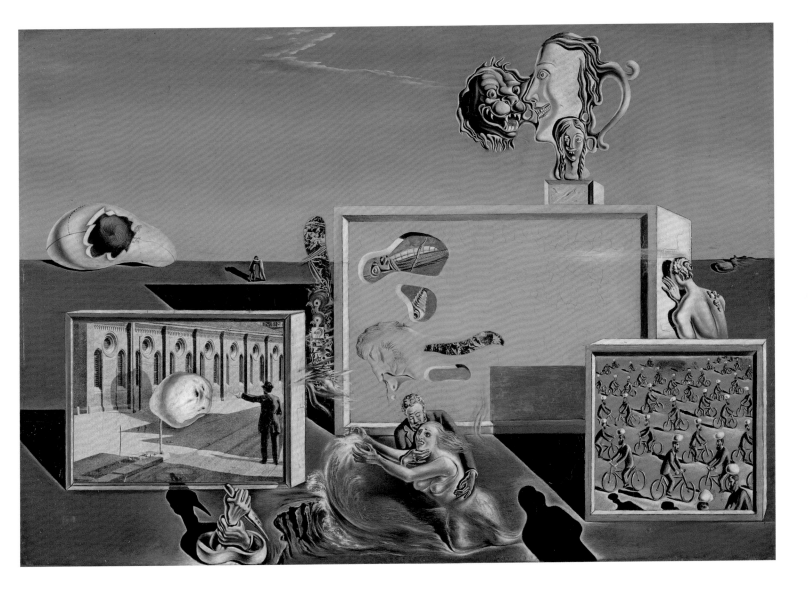

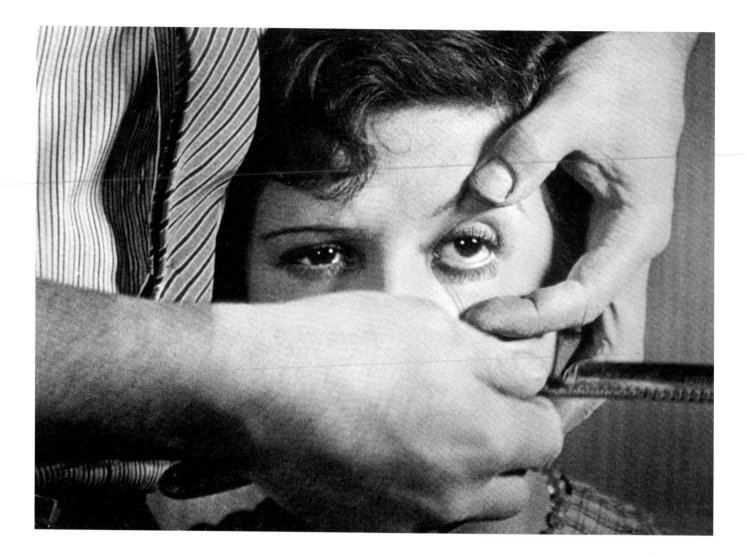

similar white ovoids on their heads. A woman's profile is transmogrified into a vessel while also seeming both to grow out of a smaller, forward-facing head and to merge with the head of a lion. Spotted through a hole in a box of blue sky, a grasshopper looms uncannily large.

But it is perhaps *Un Chien Andalou*'s most iconic and terrifying shot, even more than its formal innovations, that provides the most dramatic call for a break in historical ways of seeing: in full moonlight, a straight razor slices through a woman's eyeball (fig. 1). The image heralds the kinds of new vision — metaphorically blinded or mechanically magnified — that would preoccupy the majority of the artists

gathered in this section of *Fast Forward*. In 1929 an obsession with changing the way we see proved common to painters, sculptors, photographers, filmmakers, and graphic designers from France to Russia, Germany to America. By looking inward or skyward, through lenses or mirrors, these artists reenvisioned familiar subjects from surreal new perspectives.

If the emblem of Dalí's cinematic vision constitutes an act of ocular violence, the Russian filmmaker Dziga Vertov amplified the human eye in 1929 by fusing it with the camera. The film *The Man with the Movie Camera* (plate 47), which Vertov regarded as "a theoretical manifestation on the screen,"[5] epitomizes his concept of "Kino-Glaz," or the

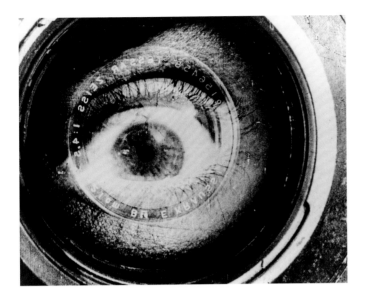

1

Luis Buñuel (Spanish, 1900–1983) and
Salvador Dalí. Frame enlargement from
Un Chien Andalou (*An Andalusian Dog*).
1928. 35mm film, black and white, silent,
16 minutes (approx.). The Museum
of Modern Art, New York. Gift of Luis
Buñuel

2

Dziga Vertov. Frame enlargement from
Chelovek s Kinoapparatom (*The Man with
the Movie Camera*). 1929. 35mm film, black
and white, silent, 65 minutes (approx.).
The Museum of Modern Art, New York.
Gosfilmofond (by exchange)

"Cine-Eye" — the synthesis of the human eye with a mechani-
cal prosthesis that can make its vision more perfect (fig. 2).
Writing in the avant-garde journal *LEF,* Vertov extolled the
possibilities of this marriage between man and technology:
"I am kino-eye, I am a mechanical eye. I, a machine, show
you the world as only I can see it.... My path leads to a fresh
perception of the world. I decipher in a new way a world
unknown to you."[6] Embodying this principle, *The Man with
the Movie Camera* is a montage of footage from the Soviet
cities of Moscow, Kiev, and Odessa in which everyday activi-
ties and architectures are seen from dizzying perspectives:
the street observed from high above, a looming bridge
regarded from far below, a train hurtling straight toward
the cameraman — and the viewer — until it runs right over
us, exposing its undercarriage as it rushes overhead.

Vertov's utopian belief in the possibilities of
machine-enhanced vision was shared by the Hungarian
photographer Lázló Moholy-Nagy, who coined the phrase
"*neue Optik,*" or the "New Vision," to characterize inter-
national trends in photography that emerged in the years
following World War I. Laying out his principles in the book
Painting, Photography, Film, originally published in 1925
while he was teaching at the Bauhaus, Moholy-Nagy echoed
Vertov's faith in the truthfulness of the image afforded by
the camera, which can "*make visible* existences which cannot
be perceived or taken in by our optical instrument, the eye."[7]
The landmark exhibition *Film und Foto* — held in Stuttgart
in 1929 and featuring over a thousand works by approximately
two hundred artists — evidenced the aesthetic innovations
summarized by Moholy-Nagy. Revolutionary techniques like
the photogram, made by placing objects on photosensitive
paper and exposing it to light (see fig. 3 for an example), and
photomontage, created from cut-and-pasted photographic
fragments, were on display. These methods served not only
the high-art realm of abstraction but also the sphere of com-
mercial advertising.

The photography on view in this section of *Fast
Forward* reflects the kinds of experiments seen in *Film
und Foto,* with the same transnational scope. Featuring

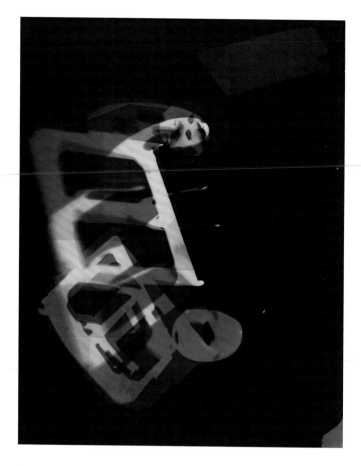

3
Lázló Moholy-Nagy. *Photogram*.
1929. Gelatin silver print (photogram),
11¾ × 9⅜ in. (29.8 × 23.8 cm).
The Museum of Modern Art, New York.
Gift of James Johnson Sweeney

destabilizing views similar to those in *The Man with the Movie Camera,* works by photographers as diverse as the Bauhaus-trained Americans Theodore Lux Feininger (plate 38) and Florence Henri (plate 41), French Surrealist Man Ray (plate 44), Russian Constructivist Aleksandr Rodchenko (plate 55), and Moholy-Nagy himself (plate 39) all dispense with horizon lines in favor of vertiginous, disorienting perspectives. These compositions reflect Moholy-Nagy's exhortation not to "regard the ability of the lens to distort — the view from below, from above, the oblique view — as in any sense merely negative, for it provides an impartial approach, such as our eyes, tied as they are to the laws of association, do not give."[8] One of two publications that accompanied the Stuttgart show, *Photo-Eye* features a photomontage by El Lissitzky on its cover, in which the artist's hand is fused, through superimposition, with his eye (plate 50). The volume was designed and co-edited (with the German art historian Franz Roh) by Jan Tschichold — the Swiss typographer whose theory of the "New Typography" would become the graphic design counterpart to Moholy-Nagy's "New Vision."

Published in Berlin in 1928, *The New Typography* highlights works by many of the artists in this section as examples of Tschichold's call for clarity and dynamism in modern design. A preference for simplified, sans serif fonts can be seen in Herbert Bayer's printed card for the annual meeting of the Deutsche Werkbund — the German association of industrial artists that organized *Film und Foto* (plate 60) — and in Walter Dexel's film and exhibition posters (plates 42, 45, and 61). Johannes Canis's layout marketing a "Progress Chair" (plate 56) and Johannes Molzahn's poster for the Deutsche Werkbund exhibition *Dwelling and Workplace* (plate 57) both incorporate the principle of "typophoto," the integration of text and photography that Tschichold adopted from Moholy-Nagy. Finally, each of these examples embraces asymmetry, exemplifying Tschichold's belief that "the liveliness of asymmetry is also an expression of our own movement and that of modern life."[9] Indeed, all of these typographic principles reflect the larger values

of their modern industrial moment, such as clarity in communication and an emphasis on functionality.

Though art by American modernists is often considered — and frequently displayed — independently from that of their European contemporaries, the works included here testify to common aesthetic concerns. Alfred Stieglitz's Equivalents, a series of cloud photographs he made in the 1920s and '30s (plates 28–31), are often discussed in subjective and spiritual terms at odds with the New Vision aim for objectivity.[10] Yet, their groundlessness causes the same vertigo as Moholy-Nagy's aerial views. As Rosalind Krauss writes, "The incredible verticality of these clouds as they rise upward along the image creates an extraordinary sense of disorientation.... We do not understand what is up and what is down.... These are images without grounds."[11] Georgia O'Keeffe's *Farmhouse Window and Door* (plate 32) is widely recognized for its evocative description of Adirondack architecture — it shows the Lake George house where O'Keeffe and Stieglitz spent their summers. But the painting's abstract language reduces its referent to a geometric arrangement not terribly far from the Dutch artist Theo van Doesburg's purely nonrepresentational *Simultaneous Counter-Compositions* (plates 63 and 64); both artists use thin black lines and thicker black rectangles to define their fields. Finally, Gerald Murphy's variation on the still life, *Wasp and Pear* (plate 34), relies on "technological extensions of sight" in much the same way that Vertov endorses; he "graphically represent[s] the multiple levels of reality opened up by modern science by depicting both a wasp and a microscopic segment of a wasp's leg."[12]

Murphy's wasp scrutinized through a microscope, Dalí's grasshopper glimpsed through a hole in a screen that is also the sky — artists in 1929 made the very act of seeing their subject matter. Thanks to the way their works play with transparency and opacity, magnifying the most common objects or imagining the most fantastic surrealities, "We may say," as Moholy-Nagy did, "that we see the world with entirely different eyes."[13] — SAMANTHA FRIEDMAN

1. Breton, in *Dalí* (Paris: Galerie Goemans, 1929), n.p. Translated in Simon Wilson, "Salvador Dalí," in *Salvador Dalí* (London: Tate Gallery, 1980), p. 15.

2. Chronological disjunctions occur with the help of title cards that read successively: "once upon a time," "eight years later," "around three in the morning," "sixteen years ago," and finally "in spring." Perhaps the most notable metamorphosis in this film is the fade between a hairy armpit and a sea urchin; uncanny close-ups include ants crawling on a man's palm and a stick poking a severed hand.

3. For a larger discussion of the relationship between painting and film in the artist's work, see Matthew Gale, ed., *Dalí and Film* (New York: The Museum of Modern Art, 2007).

4. This architectural setting is a photomechanically reproduced collage element; for its identification as a church facade, see Dawn Ades and Michael Taylor, *Dalí* (New York: Rizzoli, in association with the Philadelphia Museum of Art, 2005), p. 124.

5. Dziga Vertov, "The Man with a Movie Camera," in *Kino-Eye: The Writings of Dziga Vertov*, ed. Annette Michelson, trans. Kevin O'Brien (Berkeley: University of California Press, 1984), p. 83.

6. Dziga Vertov, "Kinocks: A Revolution," *LEF*, no. 3 (1923). Translated in Michelson, ed., *Kino-Eye*, pp. 17–18.

7. Lázló Moholy-Nagy, *Painting, Photography, Film*, trans. Janet Seligman (Cambridge, Mass.: MIT Press, 1969), p. 28.

8. Ibid., p. 7.

9. Jan Tschichold, *The New Typography: A Handbook for Modern Designers*, trans. Ruari McLean (Berkeley: University of California Press, 1995), p. 68.

10. "In 1924 or 1925 Stieglitz began to call his sky pictures Equivalents; they were to be seen as the '*equivalents* of my most profound life experience, my basic philosophy of life.'" John Szarkowski, "The Sky Pictures of Alfred Stieglitz," *MoMA*, no. 20 (Autumn 1995): 17.

11. Rosalind Krauss, "Stieglitz / 'Equivalents,'" *October* 11 (Winter 1979): 135.

12. George H. Roeder, Jr., "What Have Modernists Looked At? Experiential Roots of Twentieth-Century American Painting," *American Quarterly* 39, no. 1 (Spring 1987): 73.

13. Moholy-Nagy, *Painting, Photography, Film*, p. 29.

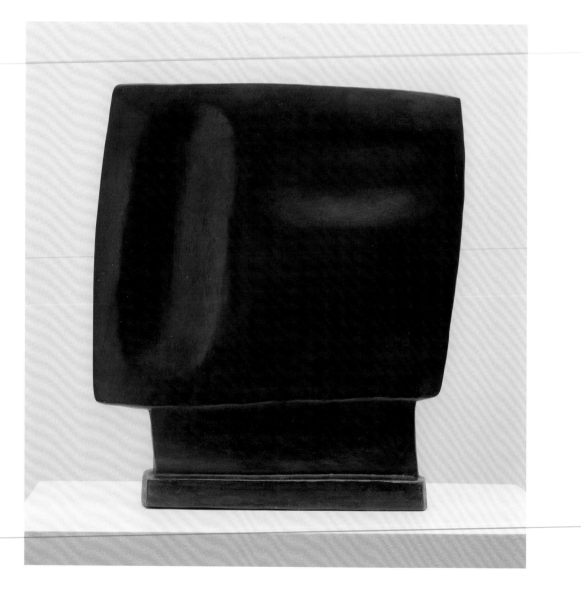

Plate 22

Alberto Giacometti. *Gazing Head.*
1928–29. Bronze, 15½ × 14½ × 2½ in.
(39.3 × 36.8 × 6.3 cm)

Plate 23

René Magritte. *The Palace of Curtains, III.*
1928–29. Oil on canvas, 32 × 45⅞ in.
(81.2 × 116.4 cm)

Plate 24

Joan Miró. *Portrait of Mistress Mills in 1750.*
Winter–spring 1929. Oil on canvas,
46 × 35¼ in. (116.7 × 89.6 cm)

Plate 25

Jean (Hans) Arp. *Two Heads.* 1929.
Painted wood, 47¼ × 39¼ in.
(120 × 99.7 cm)

Plate 26

Max Ernst. *Birds above the Forest.*
1929. Oil on canvas, 31¾ × 25¼ in.
(80.6 × 64.1 cm)

Plate 27

Pierre Roy. *Daylight Savings Time.*
1929. Oil on canvas, 21½ × 15 in.
(54.6 × 38.1 cm)

Plate 28

Alfred Stieglitz. *Equivalent*. 1929.
Gelatin silver print,
3⁵⁄₈ × 4⁵⁄₈ in. (9.2 × 11.8 cm)

Plate 29

Alfred Stieglitz. *Equivalent*. 1929.
Gelatin silver print,
4¹¹⁄₁₆ × 3¹¹⁄₁₆ in. (11.9 × 9.3 cm)

Plate 30

Alfred Stieglitz. *Equivalent*. 1929.
Gelatin silver print,
4¹¹⁄₁₆ × 3⁵⁄₈ in. (11.9 × 9.2 cm)

Plate 31

Alfred Stieglitz. *Equivalent*. 1929.
Gelatin silver print,
4¹¹⁄₁₆ × 3¹¹⁄₁₆ in. (11.9 × 9.3 cm)

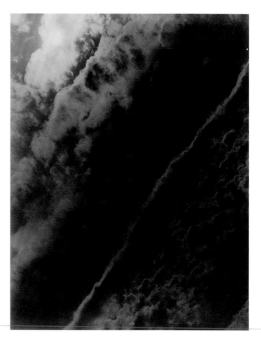

Plate 32

Georgia O'Keeffe. *Farmhouse Window and Door*. October 1929. Oil on canvas, 40 × 30 in. (101.6 × 76.2 cm)

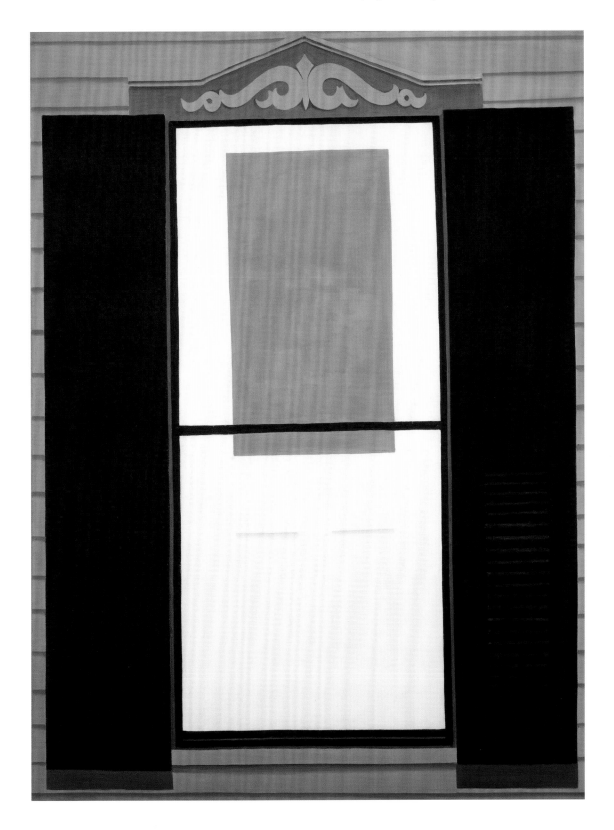

Plate 33

Helen Torr. *Basket of Vegetables*.
1928–29. Charcoal on paper,
14 × 18⅛ in. (35.6 × 45.8 cm)

Plate 34

Gerald Murphy. *Wasp and Pear*.
1929. Oil on canvas, 36¾ × 38⅝ in.
(93.3 × 97.9 cm)

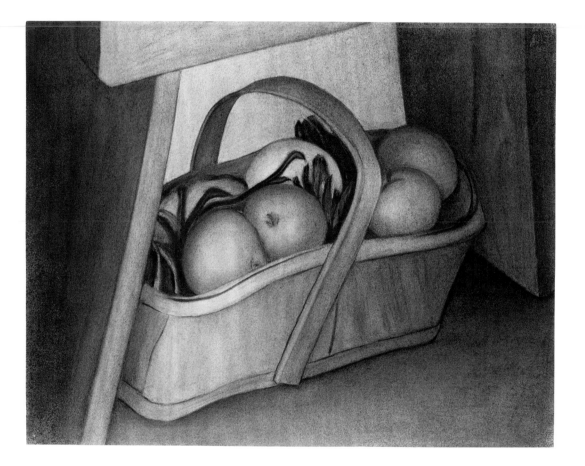

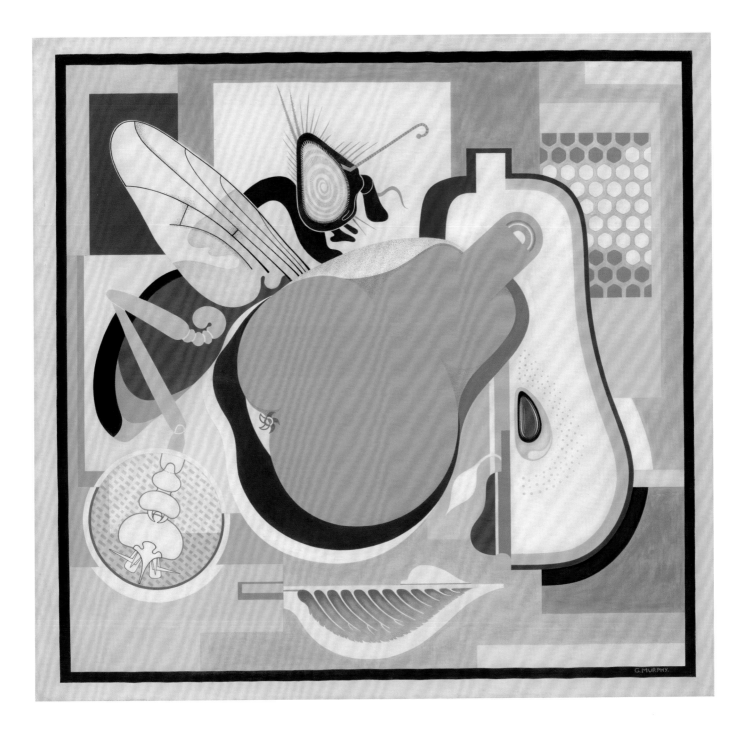

Plate 35

Henri Cartier-Bresson. *France*. 1929
(printed 1986). Gelatin silver print,
9⁷/₁₆ × 12⁹/₁₆ in. (24 × 32 cm)

Plate 36

Francis Bruguière. Untitled.
c. 1928–29. Gelatin silver print,
10⁵/₈ × 7⁵/₈ in. (24.4 × 19.3 cm)

Plate 37

W. Grancel Fitz. *Cellophane*.
1928 or 1929. Gelatin silver print,
9³/₁₆ × 7⁹/₁₆ in. (23.3 × 19.3 cm)

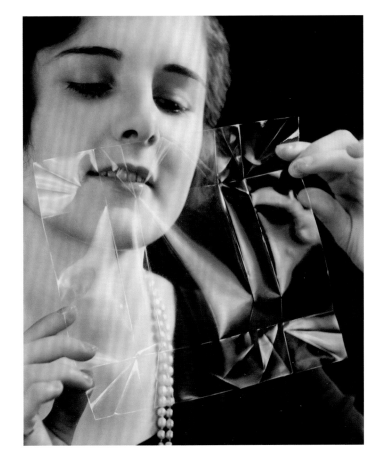

Plate 38

Theodore Lux Feininger. *From the
Bauhaus Roof.* c. 1929. Gelatin silver print,
14⅜ × 11⁷/₁₆ in. (36.6 × 29.1 cm)

Plate 39

László Moholy-Nagy. *Play.*
c. 1929. Gelatin silver print,
14⅝ × 10¹¹/₁₆ in. (37.1 × 27.1 cm)

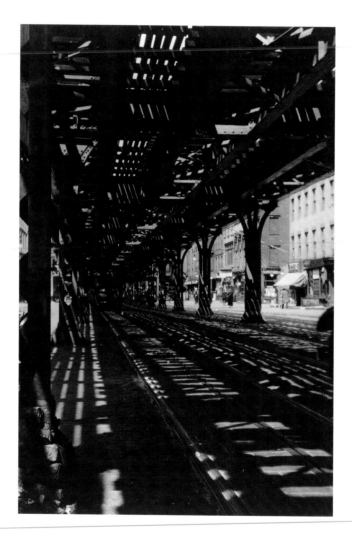

Plate 40

Walker Evans. *Third Avenue "L," Light Patterns, New York.* 1929 (printed 1979 by Joel Snyder). Gelatin silver print, 7³⁄₈ × 4¹⁵⁄₁₆ in. (18.8 × 12.6 cm)

Plate 41

Florence Henri. *Windmill Composition, No. 76.* c. 1929. Gelatin silver print, 10¹⁄₁₆ × 14³⁄₁₆ in. (25.6 × 36.1 cm)

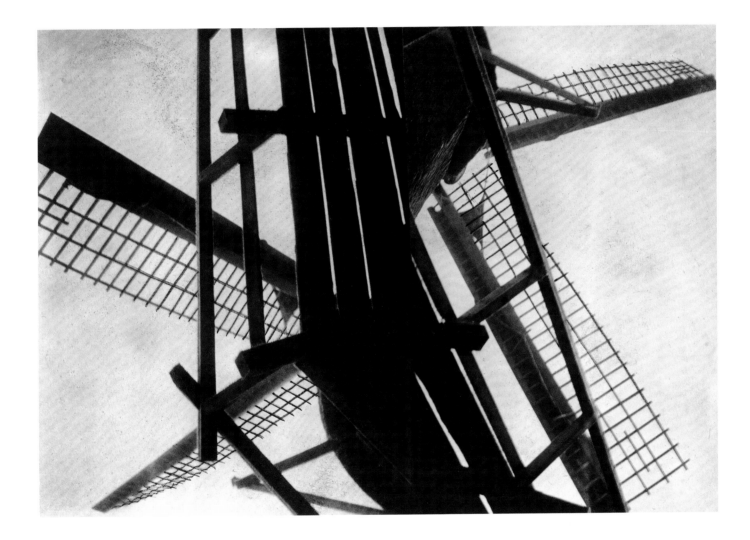

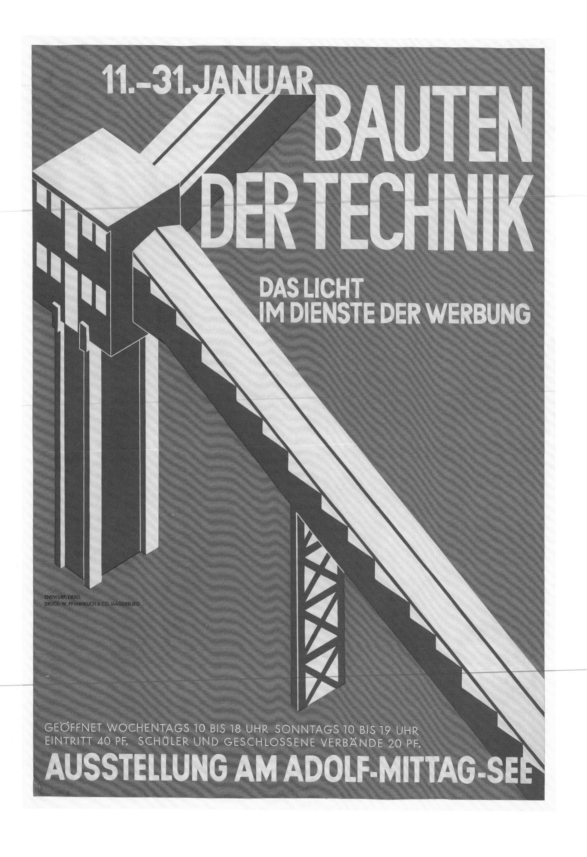

62

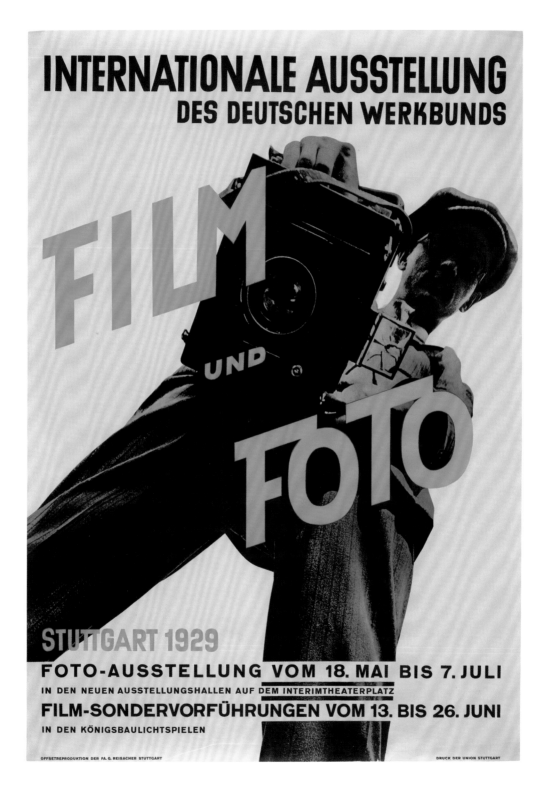

Plate 47

Dziga Vertov. *Chelovek s Kinoapparatom*
(*The Man with the Movie Camera*). 1929.
35mm film, transferred to DVD, black and
white, silent, 65 minutes (approx.)

Plate 48

Vladimir Stenberg and Georgii Stenberg.
Chelovek s Kinoapparatom (*The Man
with the Movie Camera*). 1929. Lithograph,
39½ × 27¼ in. (100.5 × 69.2 cm)

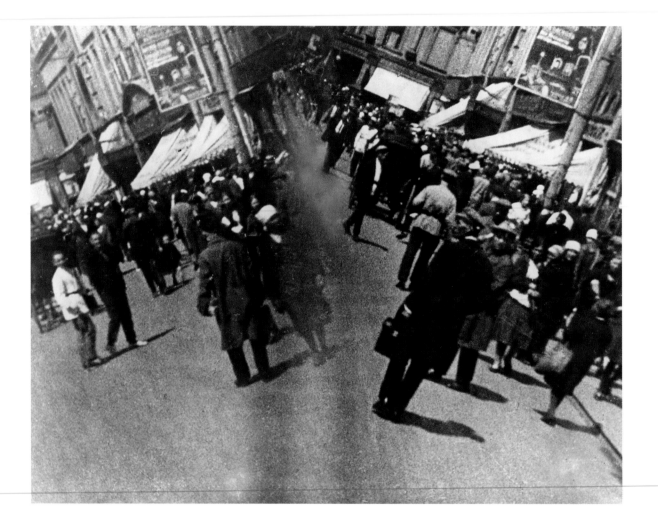

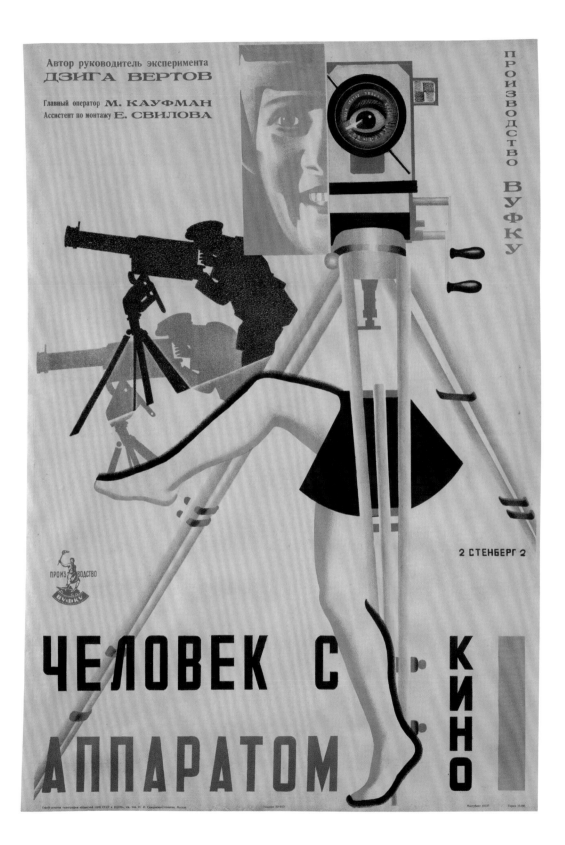

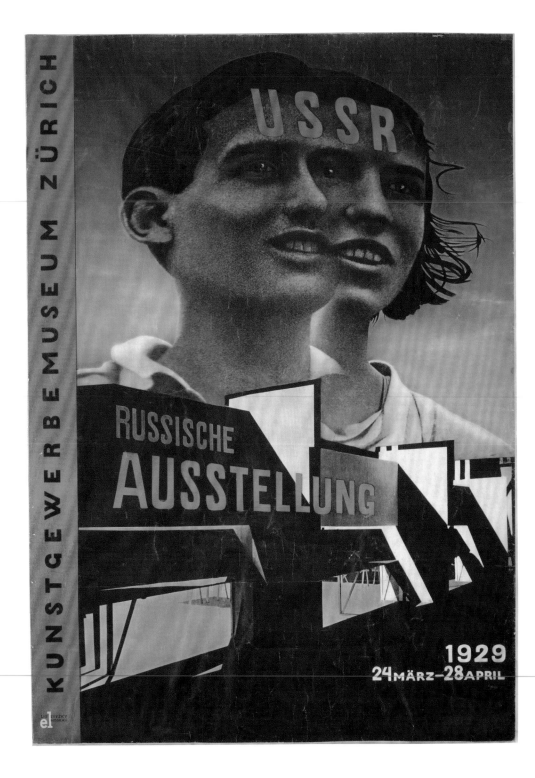

Plate 49

El Lissitzky. *USSR Russische Ausstellung
(Russian Exhibition)*. 1929. Gravure,
49⅞ × 35⅝ in. (126.7 × 90.5 cm)

Plate 50

El Lissitzky and Jan Tschichold.
Foto-Auge (Photo-Eye). 1929. Illustrated book
with photomechanical reproductions,
11⅝ × 8¹/₁₆ × ½ in. (29.5 × 20.5 × 1.2 cm)

Plate 51

Gustav Klutsis. *Rabotnitsa anglee
(The Female Worker of England)*. 1929.
Letterpress, 8³/₁₆ × 11⅜ in.
(20.9 × 28.9 cm)

Plate 52

Aleksandr Rodchenko. *Biznes. Sbornik
literaturnogo tsentra konstruktivistov
(Business: Collection of the Literary Center
of Constructivists)*. 1929. Illustrated book
with 1 photomechanical reproduction,
8⅞ × 6 × ½ in. (22.6 × 15.2 × 1.2 cm)

Plate 53

El Lissitzky. *Stroitel'stvo Moskvy.
Ezhemesiachnyi zhurnal Moskovskogo
oblastnogo ispolnitel'nogo komiteta
Soveta R., K. i K. deputatov, no. 5
(Building Moscow: Monthly Journal of
The Moscow Soviet of Workers, Peasants,
and Red Army Deputies, no. 5)*. 1929.
Illustrated book with photomechanical
reproductions, 11⅞ × 9¹/₁₆ × ³/₁₆ in.
(30.1 × 23 × 0.4 cm)

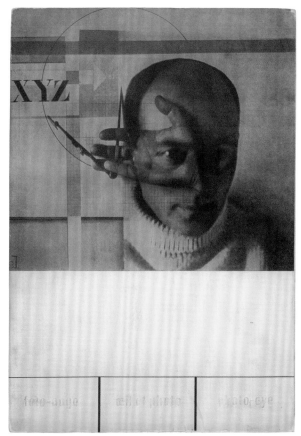

50

51

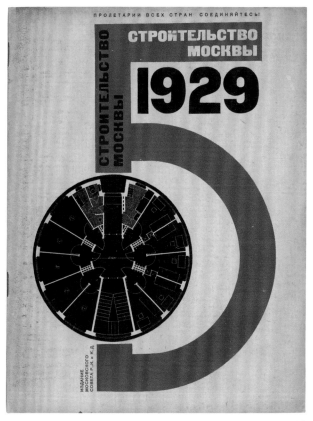

53

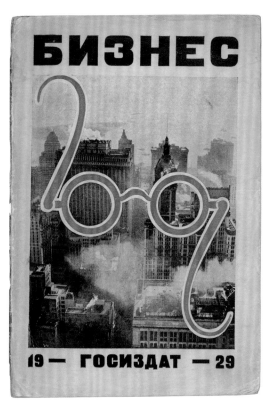

52

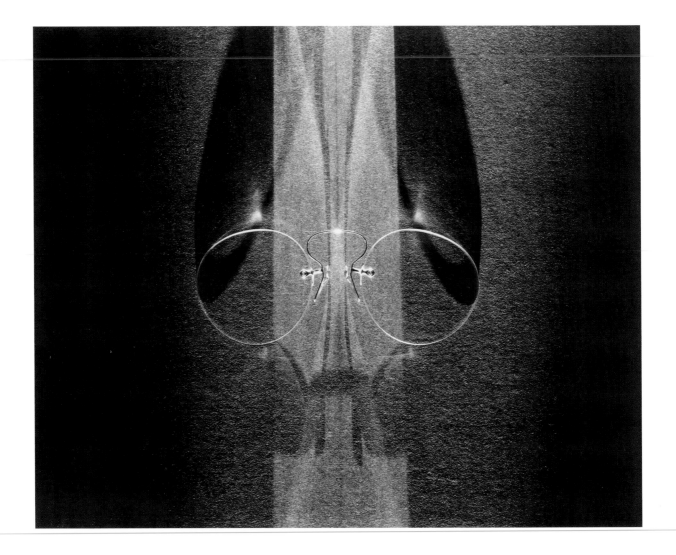

Plate 54

John Collins. *Advertisement for Shur-On
Optical Company.* c. 1929. Gelatin silver
print, 7¼ × 9¼ in. (18.5 × 23.4 cm)

Plate 55

Aleksandr Rodchenko. *Chauffeur.*
1929. Gelatin silver print,
11¾ × 16½ in. (29.8 × 41.8 cm)

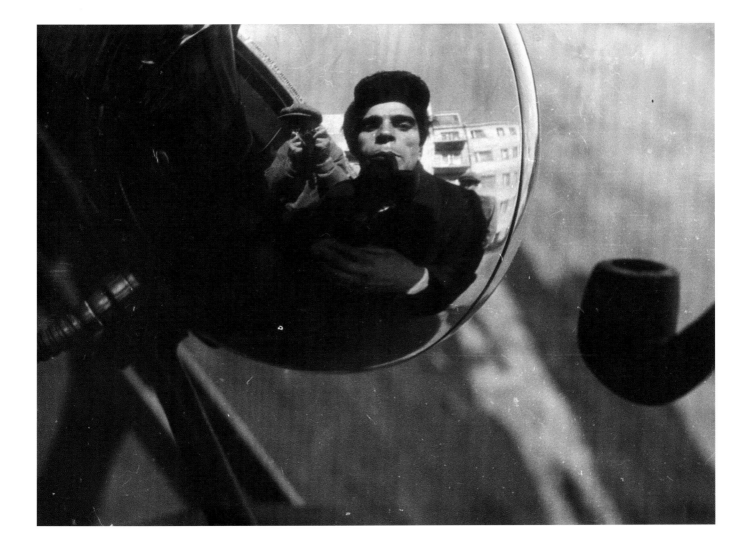

Plate 56

Johannes Canis. *Fortschritt-Stuhl*
(*Progress Chair*). 1928–29. Letterpress,
9⅞ × 7⅞ in. (25.1 × 20 cm)

Plate 57

Johannes Molzahn. *Wohnung und
Werkraum (Dwelling and Workplace)*.
Poster for Deutsche Werkbund Exhibition
in Breslau. 1929. Photolithograph,
23⅝ × 33 in. (60 × 83.8 cm)

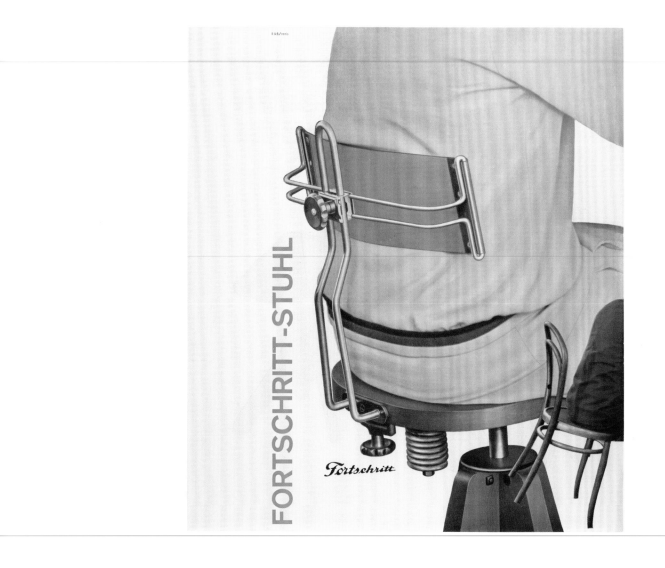

FORTSCHRITT-STUHL

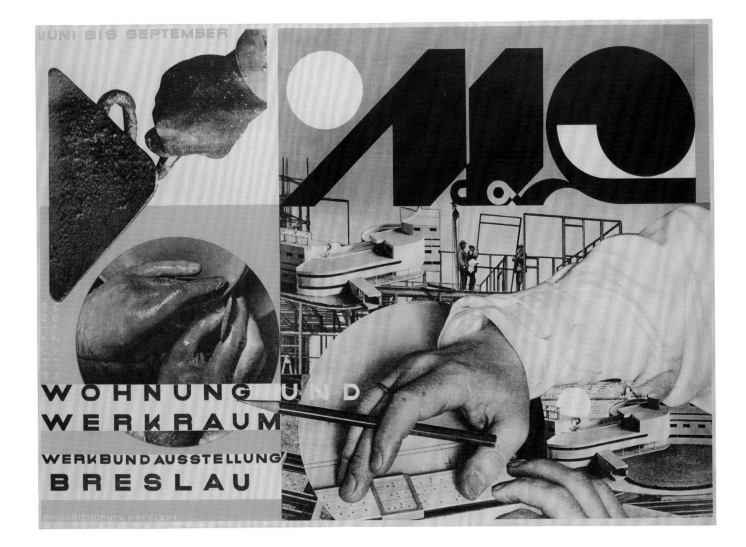

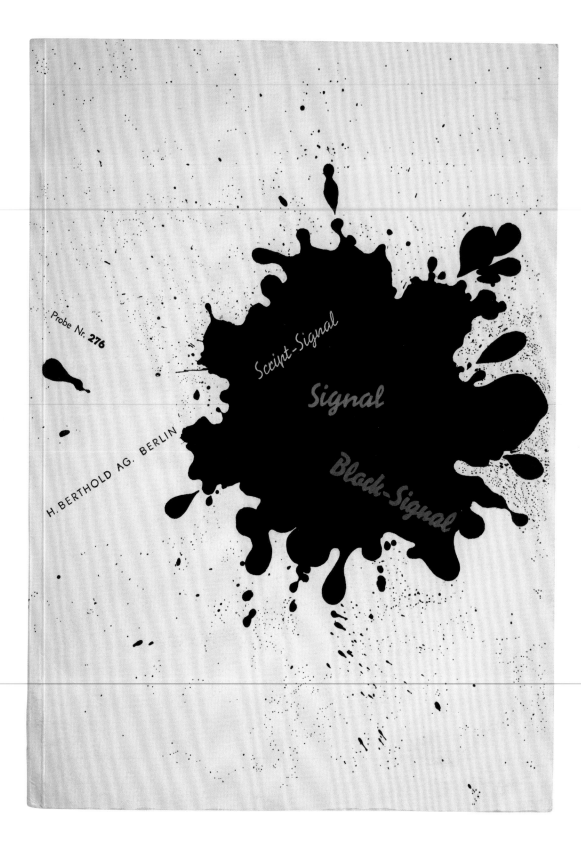

Probe Nr. **276**

Script-Signal

Signal

H. BERTHOLD AG. BERLIN

Black-Signal

Plate 58

Herbert Bayer. *Signal, H. Berthold AG Berlin,
Probe Nr. 276.* 1929. Cover: letterpress;
interior: letterpress and offset lithograph,
11¾ × 8⁵⁄₁₆ in. (29.8 × 21.1 cm)

Plate 59

Walter Dexel. *Technische Vereinigung
Magdeburg (Technical Association
of Magdeburg).* 1928–29. Lithograph,
4⅛ × 5¾ in. (10.5 × 14.6 cm)

Plate 60

Herbert Bayer. *DWB Jahresversammlung
(DWB Annual Meeting).* 1929. Letterpress,
4³⁄₁₆ × 5¹³⁄₁₆ in. (10.6 × 14.8 cm)

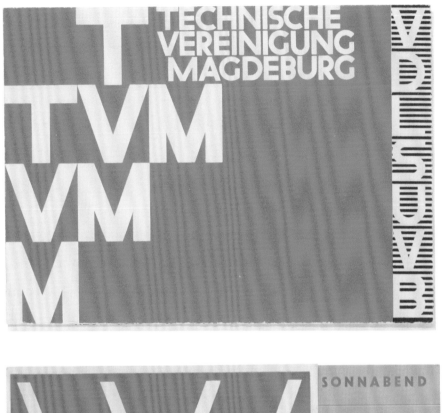

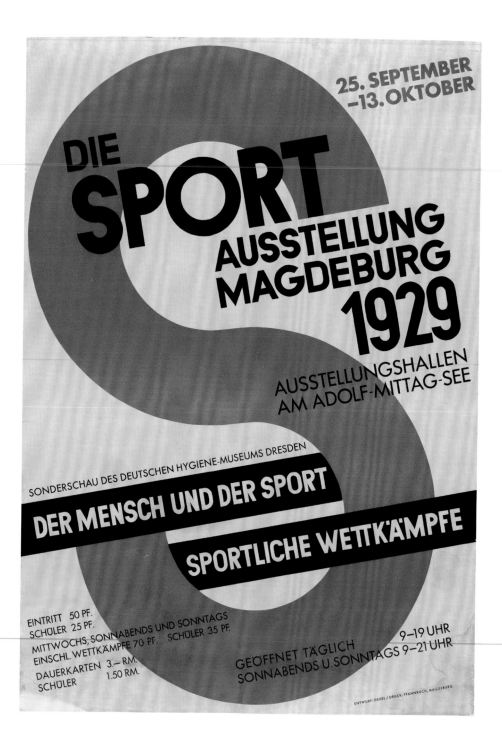

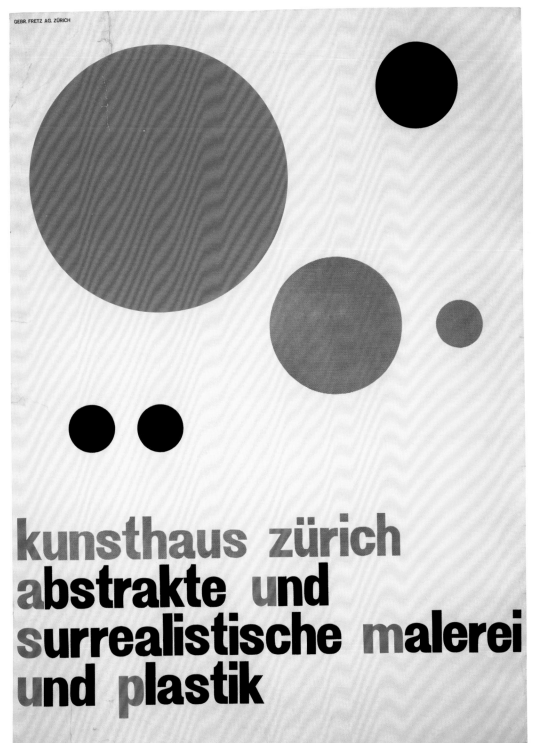

Plate 63

Theo van Doesburg. *Simultaneous Counter-Composition*. 1929–30. Oil on canvas, 19½ × 19½ in. (49.5 × 49.5 cm)

Plate 64

Theo van Doesburg. *Simultaneous Counter-Composition*. 1929–30. Oil on canvas, 19¾ × 19⅝ in. (50.1 × 49.8 cm)

1950

>> Like many of the other American painters who embraced abstraction in the late 1940s and early 1950s, Franz Kline had initially worked in a figurative vein. And as with many of his contemporaries, Kline's turn to abstraction has been mythologized by a compelling narrative. As told by Elaine de Kooning, a New York School painter and wife of artist Willem de Kooning, the tale is worth quoting at length: "One day in '49, Kline dropped in on a friend who was enlarging some of his own sketches in a Bell-Opticon. 'Do you have any of those little drawings in your pocket?' the friend asked. Franz always did and supplied a handful. Both he and his friend were astonished at the change of scale and dimension when they saw the drawings magnified bodilessly against the wall. A 4-by-5-inch brush drawing of the rocking chair Franz had drawn and painted over and over, so loaded with implications and aspirations and regrets, loomed in gigantic black strokes which eradicated the image, the strokes expanding as entities in themselves, unrelated to any reality but that of their own existence. He fed in the drawings one after the other and, again and again, the image was engulfed by the strokes that delineated it. From that day, Franz Kline's style of painting changed completely."[1]

Plate 65

Franz Kline. *Chief.* 1950.
Oil on canvas, 58⅜ in. × 6 ft. 1½ in.
(148.3 × 186.7 cm)

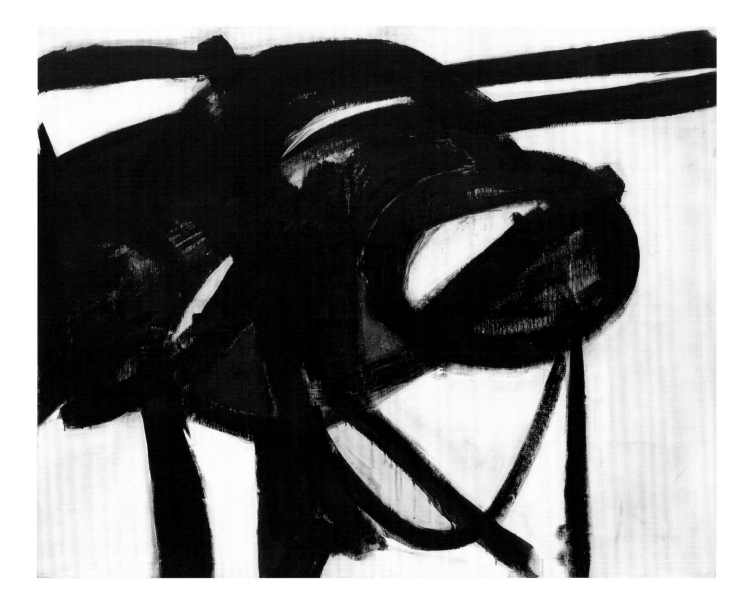

Raising the stakes of the story, de Kooning categorizes Kline's session with her husband ("the friend") and the enlarging projector as "a total and instantaneous conversion," in which "any allegiance to formalized representation was wiped out of his consciousness."[2] While seeing the forms of his small drawings blown up beyond reference undoubtedly contributed to Kline's adoption of large-scale abstraction, the switch was surely not so immediate. His figurative work had been gradually tending toward abstraction since the mid-1940s: some works on paper from that time already experimented with pure form (see fig. 1), and though his paintings had retained recognizable subjects, these became as much excuses for exploring space and structure as ends in themselves (see fig. 2).[3]

More gradually than instantaneously, but no less decisively, Kline turned toward abstraction, and the eleven paintings featured in his debut solo exhibition, at New York's Charles Egan Gallery in the fall of 1950, were all large-scale abstractions, predominantly in black and white.[4] Among them was *Chief* (plate 65), a muscular, looping knot with a gestural energy that reminds us why Abstract Expressionism was also dubbed Action Painting. Though the calligraphic quality of this and similar paintings has led many critics to compare Kline's practice to Japanese brush painting, Kline

refuted the connection. "People sometimes think I take a white canvas and paint a black sign on it, but this is not true. I paint the white as well as the black, and the white is just as important."[5] Looking at *Chief* with the artist's comment in mind, the areas in which white paint encroaches on the black become apparent; an active jockeying between the two elements replaces an initial impression of figure on ground.

As with his conversion to abstraction, the significance of Kline's titles has been steeped in lore. "Franz invited the de Koonings to help him title the pictures in his first show," the art historian Irving Sandler recounts. "They all had to agree. Franz decided to call one work *Chief,* named after a Lehighton locomotive, but Elaine persuaded him that the name would go better with the canvas that now bears the title."[6] Thus, while the titles of Kline's 1950 canvases relate to meaningful aspects of his personal history — both *Chief* and *Cardinal* reference trains from the Pennsylvania mining country where he grew up; *High Street* and *Hoboken* allude to urban haunts in New York and New Jersey; *Giselle* and *Wotan* speak to his interest in ballet and opera — they should not be understood as clues to latent subject matter within the paintings. "If you look at an abstraction, you can imagine that it's a head, a bridge, almost anything — but it's not these things that get me started on a painting,"[7] Kline cautioned.

The artist instructs us to resist, for example, the urge to read two parallel lines trailing off *Chief*'s upper right corner as a set of railroad tracks, despite the title's link to a train. Still, there is something in the spirit of that word — and in the power of the painting it identifies — that encapsulates the energy of art making in 1950, especially in the context of the New York School. Something that is *chief* is singular, dominant, vital, and the artists featured in this section of *Fast Forward* each found individual and potent ways to enliven abstraction. Asserting their signature styles on a monumental scale, they infused mark making with new force as they renounced representation for action.

Kline's adoption of abstraction and his resulting critical acclaim came relatively late, compared to his contemporaries. Jackson Pollock had already transitioned from a

1
Franz Kline. *47 Series, No. 5.* 1947.
Gouache on tagboard, 22 × 28 in.
(55.9 × 71.1 cm). The Martha
Jackson Collection at the Albright-
Knox Art Gallery

2
Franz Kline. *Woman in a Rocker.*
c. 1945. Oil on canvas, 16⅛ × 14 in.
(41 × 35.6 cm). The Metropolitan
Museum of Art, New York. Gift of
Rufus F. Zogbaum

Surrealist-inspired, totemic language to the so-called "drip technique" by 1947, a breakthrough with a mythology even denser than the one surrounding Kline's. In his barn studio in Springs, New York, Pollock abandoned the easel, preferring "to tack the unstretched canvas to the hard wall or the floor" in order to be "more a part of the painting, since this way I can walk around it, work from the four sides and literally be *in* the painting."[8] In addition to radically repositioning his canvases on the floor, Pollock adopted nonart materials; instead of applying oil paint with a brush, he flung various kinds of industrial paint with sticks and trowels. In the frieze-like *Number 7, 1950* (plate 68), Pollock applied aluminum paint and enamel, as well as oil, with this technique; the metallic material contributes a reflective quality to the rhythmic allover tangle. With its resolutely horizontal format, *Number 7, 1950* embodies a conviction Pollock expressed in a 1947 application for a Guggenheim fellowship: "I believe the easel picture to be a dying form, and the tendency of modern feeling is towards the wall picture or mural."[9]

By 1948 Pollock had stopped giving descriptive titles to his paintings. His wife, the painter Lee Krasner, explained: "Jackson used to give his pictures conventional titles…but now he simply numbers them. Numbers are neutral. They make people look at a picture for what it is — pure painting."[10] During an April 1950 session of Studio 35, an artists' salon, a number of participants debated whether abstract art should be titled at all. Alluding to just the kinds of evocative but tangential names that Kline assigned to his 1950 canvases, the painter Ad Reinhardt wondered, "If a title does not mean anything and creates a misunderstanding, why put a title on a painting?"[11] Reinhardt's *Number 107* (plate 66), with its horizontal strokes of white on white, bears the neutral designation of a number.

Mark Rothko, too, named his paintings with numbers, and like Reinhardt, he developed a signature form characterized by subtle chromatic shifts rather than vigorous gestures. But while Reinhardt eschewed expressionism in favor of an absolute "art-as-art" philosophy, Rothko was "interested only in expressing basic human emotions — tragedy, ecstasy,

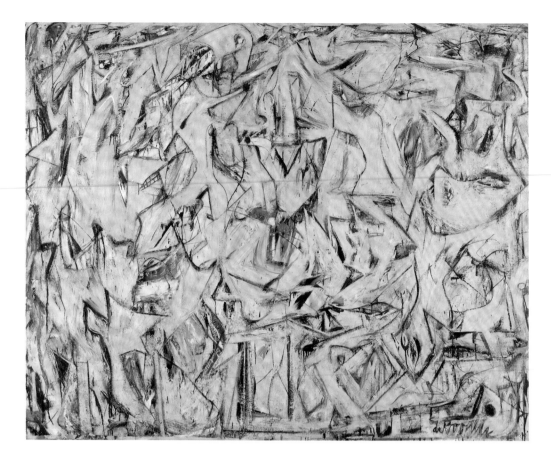

3
Willem de Kooning. *Excavation*. 1950.
Oil on canvas, 6 ft. 9 in. × 8 ft. 4¼ in.
(205.7 × 254.6 cm). The Art Institute
of Chicago. Mr. and Mrs. Frank G. Logan
Purchase Prize Fund; restricted gifts
of Edgar T. Kaufmann, Jr. and Mr. and
Mrs. Noah Godowsky, Jr.

doom."[12] In his so-called multiform paintings such as *No. 10* (plate 67), rectangles of luminous color seem to hover in front of the surface of the canvas, their loosely brushed edges vibrating against the adjacent hues. More metaphysical than physical, Rothko's compositions do not index external action as Kline's and Pollock's do; nonetheless, they suggest a performance. "I think of my pictures as dramas; the shapes in the pictures are the performers," Rothko said. "They have been created from the need for a group of actors who are able to move dramatically without embarrassment and execute gestures without shame."[13] Rothko used the language of Action Painting to describe his paintings but cast his forms and colors, rather than himself, as the actors.

Willem de Kooning, who had helped Kline name his paintings, offered his own opinion on titles: "One day, some painter used 'Abstraction' as a title for one of his paintings.... And it was a very tricky title. And it wasn't really a

very good one."[14] Starting in 1946, de Kooning painted a series of black and white abstractions, which were featured in his own first solo show at the Egan Gallery, in 1948. True to his word, he gave these canvases titles ranging from the poetic *Light in August* to the classical *Orestes.* As soon as the culminating work of this period, the monumental *Excavation* (fig. 3), left his studio in June 1950, de Kooning shifted gears. With *Woman, I* (plate 71), the first in a series of six canvases depicting female figures, he not only reverted to figuration but also chose one of art history's most time-honored subjects. With her hulking body and bared teeth, however, this woman — incorporating archetypes from an ancient fertility goddess to a contemporary pin-up — is as far in approach from, say, Édouard Manet's *Olympia* as that provocative nineteenth-century nude was from Titian's sixteenth-century *Venus of Urbino.*

De Kooning wrestled with *Woman, I* for two years, scraping out and repainting the figure so often that his wife estimated that two hundred different compositions must have intermittently emerged.[15] With its chaotic impasto and ghostlike pentimenti, the finished canvas records this protracted struggle, proving that the artist's experiment was always as much about process and paint as it was about representation. When the Woman series was exhibited at the Sidney Janis Gallery in 1953, critics complained about de Kooning's refusal to adopt one mode exclusively. One wrote, "He does not…commit himself to either their representational or their abstract possibilities but hesitates constantly between the two."[16] To the reviewer's chagrin, there was no mythical instantaneous conversion to be read into de Kooning's latest gesture. — SAMANTHA FRIEDMAN

1. Elaine de Kooning, "Franz Kline: Painter of His Own Life," 1962, reprinted in Elaine de Kooning, *The Spirit of Abstract Expressionism: Selected Writings* (New York: George Braziller, 1994), p. 196.

2. Ibid.

3. For an analysis of proto-abstract tendencies in Kline's work of the mid-1940s, see Harry F. Gaugh, *The Vital Gesture: Franz Kline* (Cincinnati: Cincinnati Art Museum; New York: Abbeville Press, 1985), pp. 75–81. Gaugh points out that Kline began his exploration of abstraction with drawing because it was comparatively affordable; the high cost of paint and canvas discouraged such experimentation.

4. *Franz Kline,* Charles Egan Gallery, New York, October 16–November 4, 1950. Several works on paper were also exhibited.

5. Kline, quoted in Katharine Kuh, *The Artist's Voice: Talks with Seventeen Artists* (New York: Harper and Row, 1962), p. 144.

6. Irving Sandler, *A Sweeper-Up after Artists: A Memoir* (New York: Thames and Hudson, 2003), p. 59.

7. Kline, quoted in Kuh, *Artist's Voice,* pp. 144–45.

8. Jackson Pollock, "My Painting," *Possibilities,* no. 1 (Winter 1947–48): 79. Reprinted in Pepe Karmel, ed., *Jackson Pollock: Interviews, Articles, and Reviews* (New York: The Museum of Modern Art, 1988), p. 17.

9. Jackson Pollock, application for Guggenheim fellowship, 1947. Reprinted in Karmel, ed., *Jackson Pollock,* p. 17.

10. Krasner, quoted in Pollock, "My Painting," p. 129 and p. 154 n. 48.

11. Ad Reinhardt, in "Artists' Session at Studio 35, 1950," reprinted in *Abstract Expressionism: Creators and Critics,* ed. Clifford Ross (New York: Harry N. Abrams, 1990), p. 216.

12. Ad Reinhardt, "Art-as-Art," *Art International,* December 1962, pp. 36–37. Rothko, quoted in Selden Rodman, *Conversations with Artists* (New York: Devin-Adair, 1957), p. 93.

13. Mark Rothko, "The Romantics Were Prompted," *Possibilities,* no. 1 (Winter 1947–48): 84.

14. Willem de Kooning, in "What Abstract Art Means to Me," *Bulletin of The Museum of Modern Art* 28, no. 3 (Spring 1951): 4–5.

15. See Harry F. Gaugh, *Willem de Kooning* (New York: Abbeville Press), p. 41.

16. Robert M. Coates, "The Art Galleries," *The New Yorker,* April 4, 1953, p. 96.

Plate 66

Ad Reinhardt. *Number 107*. 1950.
Oil on canvas, 6 ft. 8 in. × 36 in.
(203.2 × 91.4 cm)

Plate 67

Mark Rothko. *No. 10*. 1950.
Oil on canvas, 7 ft. 6⅜ in. × 57⅛ in.
(229.6 × 145.1 cm)

Plate 68

Plate 69

Jackson Pollock. *Number 7, 1950*. 1950.
Oil, enamel, and aluminum paint on canvas,
23¹/₁₆ in. × 8 ft. 9¾ in. (58.5 × 268.6 cm)

Bradley Walker Tomlin. *Number 9:
In Praise of Gertrude Stein*. 1950. Oil on canvas,
49 in. × 8 ft. 6¼ in. (124.5 × 259.8 cm)

Plate 70

Philip Guston. *Red Painting*. 1950.
Oil on canvas, 34⅛ × 62¼ in.
(86.4 × 158.1 cm)

Plate 71

Willem de Kooning. *Woman, I*. 1950–52.
Oil on canvas, 6 ft. 3⅞ in. × 58 in.
(192.7 × 147.3 cm)

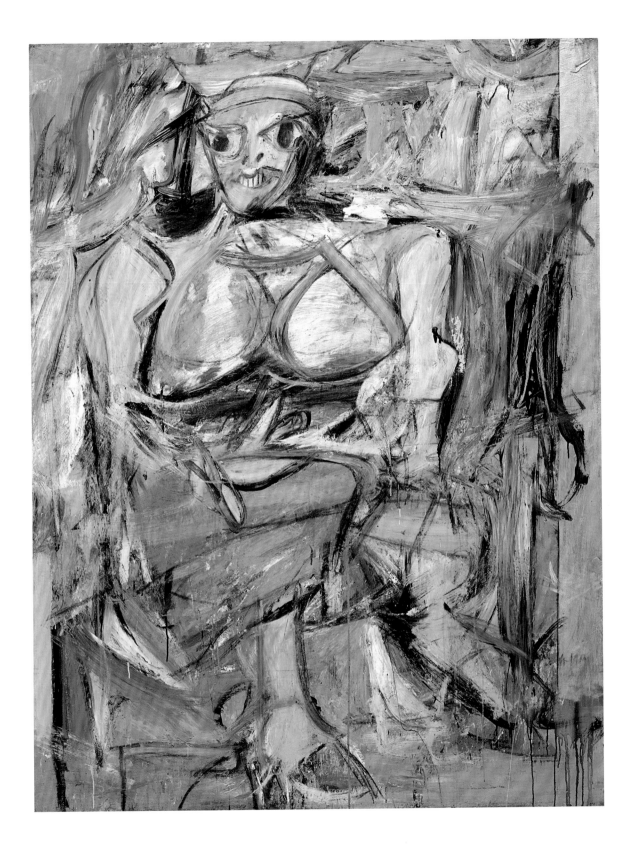

Plate 72

Jean Dubuffet. *Corps de Dame (Body of a Lady)*. June–December 1950. Ink on paper, 10¾ × 8⅜ in. (27.2 × 21.3 cm)

Plate 73

Jean Dubuffet. *Corps de Dame (Body of a Lady)*. June–December 1950. Ink on paper, 10⅝ × 8⅜ in. (27 × 21.3 cm)

Plate 74

Jean Dubuffet. *Corps de Dame (Body of a Lady)*. June–December 1950. Ink on paper, 12¾ × 9⅞ in. (32.3 × 24.9 cm)

Plate 75

Jean Dubuffet. *The Jewish Woman*.
October 1950. Oil on canvas,
45¾ × 35 in. (116.2 × 88.7 cm)

Plate 76

Alberto Giacometti. *The Chariot*. 1950. Painted
bronze on wood base, 57 × 26 × 26⅛ in.
(144.8 × 65.8 × 66.2 cm); base: 9¾ × 4½ × 9¼ in.
(24.8 × 11.5 × 23.5 cm)

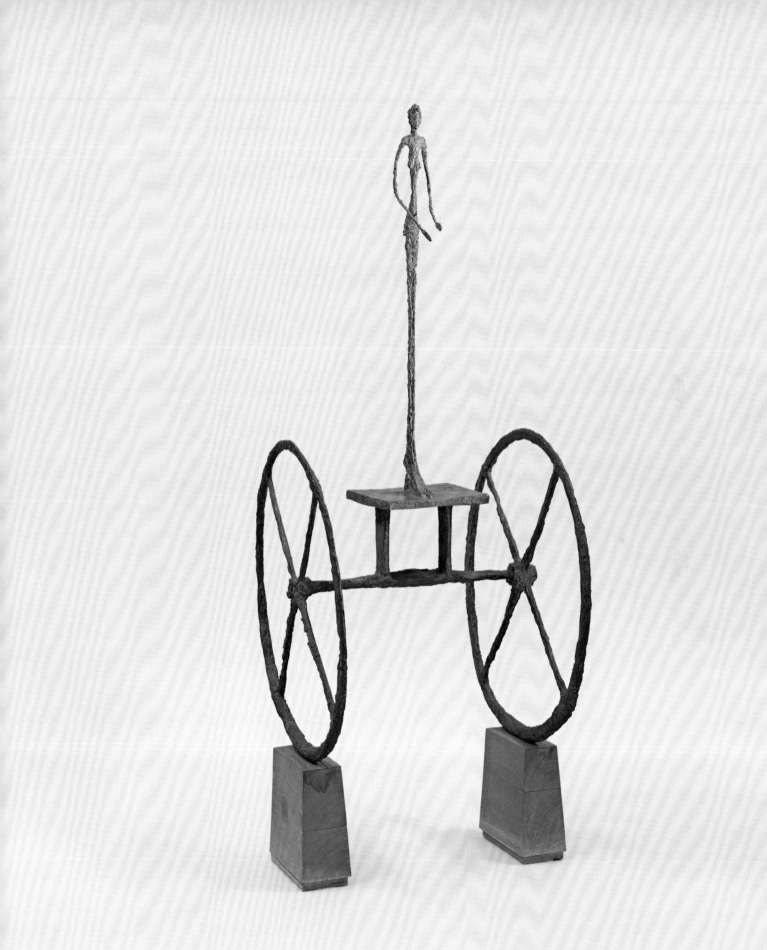

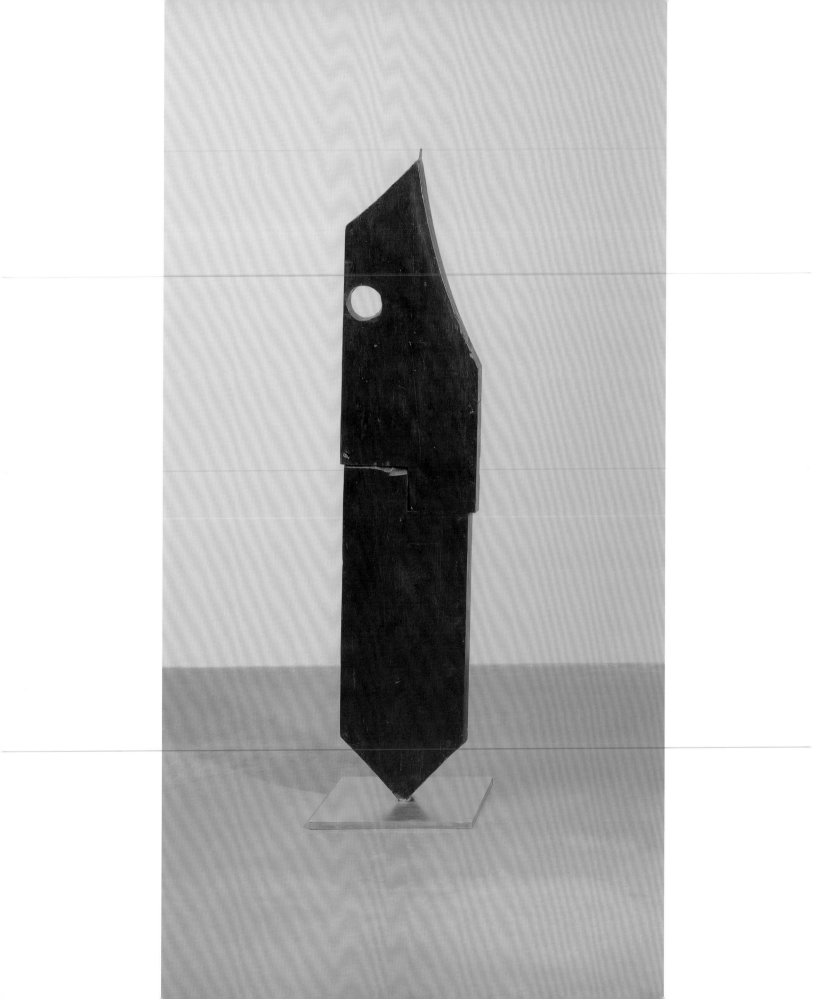

Plate 77

Louise Bourgeois. *Quarantania, III.*
1949–50 (cast 2001). Bronze,
58¼ × 12¾ × 2 in. (148 × 32.4 × 5.1 cm)

Plate 78

David Smith. *Twenty-Four Greek Y's.*
1950. Painted steel, 42¾ × 29⅛ × 6 in.
(108.6 × 73.9 × 15.2 cm)

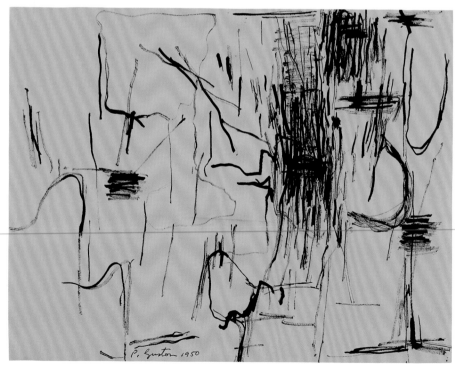

Plate 79

Ellsworth Kelly. *Automatic Drawing:*
Pine Branches VI. 1950. Pencil on paper,
16½ × 20¼ in. (41.9 × 51.4 cm)

Plate 80

Philip Guston. *Loft 1*. 1950.
Ink on paper, 17 × 22 in.
(43.2 × 55.9 cm)

Plate 81

Ellsworth Kelly. *Study for "La Combe II."*
1950. Ink and pencil on paper,
25½ × 31½ in. (64.8 × 80 cm)

Plate 82

Otl Aicher. *Kurs montags: Geologie unserer Heimat (Monday Lecture: Geology of Our Homeland).* c. 1950. Photolithograph, 16 × 16 in. (40.6 × 40.6 cm)

Plate 83

Otl Aicher. *Rosen und Orchideen, Vortrag 17. Dez. (Roses and Orchids, Lecture Dec. 17).* c. 1950. Photolithograph, 16¼ × 16⅛ in. (41.3 × 40.9 cm)

Plate 84

Otl Aicher. *Kurs freitags: Physik des Alltags (Friday Lecture: Physics of Everyday Life).* 1949–51. Photolithograph, 16¼ × 16¼ in. (41.3 × 41.3 cm)

Plate 85

Otl Aicher. *Jazz.* c. 1950. Photolithograph, 16 × 16¼ in. (40.6 × 41.3 cm)

Plate 86

Otl Aicher. *Vortrag über Sartres "Das Sein und das Nichts" (Lecture on Sartre's "Being and Nothingness").* c. 1950. Photolithograph, 16¼ × 16 in. (41.4 × 40.8 cm)

Plate 87

Otl Aicher. *Kurs freitags: Vom Rundfunk zur Funknachrichtentechnik (Friday Lecture: From Broadcast to Radio Communications Technology).* c. 1950. Photolithograph, 16¼ × 16 in. (41.2 × 40.6 cm)

Plate 88

Otl Aicher. *Massenmensch und Persönlichkeit: Kurs dienstags (Mass Society and Personality: Tuesday Lecture).* c. 1950. Photolithograph, 16¼ × 15⅞ in. (41.3 × 40.2 cm)

Plate 89

Otl Aicher. *Musik des Barock (Baroque Music).* 1949–51. Photolithograph, 16¼ × 16⁵⁄₁₆ in. (41.3 × 41.4 cm)

Plate 90

Otl Aicher. *Der europäische Familienzwist: Kurs montags (The European Family Quarrel: Monday Lecture).* c. 1950. Photolithograph, 16 × 16 in. (40.6 × 40.6 cm)

82

85

88

83

Vortrag
17. Dez.

Rosen
und
Orchideen

84

Physik

des

Alltags

Kurs Freitags

86

Vortrag
über Sartres
„Das Sein
und das Nichts"
23. Juni
Schuhhaussaal

87

Kurs freitags

Vom Rundfunk

zur Funknachrichtentechnik

89

Musik des Barock · 27. + 29. Oktober

90

Der europäische Familienzwist

Kurs montags

1961

>> In his 1958 essay "The Legacy of Jackson Pollock," Allan Kaprow, the artist who would soon pioneer the performance events called Happenings, predicted the future course of art making in the wake of Abstract Expressionism. "Pollock, as I see him, left us at the point where we must become preoccupied with and even dazzled by the space and objects of our everyday life, either our bodies, clothes, rooms, or if need be, the vastness of Forty-second Street."[1] Perhaps no artist realized Kaprow's prophesy more effectively than Robert Rauschenberg, who coined the name Combines to describe the assemblages he began making in the mid-1950s. Part painting, part sculpture, these constructions protruded off the wall into real space, incorporating quotidian objects and common materials from the artist's urban environment. With Combines such as *First Landing Jump* (plate 91), Rauschenberg fulfilled Kaprow's prediction that artists "will discover out of ordinary things the meaning of ordinariness. They will not try to make them extraordinary but will only state their real meaning."[2]

First Landing Jump consists of such "ordinary things" as a tire, a striped street barricade, a black tarpaulin, an enamel light reflector, a license plate, a blue lightbulb in a can, and a man's shirt. The presence of the tire attests to the direct influence of Rauschenberg's gritty downtown neighborhood:

Plate 91

Robert Rauschenberg. *First Landing Jump.* 1961. Cloth, metal, leather, electric fixture, cable, and oil paint on composition board, with automobile tire and wood plank, 7 ft. 5⅛ in. × 6 ft. × 8⅞ in. (226.3 × 182.8 × 22.5 cm)

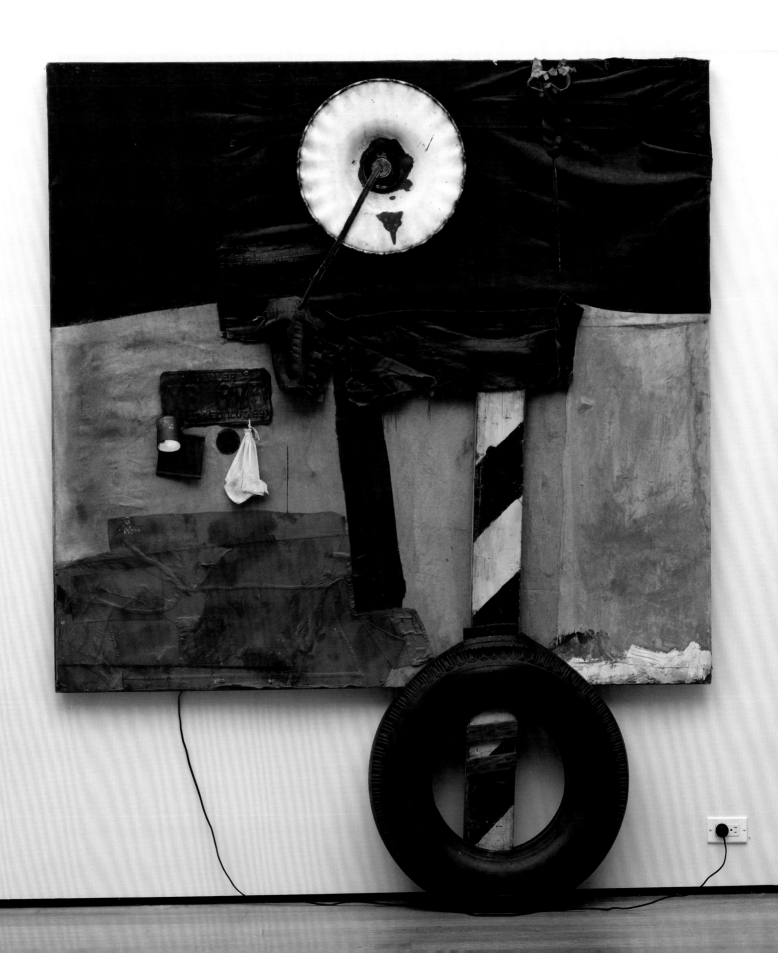

"I just got a bunch of tires, not because I'm crazy about tires but because they're so available around here in New York, even on the street."[3] Other artists in his circle found this particular object equally accessible, even emblematic. For his 1961 Happening *The Yard,* Kaprow piled a mountain of tires in a lot behind the Martha Jackson Gallery, inviting visitors to romp through the rubber (fig. 1). And in a manifesto of the same year, the Swedish-born artist Claes Oldenburg enthusiastically declared that he was "for an art of fat-truck tires."[4] The tire is an unmistakable nod to Marcel Duchamp's *Bicycle Wheel* (plate 3), which Rauschenberg said struck him "as one of the most beautiful pieces of sculpture I've ever seen"[5] — despite the fact that readymades were meant to undermine the very idea of beauty. Thanks to such affinities, the kind of art that Rauschenberg was pioneering, along with the artist Jasper Johns (plate 114), in particular, was dubbed "Neo-Dada" in homage to Duchamp's iconoclastic movement.

Where the tire is positioned within Rauschenberg's Combine is just as significant as its humble provenance and art historical allusions. Jutting out from the picture plane into real space, and extending below the support's bottom edge to rest on the floor, the tire confounds the work's status as either painting or sculpture. Describing the origins of the Combines, Rauschenberg explained: "The nature of some of my materials gave me an additional problem because I had to figure out how they could be physically supported on a wall when they obviously had no business being anywhere near a wall."[6] The intentionally exposed cord in *First Landing Jump* similarly leaves the space of the wall; beyond the merely practical function of powering the lightbulb, this hardware lays bare the mechanics of the work, quite literally plugging it into reality.

First Landing Jump sits at the nexus of two tendencies that emerged in the early 1960s, both of which are evident in the works selected for this section of *Fast Forward.* In terms of content, its integration of everyday objects points to Pop art's more explicit celebration of consumer culture. Formally, its disruption of the medium specificity so prized in the art criticism of the 1950s gave rise to reliefs — painting-sculpture hybrids whose intrusion into three-dimensional

space would pave the way for Minimalist objects. Though these two inclinations led to markedly different visual results, both shared Rauschenberg's desire to "relate to both art and life," and to "act in that gap between the two."[7]

Reacting against the reign of abstraction over avant-garde art during the 1950s, Pop artists embraced the products of a rising mass consumer culture for their subject matter and borrowed the seductive language of advertising for its form. Though the culture of cars and comics that inspired this new art was largely American, the movement actually began in England. The British artist Richard Hamilton defined Pop art in 1957 as "Popular (designed for a mass audience); Transient (short term solution); Expendable (easily forgotten); Low Cost; Mass Produced; Young (aimed at Youth); Witty; Sexy; Gimmicky; Glamorous; and Big Business."[8] A kind of anthology of these attributes, Hamilton's painting *Glorious Techniculture* (plate 94) incorporates such symbols of U.S. prosperity and leisure as "the three-ring pump agitator of the Frigidaire washing machine...a black line derived from a diagrammatic cross-section of the General Motors Corvair engine," and "an electronic guitar used by Tony Conn," derived from a *Life* magazine photograph of that American rockabilly singer.[9]

Encouraged both by these British forebears and by the experiments of Rauschenberg and Johns, American Pop artists emerged in the early 1960s. Having trained as a commercial artist, Andy Warhol was fluent in the language of mass media, and like Hamilton, he appropriated images from periodicals for his paintings: *Water Heater* (plate 95) is based on an advertisement from the Sunday *Daily News.* Roy Lichtenstein, who developed a painting style that mimicked the Benday dots of the mechanical printing process, found the source imagery for *Girl with Ball* (plate 93) in an ad for a Pocono Mountains hotel. Reimagining a nineteenth-century odalisque for the age of the *Playboy* pin-up, Tom Wesselmann demonstrated in the *Great American Nude, 2* (plate 92) and other paintings that the female form could be made into just as much a commodity as a car. Collaged into the interior surrounding this bright pink figure are a landscape clipped

from a travel poster, a painting taken from an art magazine, and a still life ripped from a subway poster.

In 1961 Pop art was not yet as slick or as impersonal as it would become. Though Warhol would turn exclusively to screenprinting by 1963, his *Water Heater* was still hand painted, its black lettering showing drips from the application of paint. The painted-plaster food items and other merchandise that Oldenburg made for his 1961 environment *The Store* had an even more handmade aesthetic. After an initial installation at the Martha Jackson Gallery's *Environments, Situations and Spaces* exhibition, Oldenburg opened a second version of *The Store* in his East Second Street studio on December 1, 1961 (fig. 2). With this project, he hoped "to create the environment of a store, by painting and placing...

3
Installation view, *The Art of Assemblage*,
The Museum of Modern Art, New York,
October 2–November 12, 1961. From
left to right: César, *The Yellow Buick* (1961);
Mimmo Rotella, *Before or After* (1961);
Robert Mallary, *Jouster* (1960); Robert
Rauschenberg, *Canyon* (1959)

objects after the spirit and in the form of popular objects of merchandise, such as may be seen in stores and store-windows of the city."[10] Sculptures like *Pastry Case* (plate 96) not only embody the color and gooey materiality of cupcakes or pie but also incorporate their conventional mode of display in a bakery's glass case. Situated squarely in the gap between art and life, *The Store* not only recreated the look of a retail establishment but even operated like one. "The store will be constantly supplied with new objects which I will create out of plaster and other materials in the rear half of the place," Oldenburg continued. "The objects will be for sale in the store."[11]

While early Pop artists employed the traditional media of painting and sculpture to represent everyday objects, other practitioners emphasized the extent to which paintings and sculptures were objects themselves. In order to call attention to the objecthood of paintings, artists like Robert Ryman emphasized the materiality of the medium's two constituent elements — paint and canvas. Adopting the strategy of the monochrome, Ryman (who began to paint full time in 1961) limited his palette to white in order to "make other aspects of painting visible that would not be so clear with the use of other colors."[12] In *Untitled* (plate 115), visible brushstrokes lay bare the artist's process and emphasize the physical quality of the medium. "I want to paint the paint," Ryman has said.[13] By leaving the edges of unstretched canvas exposed, he acknowledged the ordinary material that forms the foundation of painting, elevating the linen fabric from a mere support to a compositional component.

Canvas is also the primary element in many of Lee Bontecou's sculptures, such as *Untitled* (plate 112), in which panels of it are stretched across a steel framework. Like Rauschenberg, Bontecou scavenged materials from her own New York environs,[14] and her sculptures, like his Combines, defy the conventional boundaries of medium. Made from the stuff of paintings, they possess the bulk of sculpture; affixed to the wall, they thrust confrontationally into three-dimensional space. And though the abstract voids and muted tones of her sculptures diverge from Pop art's explicit cultural

content and punchier palette, they too relate, if more subtly, to cultural stimuli. Imagery associated with the Cold War climate of the late 1950s and early 1960s — the riveting of military metal or the science fiction fantasies inspired by the space race — informed Bontecou's aesthetics. Even in its abstract forms, *Untitled* evokes the nose of an airplane or the cosmic void of a black hole.

A similar Bontecou sculpture was included in the 1961 exhibition *The Art of Assemblage* at The Museum of Modern Art, as were two Rauschenberg Combines and a Johns sculpture of a book encased in encaustic.[15] This landmark exhibition, curated by William C. Seitz, sought to recognize an ascendant "new medium" of the moment, in which "collages, objects, and constructions…are predominantly assembled rather than painted, drawn, modeled, or carved," and whose "constituent elements are preformed natural or manufactured materials, objects, or fragments not intended as art materials."[16] Two of the works included in this section of *Fast Forward* were shown in *The Art of Assemblage* and exemplify Seitz's conditions: Lucas Samaras's *Untitled,* with its plaster-covered feathers framing a pile of cast-off hardware (plate 116), and César's *Yellow Buick,* an actual automobile compressed into a geometric block (plate 117; see fig. 3 for installation view). Exhibiting "works that incorporate reality…without imitating it,"[17] Seitz substantiated what Kaprow had sensed, that the art of this moment would inhabit the space and incorporate the objects of everyday life.

— SAMANTHA FRIEDMAN

1. Allan Kaprow, "The Legacy of Jackson Pollock," in *Essays on the Blurring of Art and Life,* ed. Jeff Kelley (Berkeley: University of California Press, 1993), p. 7.

2. Ibid., p. 9.

3. Rauschenberg, quoted in Robert Saltonstall Mattison, *Robert Rauschenberg: Breaking Boundaries* (New Haven, Conn.: Yale University Press, 2003), p. 47.

4. Claes Oldenburg, *Store Days: Documents from The Store (1961) and Ray Gun Theater (1962),* ed. Emmett Williams (New York: Something Else Press, 1967), p. 39.

5. Rauschenberg, quoted in Calvin Tomkins, "Profiles: Moving Out," *The New Yorker,* February 29, 1964, p. 31.

6. Rauschenberg, quoted in Barbara Rose, *An Interview with Robert Rauschenberg,* ed. Elizabeth Avedon (New York: Vintage Books, 1987), p. 58.

7. Rauschenberg's oft-quoted dictum — "Painting relates to both art and life. Neither can be made. (I try to act in that gap between the two.)" — appeared as his statement in the catalogue to MoMA's *Sixteen Americans* exhibition. Dorothy C. Miller, ed., *Sixteen Americans* (New York: The Museum of Modern Art, 1959), p. 58.

8. Letter from Hamilton to Alison and Peter Smithson, January 16, 1957. Reprinted in *Richard Hamilton: Collected Words, 1953–1982* (New York: Thames and Hudson, 1982), p. 28.

9. Richard Hamilton, "Statement on 'Glorious Techniculture,'" *Architectural Design* 21, no. 11 (November 1961): 497. Reprinted in *Richard Hamilton* (New York: Solomon R. Guggenheim Museum, 1973), p. 35. Hamilton initially thought about calling this painting *Anthology,* "since the work was conceived as a compilation of the principal myths of popular culture and the styles and techniques in which they were rendered." *Richard Hamilton* (London: Tate Gallery, 1992), p. 153.

10. Oldenburg, "The Store Described & Budget for the Store," in Oldenburg, *Store Days,* p. 16.

11. Ibid.

12. Ryman, quoted in Nancy Grimes, "White Magic," *Art News,* Summer 1986, p. 90.

13. Ryman, quoted in Robert Storr, *Robert Ryman* (London: Tate Gallery; New York: The Museum of Modern Art, 1993), p. 32.

14. Elizabeth A. T. Smith notes, "The location of [Bontecou's] studio yielded a variety of items that she scavenged or purchased cheaply — laundry bags and canvas conveyor belts acquired from the owner of the laundry directly underneath her loft, metal bolts, gears, war helmets, shrapnel, knapsacks and an abundance of army surplus items, rope, and various other detritus found on Canal Street." Smith, "All Freedom in Every Sense," in *Lee Bontecou: A Retrospective* (Chicago: Museum of Contemporary Art; Los Angeles: UCLA Hammer Museum; New York: Harry N. Abrams, 2003), p. 173.

15. Lee Bontecou, *Untitled* (1960), cat. no. 18; Robert Rauschenberg, *Talisman* (1958) and *Canyon* (1959), cat. nos. 170 and 171; and Jasper Johns, *Book* (1957), cat. no. 120. See William C. Seitz, *The Art of Assemblage* (New York: The Museum of Modern Art, 1961).

16. Ibid., p. 87 and p. 6.

17. Seitz, quoting Margaret Miller in a 1948 MoMA press release, ibid., p. 6.

Plate 92

Tom Wesselmann. *Great American Nude, 2.* 1961. Synthetic polymer paint, gesso, charcoal, enamel, oil, and collage on plywood, 59⅝ × 47½ in. (151.5 × 120.5 cm)

Plate 93

Roy Lichtenstein. *Girl with Ball.* 1961. Oil on canvas, 60¼ × 36¼ in. (153 × 91.9 cm)

Plate 94

Richard Hamilton. *Glorious Techniculture*.
1961–64. Oil and collage on panel,
48⅜ × 48⅜ in. (122.9 × 122.9 cm)

Plate 95

Andy Warhol. *Water Heater*. 1961.
Casein on canvas, 44¾ × 40 in.
(113.6 × 101.5 cm)

Plate 96

Claes Oldenburg. *Pastry Case*. 1961.
Painted plaster sculptures in glass-and-
metal case, 14½ × 10¼ × 10⅝ in.
(37 × 26 × 26.9 cm)

Plate 97

Claes Oldenburg. *Store Poster, Torn Out
Letters Newspaper Pie Cup Cakes and
Hot Dog*. 1961. Cut-and-pasted paper and
printed paper, watercolor, and crayon
on paper, 20 × 26 in. (50.8 × 66.1 cm)

Plate 98

Claes Oldenburg. *The Store*. 1961.
Letterpress poster, sheet: 28¼ × 22¹/₁₆ in.
(71.8 × 56 cm)

Plate 99

Wayne Thiebaud. *Cut Meringues*.
1961. Oil on canvas, 16 × 20 in.
(40.6 × 50.6 cm)

Plate 100

Jim Dine. *Six White Rainbows*.
1961. Oil on canvas, 6 panels,
overall: 6 ft. ½ in. × 40½ in.
(184.1 × 102.7 cm)

Jim Dine. *These Are Ten Useful Objects Which
No One Should Be Without When Traveling.*
1961. Portfolio of 10 drypoints with gouache
additions, various plate dimensions;
sheet (each): 12¹⁵⁄₁₆ × 10¹⁄₁₆ in. (32.9 × 25.6 cm)

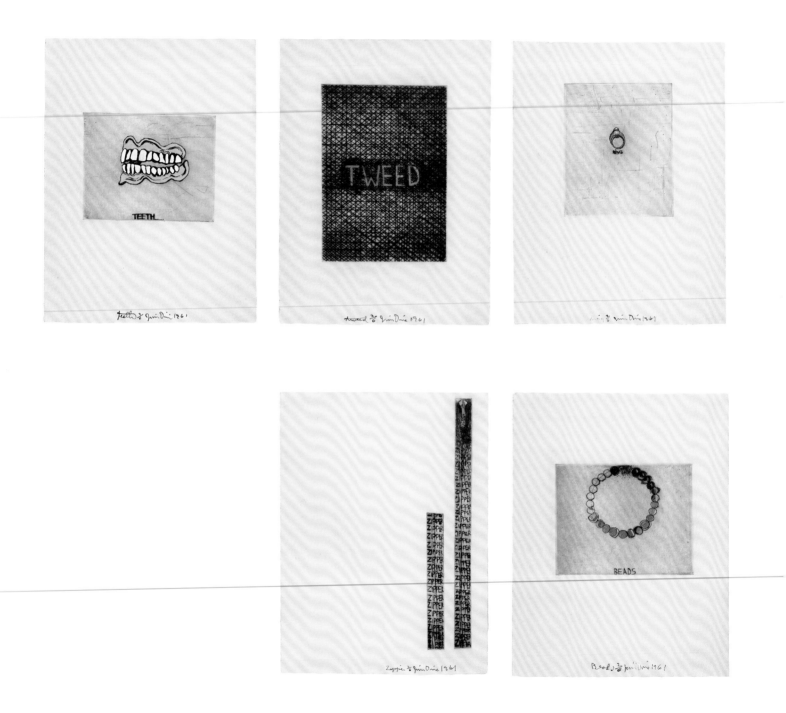

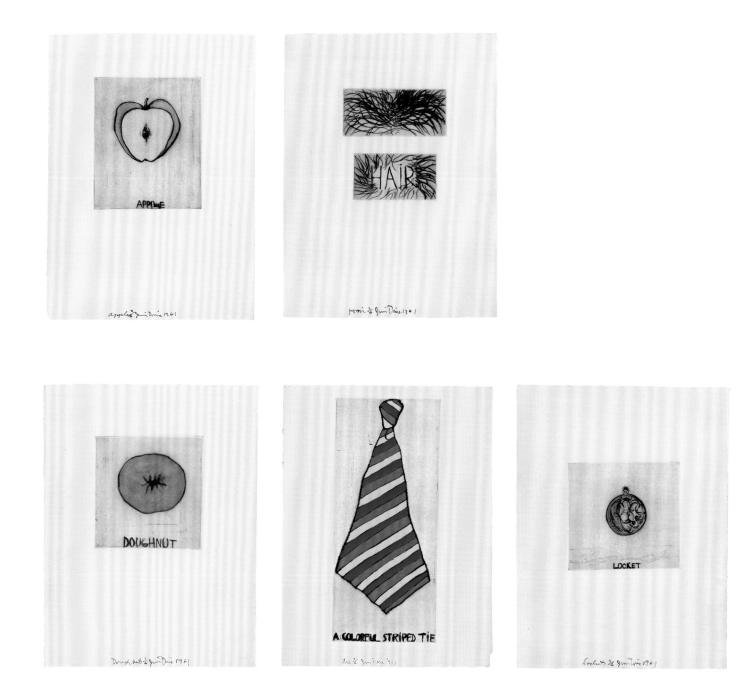

Plate 113

Donald Judd. *Relief.* 1961. Oil on
board and wood, with tinned-steel
baking pan, 48⅛ × 36⅛ × 4 in.
(122.2 × 91.8 × 10.2 cm)

Plate 114

Jasper Johns. *Painting Bitten by a Man.*
1961. Encaustic on canvas
mounted on type plate, 9½ × 6⅞ in.
(24.1 × 17.5 cm)

Plate 115

Robert Ryman. *Untitled*. 1961.
Oil on unstretched linen,
10³⁄₄ × 10¹⁄₄ in. (27.3 × 26 cm)

Plate 116

Lucas Samaras. *Untitled*. 1960–61. Wood panel
with plaster-covered feathers, nails, screws,
nuts, pins, razor blades, flashlight bulbs, buttons,
bullets, and aluminum foil, 23 × 19 × 4 in.
(59 × 48.2 × 10.2 cm)

Plate 117

César. *The Yellow Buick*. 1961. Compressed
automobile, 59½ × 30¾ × 24⅞ in.
(151.1 × 77.7 × 63.5 cm)

Plate 118

Yves Klein. *Blue Monochrome*. 1961.
Dry pigment in synthetic polymer
medium on cotton over plywood,
6 ft. 4⅞ in. × 55⅛ in. (195.1 × 140 cm)

Plate 121

George Brecht. *Water Yam*. 1963
(actions on selected cards from 1961).
Cardboard box with offset label,
containing 69 offset cards,
overall (box): 5⁷⁄₈ × 6⁵⁄₁₆ × 1³⁄₄ in.
(15 × 16 × 4.5 cm)

Plate 122

George Brecht. *Keyhole*. c. 1961.
Ink on paper in artist's frame and
metal escutcheon mounted on wood,
overall (frame): 6¹¹⁄₁₆ × 5⁹⁄₁₆ × ¹³⁄₁₆ in.
(17 × 14.2 × 2.1 cm); overall
(wood with metal escutcheon):
4³⁄₄ × 3⁵⁄₈ × ¹³⁄₁₆ in. (12 × 9.2 × 2.1 cm)

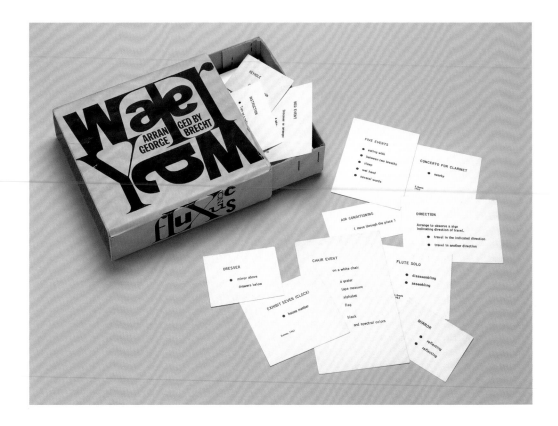

Plate 123
George Brecht. *Exit*. 1961 (object
realized c. 1962–63). Metal sign mounted
on painted wood, 3⁹/₁₆ × 11⅛ × ⅞ in.
(9 × 28.2 × 2.2 cm)

Plate 124
Dick Higgins. *Graphis 89, for a Drama*.
1961. Ink on paper, 13⅞ × 16¾ in.
(35.2 × 42.5 cm)

125

126

127

128

Plates 125–28

Jackson Mac Law. *Drawing-Asymmetries* nos. 5, 7, 10, and 21. 1961. Ink on paper (no. 5, ink and colored ink on paper), sheet (each): 8⁹/₁₆ × 1⁷/₈ in. (21.7 x 30.2 cm)

Plate 129

Robert Watts. Mechanical for artist's self-published *Safepost/K.U.K. Feldpost/Jockpost* postage stamps. 1961. 15 cut-and-pasted gelatin silver prints in artist's frame, overall (frame): 15¹/₁₆ × 21¹/₁₆ × ³/₈ in. (38.3 × 53.5 × 1 cm)

Plate 130

Dan Drasin. *Sunday*. 1961. 35mm film,
transferred to DVD, black and white,
sound, 17 minutes

Plate 131

Harry Callahan. *Chicago*. 1961.
Gelatin silver print, 15¾ × 10¼ in.
(40 × 26 cm)

Plate 132

Harry Callahan. *Chicago*. 1961.
Gelatin silver print, 15¹¹⁄₁₆ × 10⁵⁄₁₆ in.
(39.8 × 26.2 cm)

Plate 133

Garry Winogrand. Untitled. 1961.
Gelatin silver print, 9 1/16 × 13 7/16 in.
(23.1 × 34.1 cm)

Plate 134

Garry Winogrand. Untitled. 1961.
Gelatin silver print, 8 3/4 × 13 5/16 in.
(22.3 × 33.9 cm)

Plate 135

Simpson Kalisher. Untitled. 1961.
Gelatin silver print, 8⅞ × 13½ in.
(22.6 × 34.3 cm)

Plate 136

Simpson Kalisher. Untitled. 1961.
Gelatin silver print, 9³⁄₁₆ × 13⁷⁄₁₆ in.
(23.3 × 34.1 cm)

Simpson Kalisher. Untitled. 1961.
Gelatin silver print, 8⅞ × 13½ in.
(22.6 × 34.3 cm)

Simpson Kalisher. Untitled. 1961.
Gelatin silver print, 9³⁄₁₆ × 13⁷⁄₁₆ in.
(23.3 × 34.1 cm)

Plate 137

Lee Friedlander. *Philadelphia, Pennsylvania.*
1961. Gelatin silver print, 8¹¹/₁₆ × 13¹/₁₆ in.
(22 × 33.1 cm)

Plate 138

Dennis Hopper. *Double Standard.*
1961. Gelatin silver print, 16 × 23¹³/₁₆ in.
(40.7 × 60.5 cm)

Lee Friedlander. *Philadelphia, Pennsylvania.*

Dennis Hopper. *Double Standard.*
1961. Gelatin silver print, 16 × 23¹³/₁₆ in.
(40.7 × 60.5 cm)

1988

>> In an interview devoted to "My 1980s," the French artist Annette Messager recalls that the series *My Vows* came about accidentally, while she was preparing for her first retrospective. Revisiting an earlier assemblage of photographs and paint, she found it to be "not exactly a resounding success." She "tried desperately to improve it, and after several attempts... sent the whole pile of photographs packing with a furious gesture. That was when all the different things got messed up," Messager remarks. "That unintentional intermingling immediately seemed to me to be something tremendous."[1]

The fact that *My Vows* arose out of an unpremeditated and messy recombination of preexisting elements remains perceptible in the series' finished works (fig. 1), each of which comprises hundreds of individually framed photographs of body parts, interspersed with words repeatedly scrawled in colored script (plate 139). The work's French title, *Mes Voeux,* refers not only to the vows or wishes expressed in these mantras, but also suggests votive offerings made to saints. Each component is hung from a string of predetermined length so that together they add up to a holistic circle. The distinct mediums of photography and writing, and the discrete images and words enclosed in their individual frames, merge into a heterogeneous whole. That the photographs being amassed depict isolated organs and cropped limbs makes this a Frankensteinian accumulation cobbled together from multiple bodies. Facial features — eyes staring confrontationally or veiled by lids, nostrils seen from below, tongues stuck out — abut extremities like hands and feet, in-between zones like the back of the neck, and eroticized areas like pubic triangles and penises.

Plate 139

Annette Messager. *My Vows.* 1988–91. Photographs, colored graphite on paper, string, black tape, and pushpins over black paper or black synthetic polymer paint, overall: 11 ft. 8¼ in. × 6 ft. 6¾ in. (356.2 × 200 cm) (approx.)

1

Installation view of the exhibition
Annette Messager, The Museum of
Modern Art, New York, October 11,
1995–January 16, 1996

2

Robert Indiana (American, born 1928).
LOVE. 1967. Screenprint, 33¹⁵/₁₆ × 33¹⁵/₁₆ in.
(86.3 × 86.3 cm). Publisher: Multiples,
Inc., New York. Printer: Sirocco Screen-
printers, North Haven, Conn. The
Museum of Modern Art, New York.
Riva Castleman Fund

The result is a transgression of the body's basic order, in which the vertical hierarchy of elevated intellectual organs and base sexual or excretory parts collapses onto a distinctionless field. By including both male and female body parts in the jumble, Messager also blurs the boundaries between the genders. "Combine an eye and a mouth from different sexes and it's no longer a man, nor a woman," the artist has noted, going on to assert that "I am a man and woman at the same time."[2]

This suggestion of an artwork's ability to express manifold aspects of its creator's identity was preceded by Messager's explicit adoption of multiple roles. Beginning in the early 1970s, she assumed various monikers to express diverse aspects of her practice, calling herself Annette Messager Trickster, Annette Messager Tinkerer, Annette Messager Practical Woman, and Annette Messager Peddler. "I always feel that my identity as a woman and as an artist is divided, disintegrated, fragmented, and never linear, always multifaceted," she wrote in a 1988 letter, proposing a connection between this splintered sense of subjectivity and her work's formal properties: "always pictures of parts of bodies, fragments and close-ups.... I always perceive the body in fragments."[3] While this approach speaks to something very personal about this artist, it also links Messager's practice to a broader context. "There was a desire for engagement behind my multiple identities," she has said. "It's commonplace to pretend artists don't have nationalities or sexes. Not for me. We all come from somewhere; we have a sex, a history, and an education that marks us.... Our society and our fictions develop in parallel."[4]

At the end of the 1980s, the relationship between society and its fictions became a major concern for artists, whose work began to reflect more directly the circumstances of identity. Gender, race, nationality, even the products one consumes became principal subject matter for artists who refused to exist in an aesthetic vacuum. As with Messager's work, these manifestations of identity often appeared in multipart forms to express plural experiences. With its origin in "different things [that] get messed up," *My Vows* reflects

an intentional untidiness that characterizes much of the work that dominated the landscape of art in 1988. At that moment, it seemed as if the twentieth century itself was, like Messager, beginning to prepare for an upcoming retrospective, one that would cause the "unintentional intermingling" of the "whole pile" of modern art history.

In an essay related to a 1992 exhibition called *Corporal Politics,* curator Helaine Posner identified "the dismembered body" as "the site for the investigation of some of our most urgent contemporary concerns including sexism, sexual identity, reproductive rights, homophobia, social inequity, brutality, disease, and death."[5] Accompanying Messager's *My Vows* in that exhibition were works by two other artists included in this section of *Fast Forward* — David Wojnarowicz (plate 148) and Kiki Smith. With its thirty-six sheets of handmade Thai paper screenprinted with repeated images of a fetus, Smith's *All Souls* (plate 140) shares the simultaneous intimacy and monumentality of Messager's photographic composite. Smith found this source image in a Japanese anatomy book and photocopied it in different sizes, making reproduction both her subject and her method. "Prints mimic what we are as humans," Smith has said, bringing the question of identity to the fore. "We are all the same and yet everyone is different."[6]

Due largely to the rise of the AIDS epidemic in the late 1980s, death and disease rivaled birth and regeneration as a preoccupation for artists of this generation.[7] The Canadian artists and activists AA Bronson, Felix Partz, and Jorge Zontal began to live and work together in Toronto in 1968, actively collaborating as General Idea until Zontal and Partz died of AIDS-related causes in 1994. Like Kiki Smith, this collective harnessed the reproductive possibilities of the printed medium for metaphorical ends. Approached in 1987 to participate in AMFAR's "Art Against AIDS" benefit, the group appropriated Robert Indiana's iconic *LOVE* logo (fig. 2), exchanging the original sentiment for the name of a disease that, in 1987, the American president had yet to utter in public.[8] General Idea followed Indiana's example by disseminating the design in a myriad of formats, from street posters to

sculptures to stamps to the *AIDS (Wallpaper)* shown here (plate 154). "With the AIDS work," Bronson has said, "we took all the strategies we'd learned over the years and put them to work creating an image that could act as a virus and infiltrate the mass media. Because that was a time when AIDS wasn't being talked about."[9]

Recalling the 1980s, the artist Jenny Holzer associates the first half of the decade with artist-run, collaborative practices in the East Village but notes: "The late '80s were different. The national and the art economies were booming. People were heedless from sloppiness, happiness, or avoidance. That there was trouble around, from the AIDS epidemic to the country's domestic policy, was obvious, and though I recall many exceptions, I think Americans became less willing to recognize trouble."[10] This was the context for Holzer's Laments series. Unlike her previous projects, in which Holzer communicated clichés and other text samples with neutral matter-of-factness (see fig. 3), in the Laments she compiled subjective expressions by a series of individuals. In *LAMENTS: THE NEW DISEASE CAME . . .* (plate 142), the confessions range from medical particulars — *"I COUGH AND CANNOT*

A LITTLE KNOWLEDGE CAN GO A LONG WAY
A LOT OF PROFESSIONALS ARE CRACKPOTS
A MAN CAN'T KNOW WHAT IT'S LIKE TO BE A MOTHER
A NAME MEANS A LOT JUST BY ITSELF
A POSITIVE ATTITUDE MAKES ALL THE DIFFERENCE IN THE WORLD
A RELAXED MAN IS NOT NECESSARILY A BETTER MAN
A SENSE OF TIMING IS THE MARK OF GENIUS
A SINCERE EFFORT IS ALL YOU CAN ASK
A SINGLE EVENT CAN HAVE INFINITELY MANY INTERPRETATIONS
A SOLID HOME BASE BUILDS A SENSE OF SELF
A STRONG SENSE OF DUTY IMPRISONS YOU
ABSOLUTE SUBMISSION CAN BE A FORM OF FREEDOM
ABSTRACTION IS A TYPE OF DECADENCE
ABUSE OF POWER SHOULD COME AS NO SURPRISE
ACTION CAUSES MORE TROUBLE THAN THOUGHT
ALIENATION PRODUCES ECCENTRICS OR REVOLUTIONARIES
ALL THINGS ARE DELICATELY INTERCONNECTED
AMBITION IS JUST AS DANGEROUS AS COMPLACENCY
AMBIVALENCE CAN RUIN YOUR LIFE
AN ELITE IS INEVITABLE
ANGER OR HATE CAN BE A USEFUL MOTIVATING FORCE
ANIMALISM IS PERFECTLY HEALTHY
ANY SURPLUS IS IMMORAL
ANYTHING IS A LEGITIMATE AREA OF INVESTIGATION
ARTIFICIAL DESIRES ARE DESPOILING THE EARTH
AT TIMES INACTIVITY IS PREFERABLE TO MINDLESS FUNCTIONING
AT TIMES YOUR UNCONSCIOUS IS TRUER THAN YOUR CONSCIOUS MIND
AUTOMATION IS DEADLY
AWFUL PUNISHMENT AWAITS REALLY BAD PEOPLE
BAD INTENTIONS CAN YIELD GOOD RESULTS
BEING ALONE WITH YOURSELF IS INCREASINGLY UNPOPULAR
BEING HAPPY IS MORE IMPORTANT THAN ANYTHING ELSE
BEING HONEST IS NOT ALWAYS THE KINDEST WAY
BEING JUDGMENTAL IS A SIGN OF LIFE
BEING SURE OF YOURSELF MEANS YOU'RE A FOOL
BELIEVING IN REBIRTH IS THE SAME AS ADMITTING DEFEAT
BOREDOM MAKES YOU DO CRAZY THINGS
CALM IS MORE CONDUCIVE TO CREATIVITY THAN IS ANXIETY
CATEGORIZING FEAR IS CALMING
CHANGE IS VALUABLE BECAUSE IT LETS THE OPPRESSED BE TYRANTS
CHASING THE NEW IS DANGEROUS TO SOCIETY
CHILDREN ARE THE CRUELEST OF ALL
CHILDREN ARE THE HOPE OF THE FUTURE
CLASS ACTION IS A NICE IDEA WITH NO SUBSTANCE
CLASS STRUCTURE IS AS ARTIFICIAL AS PLASTIC
CONFUSING YOURSELF IS A WAY TO STAY HONEST
CRIME AGAINST PROPERTY IS RELATIVELY UNIMPORTANT
DECADENCE CAN BE AN END IN ITSELF
DECENCY IS A RELATIVE THING
DEPENDENCE CAN BE A MEAL TICKET
DESCRIPTION IS MORE VALUABLE THAN METAPHOR
DEVIANTS ARE SACRIFICED TO INCREASE GROUP SOLIDARITY
DISGUST IS THE APPROPRIATE RESPONSE TO MOST SITUATIONS
DISORGANIZATION IS A KIND OF ANESTHESIA
DON'T PLACE TOO MUCH TRUST IN EXPERTS
DON'T RUN PEOPLE'S LIVES FOR THEM
DRAMA OFTEN OBSCURES THE REAL ISSUES
DREAMING WHILE AWAKE IS A FRIGHTENING CONTRADICTION
DYING AND COMING BACK GIVES YOU CONSIDERABLE PERSPECTIVE
DYING SHOULD BE AS EASY AS FALLING OFF A LOG
EATING TOO MUCH IS CRIMINAL
ELABORATION IS A FORM OF POLLUTION
EMOTIONAL RESPONSES ARE AS VALUABLE AS INTELLECTUAL RESPONSES
ENJOY YOURSELF BECAUSE YOU CAN'T CHANGE ANYTHING ANYWAY
EVEN YOUR FAMILY CAN BETRAY YOU
EVERY ACHIEVEMENT REQUIRES A SACRIFICE
EVERYONE'S WORK IS EQUALLY IMPORTANT
EVERYTHING THAT'S INTERESTING IS NEW
EXCEPTIONAL PEOPLE DESERVE SPECIAL CONCESSIONS
EXPIRING FOR LOVE IS BEAUTIFUL BUT STUPID
EXPRESSING ANGER IS NECESSARY
EXTREME BEHAVIOR HAS ITS BASIS IN PATHOLOGICAL PSYCHOLOGY
EXTREME SELF-CONSCIOUSNESS LEADS TO PERVERSION
FAITHFULNESS IS A SOCIAL NOT A BIOLOGICAL LAW
FAKE OR REAL INDIFFERENCE IS A POWERFUL PERSONAL WEAPON
FATHERS OFTEN USE TOO MUCH FORCE
FEAR IS THE GREATEST INCAPACITATOR
FREEDOM IS A LUXURY NOT A NECESSITY
GIVING FREE REIN TO YOUR EMOTIONS IS AN HONEST WAY TO LIVE
GOING WITH THE FLOW IS SOOTHING BUT RISKY
GOOD DEEDS EVENTUALLY ARE REWARDED
GOVERNMENT IS A BURDEN ON THE PEOPLE
GRASS ROOTS AGITATION IS THE ONLY HOPE
GUILT AND SELF-LACERATION ARE INDULGENCES
HABITUAL CONTEMPT DOESN'T REFLECT A FINER SENSIBILITY
HIDING YOUR MOTIVES IS DESPICABLE

3

Jenny Holzer. *Truisms*. 1978–87.
Photostat, 8 ft. × 40 in.
(243.9 × 101.6 cm). Publisher:
the artist. Printer: Metro Giant,
New York. The Museum
of Modern Art, New York.
Gift of the artist

TURN MY HEAD"— to macabre vows: *"I WILL THINK MORE BEFORE I CANNOT."* In *LAMENTS: THE KNIFE CUT RUNS AS LONG . . .* (plate 143), a physical observation asks to be read as a metaphysical one: *"I HAVE MORE COLORS THAN I WOULD HAVE THOUGHT."* As with Messager's adopted identities, these transfer drawings incorporate multiple subjects, uniting various "I"s in common expressions of fear and sorrow.

"Nobody gets away from identity,"[11] the sculptor Melvin Edwards has said, suggesting that the marks of nationality, sex, history, and education to which Messager refers are as much inescapable subjects as chosen ones. In his Lynch Fragment series (plates 149 and 150), Edwards literally welds together elements from ancestral, social, and personal histories. The word *Sekuru* in one of the titles "refers in the Shona language to a grandfather or a wise elder."[12] The name of the series, like the chains that recur throughout it, alludes to violence against African Americans in the nineteenth and twentieth centuries. The oversize scissors integrated into one of these steel assemblages point to the profession of Edwards's mother, a seamstress.

And yet . . . One of the central preoccupations of the artist Glenn Ligon's project is to question the extent to which one's identity must inform an artwork. The text featured in *Untitled (There is a consciousness we all have . . .)* (plate 144) is an excerpt from a *New York Times* article about the African-American sculptor Martin Puryear, who was representing the United States in the 1989 São Paulo Bienal. "There is a consciousness we all have that he is a black American artist," a curator is quoted as saying of Puryear, "but I think his work is really superior and stands on its own."[13] Ligon appropriates this statement in order to critique it as exemplifying the tendency to evaluate a work in terms of an artist's race. Stenciling it over the break between two pieces of paper, in an ocher hard to read against the brown ground, Ligon disrupts the quote's legibility in order to highlight its implicit assumptions.

At the same time that many artists in the late 1980s were investigating language and the body as sites of political discourse, the booming economy that Holzer refers to

encouraged art that engaged with the market, whether complicitly or critically. A group of East Village artists that included Jeff Koons (plate 152), Peter Halley (plate 153), Allan McCollum (plate 141), and Ashley Bickerton were grouped under the rubrics of Neo-Geo, Commodity Art, and Simulationism — classifications that reference their work's geometric forms, emphasis on salable objects, and the simulation of mass-media images. With its collection of logos formulated into an expression of self, Bickerton's *Tormented Self-Portrait (Susie at Arles)* (plate 151) exemplifies these more market- and media-conscious practices. The artist has described this wall-mounted relief as the result of "seeing myself through the products I used,"[14] from Close-Up toothpaste to Fruit of the Loom underwear, from a CalArts education to a USAA insurance policy.

Though Bickerton's work could not be more different in tone from *My Vows* — its cynical corporate sterility has nothing of Messager's corporeal sensuality — both reimagine the genre of the portrait as a necessarily composite construction. And both see the self as a socially constructed phenomenon, which can be represented only by a series of signs, whether isolated body parts or disembodied logos. If Messager's project has been described as "a melancholy acknowledgment of the fact that the world no longer appears to be a unified entity,"[15] there is also an air of exuberance to her work's profusion. Perhaps this dual quality is what British art historian Stuart Morgan is referring to when he describes "that state of mingled excitement and misgiving which everyone feels at the end of an historical period."[16] It is the simultaneous anticipation and dread of having arrived at a retrospective. — SAMANTHA FRIEDMAN

1. Annette Messager, "My 1980s," in *Annette Messager: The Messengers* (Munich and New York: Prestel, 2007), p. 318.

2. Annette Messager, "Notes for a Film by Philippe de Montaut, 1989," in *Annette Messager: Word for Word*, ed. Marie-Laure Bernadac, trans. Vivian Rehberg (New York: D.A.P. / Distributed Art Publishers, 2006), p. 362.

3. Messager, quoted in Sheryl Conkelton and Carol S. Eliel, *Annette Messager* (Los Angeles: Los Angeles County Museum of Art; New York: The Museum of Modern Art; distributed by Harry N. Abrams, 1995), p. 67 and p. 85 n. 17.

4. Messager, "Interview by Suzanne Pagé and Béatrice Parent, 2005," in Bernadac, ed., *Annette Messager: Word for Word*, p. 446.

5. Helaine Posner, "Separation Anxiety," in *Corporal Politics* (Cambridge, Mass.: MIT List Visual Arts Center; Boston: Beacon Press, 1992), p. 22.

6. Kiki Smith, in Laura Auricchio, "New York, New York," *Art Papers* 28, no. 3 (May–June 2004): 49.

7. It was in May 1988 that the United States began a formal campaign of HIV/AIDS education; the first World AIDS Day was observed on December 1 of the same year.

8. See Lilian Tone, *Projects 56: General Idea* (New York: The Museum of Modern Art, 1996), n.p.

9. AA Bronson in C. Carr, "On Edge: General Idea Made Art from Culture's Forgotten Shell," *The Village Voice,* June 17, 2003.

10. Holzer, in "Jenny Holzer Talks to Steven Henry Madoff," *Artforum,* April 2003, p. 82.

11. Edwards, quoted in Gail Gregg, "Poetry in Heavy Metal," *Art News,* February 1995, p. 107.

12. Brooke Kamin Rapaport, "Melvin Edwards: Lynch Fragments," *Art in America,* March 1993, p. 63.

13. Ned Rifkin, quoted in Michael Brenson, "A Sculptor to Represent U.S. at São Paulo Biennale," *New York Times,* November 22, 1988.

14. Bickerton, quoted in Shaun Caley, "Ashley Bickerton," *Flash Art,* November–December 1988, p. 80.

15. Anne Karin Jortveit, "Along the Edges of Reality: An Introduction to Annette Messager's Art," in *Annette Messager: Between You and Me* (Oslo: National Museum of Contemporary Art, 2004), p. 16.

16. Stuart Morgan, introduction to *Rites of Passage: Art for the End of the Century* (London: Tate Gallery Publications, 1995), p. 19.

Plate 140

Kiki Smith. *All Souls*. 1988. Screenprint
on 36 attached sheets of handmade
Thai paper, composition and sheet,
overall: 71¼ in. × 15 ft. 1⅛ in.
(181 × 460 cm)

Plate 141

Allan McCollum. *Collection of Thirty
Drawings* (No. 14). 1988/1990.
Pencil on board in artist's frame,
overall: 39⅜ in. × 11 ft.
(100 × 335.3 cm)

Plate 140

Kiki Smith. *All Souls*. 1988. Screenprint
on 36 attached sheets of handmade
Thai paper, composition and sheet,
overall: 71¼ in. × 15 ft. 1⅛ in.
(181 × 460 cm)

Plate 141

Allan McCollum. *Collection of Thirty
Drawings* (No. 14). 1988/1990.
Pencil on board in artist's frame,
overall: 39⅜ in. × 11 ft.
(100 × 335.3 cm)

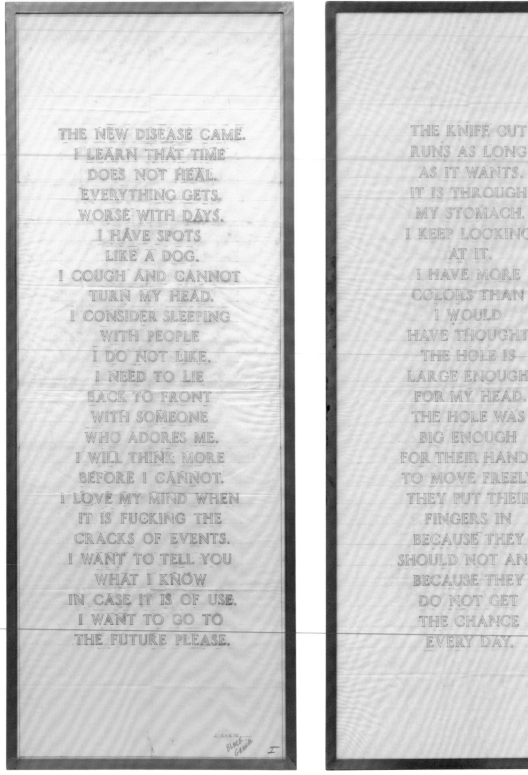

THE NEW DISEASE CAME.
I LEARN THAT TIME
DOES NOT HEAL.
EVERYTHING GETS
WORSE WITH DAYS.
I HAVE SPOTS
LIKE A DOG.
I COUGH AND CANNOT
TURN MY HEAD.
I CONSIDER SLEEPING
WITH PEOPLE
I DO NOT LIKE.
I NEED TO LIE
BACK TO FRONT
WITH SOMEONE
WHO ADORES ME.
I WILL THINK MORE
BEFORE I CANNOT.
I LOVE MY MIND WHEN
IT IS FUCKING THE
CRACKS OF EVENTS.
I WANT TO TELL YOU
WHAT I KNOW
IN CASE IT IS OF USE.
I WANT TO GO TO
THE FUTURE PLEASE.

THE KNIFE CUT
RUNS AS LONG
AS IT WANTS.
IT IS THROUGH
MY STOMACH.
I KEEP LOOKING
AT IT.
I HAVE MORE
COLORS THAN
I WOULD
HAVE THOUGHT.
THE HOLE IS
LARGE ENOUGH
FOR MY HEAD.
THE HOLE WAS
BIG ENOUGH
FOR THEIR HANDS
TO MOVE FREELY.
THEY PUT THEIR
FINGERS IN
BECAUSE THEY
SHOULD NOT AND
BECAUSE THEY
DO NOT GET
THE CHANCE
EVERY DAY.

Plate 142

Jenny Holzer. *LAMENTS: THE NEW DISEASE CAME....* 1988–89. Ink transfer and pencil on transparentized paper in artist's frame, frame: 7 ft. 1½ in. × 33⅛ in. × 1¼ in. (216.2 × 84.1 × 3.2 cm)

Plate 143

Jenny Holzer. *LAMENTS: THE KNIFE CUT RUNS AS LONG....* 1988–89. Ink transfer and pencil on transparentized paper in artist's frame, frame: 7 ft. × 32⅛ in. × 1¼ in. (213.4 × 81.6 × 3.2 cm)

Plate 144

Glenn Ligon. *Untitled (There is a consciousness we all have...).* 1988. Synthetic polymer paint and pencil on 2 sheets of paper, 30 × 44¾ in. (76.2 × 111.1 cm)

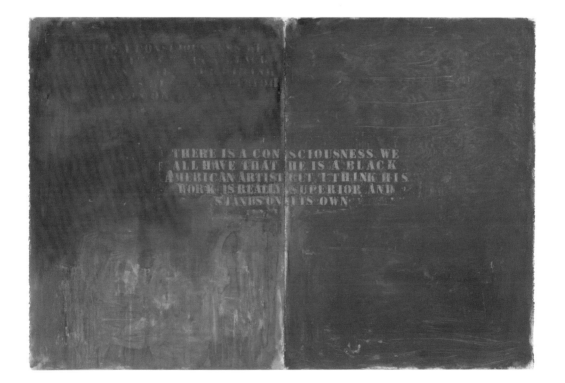

Plate 145

Mona Hatoum. *Measures of Distance.*
1988. Video, color, sound, 15 minutes,
26 seconds

Plate 146

Brice Marden. *Couplet IV.* 1988–89.
Oil on linen, 9 ft. × 60 in.
(274.3 × 152.4 cm)

Plate 145

148

Brice Marden. *Couplet IV.* 1988–89.
Oil on linen, 9 ft. × 60 in.
(274.3 × 152.4 cm)

Plate 147

Adam Fuss. *Untitled*. 1988.
Gelatin silver print, 54⅞ × 49¹/₁₆ in.
(139.4 × 124.6 cm)

Plate 148

David Wojnarowicz. *Weight of the Earth,
Part I*. 1988. 14 gelatin silver prints,
overall: 39 × 41¼ in. (99.1 × 104.8 cm)

Plate 151

Ashley Bickerton. *Tormented Self-Portrait (Susie at Arles).*
1987–88. Synthetic polymer paint, bronze powder
and lacquer on wood, anodized aluminum, rubber, plastic,
Formica, leather, chrome-plated steel, and canvas,
7 ft. 5⅜ in. × 68¾ in. × 15¾ in. (227.1 × 174.5 × 40 cm)

Plate 152

Jeff Koons. *Pink Panther.* 1988.
Porcelain, 41 × 20½ × 19 in.
(104.1 × 52 × 48.2 cm)

Plate 153

Peter Halley. *Final Attributes.*
1988–90. Screenprint,
sheet: 30¹¹/₁₆ × 38⁹/₁₆ in. (78 × 98 cm)

Plate 154

General Idea. *AIDS (Wallpaper).* 1988.
Screenprinted wallpaper, dimensions
vary upon installation

Plates 155–64

Allen Ruppersberg. *Preview.* 1988. Series of 10 lithographs,
sheet (each): 22¹⁄₁₆ × 13¹³⁄₁₆ in. (56 × 35.1 cm)

2013

>> In a well-known diagram, MoMA's founding director, Alfred H. Barr, Jr., attempted to trace the chronology of modern art by charting the cross-pollination of various styles and influences between 1890 and 1935. It became the jacket design for the catalogue of MoMA's 1936 exhibition *Cubism and Abstract Art*, which was the first in a five-part series of exhibitions devoted to the crisscrossing paths of modern art during that period of 1890–1935.[1] A half century later, another exhibition series, *MoMA2000*, likewise sought to present the overlapping and sometimes contrasting narratives of modern art, culminating in the exhibition *Open Ends*, which featured contemporary art at the onset of the twenty-first century.[2] The current exhibition, *Fast Forward*, similarly aims to provide an overview of major themes and issues in art — in this case, covering the past one hundred years. It explores the social and cultural landscape as reflected by artworks in MoMA's collection produced during certain key years: 1913, 1929, 1950, 1961, and 1988. The formidable task of historicizing the current moment as it unfolds led the curators to think of today in terms of tomorrow; thus, we have chosen to conclude this exhibition with the "near present" of 2013.

Plate 165

Sarah Sze. *Random Walk Drawing (Water)*. 2011. Mixed mediums, wood, rocks, lamps, branches, giclée prints on archival paper, string, tape, and coins. 13 ft. 4 in. × 16 ft. 11 in. × 19 ft. 10 in. (406.4 × 515.6 × 604.5 cm). Installation view, *Sarah Sze: Infinite Line*, Asia Society Museum, New York

Each of this exhibition's historical sections offers an independent art historical survey culled from MoMA's holdings. The section for 2013 departs from this curatorial framework, however, consisting of artworks that are not part of MoMA's collection but are either recent works or have been created specifically for the exhibition. Again diverging from the structure of these historical divisions, each of which encompasses more than a dozen artists, 2013 is represented by only three: Aaron Curry, Katharina Grosse, and Sarah Sze. Since no selection of artists, no matter how large, could adequately represent the global crosscurrents of contemporary art practice, these artists were asked to reflect upon and respond to the multiple histories told by the exhibition.

Each artist has created an environment that is conceptually open-ended and physically immersive. We walk through and around their works, and as we do so, our relationship to them changes: navigating the works prolongs the process of thinking about them, stretching the present moment toward those yet to come. Meanwhile, even as these works prompt a consideration of what art once was (as represented in the historical sections of the exhibition), they also expand our capacity to imagine what art can be for future generations.

Aaron Curry compresses an array of influences into his large-scale sculptures in order to address the hybridity of visual culture in this digital era, when disparate sources are being endlessly sampled, fragmented, and recombined. Curry's sculptures *Love Buzz, Boo,* and *The Heat Thing* (plates 167–69) are characterized by such binaries as flatness and dimensionality, masculinity and femininity, intimacy and monumentality, delight and fear. They summon the capricious combination of forms and the playful transgression of Marcel Duchamp's *Bicycle Wheel* (plate 3), and their irregularly shaped, volumetric silhouettes echo the illusion of depth in the windows of Salvador Dalí's *Illumined Pleasures* (plate 21). Curry's flat, painted surfaces also recall the painted sculpture of David Smith, such as *Twenty-Four Greek Y's* (plate 78), while his free association with popular culture and art history recalls the appropriations of Roy Lichtenstein's *Girl with Ball* (plate 93) and Jeff Koons's *Pink Panther* (plate 152).

Katharina Grosse seeks to enact a personal, sensual experience of painting through the physical performance of her work, in which her bodily relationship to a given architectural environment is the primary impetus (plates 171 a and b). She simultaneously expands and eliminates the traditional boundaries of painting by using a compressor to apply paint to a large, irregularly shaped support. The result is a work that relates to her own emotional reponse to painting that, when inserted in a given spatial context, transposes our ordinary experience of both art and architecture. The shaped painting on the floor, leaning against the wall, establishes an immediate relationship between the space of the painting and of the viewer. Seen in the context of this exhibition, Grosse's work recalls varying modes of abstraction from 1913 that investigate the idea of space and time in relation to visual perception. Synchromist works such as Stanton Macdonald-Wright's *Still Life Synchromy* (plate 15) are conjured by her use of color to alter the spatial dynamics of her surroundings and to suggest an evanescent experience of painting — Grosse has described color as being "like the voice in a song."[3] She also acknowledges the influence of Abstract Expressionism. Her use of a spray gun to amplify her body's reach both alludes to and departs from Jackson Pollock's process of dripping and splattering paint, as in his *Number 7, 1950* (plate 68). Finally, Grosse's ability to conceive of painting beyond its conventional physical limitations recalls Robert Rauschenberg's *First Landing Jump* (plate 91).

Taking the principles of Rauschenberg's Combines to their extremes, **Sarah Sze** produces sculptural installations composed of layers of multifarious objects and images, which are arranged at times like a display of scientific specimens, a chaotic macrocosm of architectural forms, or a machine of Rube Goldbergian complexity (plates 174 a and b). Sze organizes her ephemeral installations as if they were cryptic encyclopedias in a language that we intuit through repeated encounters. She creates moments of compression and energy that continually shift, expanding and contracting, accelerating and decelerating as the experience of her work unfolds. Using a choreography of color, light, perspective, movement,

and form, these moments embody ideas about dislocation, hybridity, and migration. Echoing Henri Matisse's *Blue Window* (plate 5) and Joan Miró's *Portrait of Mistress Mills in 1750* (plate 24), Sze's work achieves balance and harmony through the asymmetrical arrangement of disparate forms, while her evocation of the temporal qualities of light and shadow recalls Ellsworth Kelly's *Study for "La Combe II"* (plate 81). Her unexpected combinations of unlikely materials seem presaged by Lucas Samaras's *Untitled* (plate 116), while Kiki Smith's *All Souls* (plate 140) resonates with the handmade quality of Sze's work and the accumulation of its component parts.

 The work of Curry, Grosse, and Sze engages the history of modern art seen in this exhibition's diverse historical sections — from the moderns' exploration of abstraction in 1913 to the following generation's interest in new ways of seeing; from the invention of new art forms and audacious new subjects in 1961 to the new political subjectivity that sought to respond to society's ills in the 1980s. Together their work reveals how culture, as interpreted by its artists, leans forward to represent a continually expanding store of cumulative experience that shapes life in the current moment and the near present. — MICHAEL ROOKS

1. Alfred H. Barr, Jr., *Cubism and Abstract Art* (New York: The Museum of Modern Art, 1936). The diagram appears on the dust jacket of the first edition.

2. *Open Ends*, The Museum of Modern Art, New York, September 28, 2000–March 4, 2001.

3. Grosse, quoted in Viktor Neumann, "Katharina Grosse, Frank Nitsche, Pictorial Spatiality," *Flash Art*, November–December 2011, p. 64.

Aaron Curry

Plate 166

Aaron Curry's studio, Los Angeles, 2012

Plate 167

Plate 168

Plate 169

Love Buzz. 2011. Painted aluminum, 10 ft. 4 in. × 15 ft. 2½ in. × 70 in. (315 × 463.5 × 178 cm). Courtesy of Michael Werner Gallery, New York

Boo (in progress). 2012. Painted steel, 17 ft. 9½ in. × 47¾ in. × 40½ in. (542.3 × 121.3 × 102.9 cm). Courtesy of the artist and David Kordansky Gallery, Los Angeles

The Heat Thing. 2010. Powder-coated aluminum and steel, 10 ft. 8 in. × 6 ft. 4 in. × 10 ft. (325 × 193 × 305 cm). Private collection

Katharina Grosse

Plate 170

The Other George. 2009. Acrylic on laminated Styrofoam,
21 ft. 3⅞ in. × 27 ft. 10½ in. × 36 ft. 1 in. (650 × 850 × 1100 cm).
Installation view at Arken Museum for Moderne Kunst,
Copenhagen, 2009. Courtesy of Gallery Mark Müller, Zurich, and
Galerie nächst St. Stephan/Rosemarie Schwarzwälder, Vienna

Plates 171 a + b

One Floor Up More Highly. 2010. Soil, wood, acrylic, Styrofoam, clothing, acrylic on fiberglass-reinforced plastic, and acrylic on canvas, dimensions variable. Installation view, MASS MoCA, North Adams, Massachusetts. Courtesy of Christopher Grimes Gallery, Santa Monica, and Galerie nächst St. Stephan/Rosemarie Schwarzwälder, Vienna

Plate 172

Katharina Grosse's studio, Berlin, 2009

Sarah Sze

Plate 173

Hidden Relief. 2001. Mixed media, 14 ft. × 60 in. × 12 in. (426.7 × 152.4 × 30.5 cm). *Hidden Relief*, Asia Society, New York, October 1, 2001–October 1, 2004. Collection Nancy and Stanley Singer

360 (Portable Planetarium). 2010. Mixed mediums, wood, paper,
string, jeans, and rocks, 13 ft. 6 in. × 11 ft. 4 in. × 15 ft. 5 in.
(411.5 × 345.4 × 469.9 cm). Installation view, *Sarah Sze*,
Tanya Bonakdar Gallery, New York

February 17

The Armory Show, an exhibition of modern art organized by the Association of American Painters and Sculptors, opens in New York. Many viewers, accustomed to figurative art, are shocked by the Cubist works on display.

March 3

Eight thousand women march up Pennsylvania Avenue in Washington, D.C., to demand the right to vote. Ida B. Wells, an African-American journalist and civil rights advocate, protests against the self-enforced segregation of the parade and instead joins a march in Illinois.

April 24

The Woolworth Building opens — at 792 feet (241 meters), it is the tallest building in the world. With its impressive height, neo-Gothic architecture, and role as headquarters of the Woolworth Company, the structure earns the nickname "Cathedral of Commerce."

May 13

Igor Sikorsky designs and pilots the world's first multi-engine aircraft, referred to as Sikorsky Russky Vityaz (Russian Night) or Le Grande (The Big One).

September 23

French aviator Roland Garros crosses the Mediterranean in a Morane-Saulnier plane. The 454-mile (730-kilometer) journey from southern France to Tunisia leaves him only seven minutes of fuel to spare.

November 17

Although the tugboat Gatun had made an earlier test run through part of the Panama Canal, the USS Ancon is the first ship to travel the entire length of the canal connecting the Pacific and the Atlantic.

December 1

Ford Motor Company introduces the moving assembly line to its factories, decreasing the manufacturing time of a Model T car from twelve hours to two hours and thirty minutes.

December 16

Charlie Chaplin launches his film career by signing a contract with Keystone Studios.

Time Line 1913

COMPILED BY SARAH ZABRODSKI

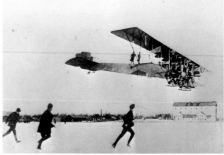

1.
A cartoon parody of Marcel Duchamp's *Nude Descending a Staircase (No. 2)*, published on the occasion of the Armory Show in New York.

2.
Suffragists on their way to the Woman Suffrage Procession in Washington, D.C.

3.
Construction of the Woolworth Building nears completion.

4.
Igor Sikorsky flies *Le Grande*, the world's first four-engine plane.

5.
Roland Garros, posing in civilian clothes, in front of his plane after landing in Bizerte, Tunisia.

6.
The tugboat *Gatun* enters the Panama Canal.

7.
Employees of the Ford Motor Company Highland Park Plant assemble cars on a moving assembly line.

January 20

The Adventures of Tintin, a comic created by Hergé, debuts in the children's supplement of a Belgian newspaper. The first series, "Tintin in the Land of Soviets," is immediately successful.

February 14

Al Capone's gang executes several members of a rival mob on Chicago's North Side in what comes to be known as the Saint Valentine's Day Massacre.

May 16

The first Academy Awards ceremony takes place at the Hollywood Roosevelt Hotel in Los Angeles. It lasts only fifteen minutes.

May 20

The Barcelona Chair, designed by Ludwig Mies van der Rohe, debuts at the German Pavilion of the International Exposition in Barcelona.

June 27

Bell Telephone Laboratories holds the first public demonstration of color television, in New York City. A bouquet of roses and an American flag are among the first images broadcast.

August 8

The *Graf Zeppelin* begins its round-the-world flight from Lakehurst, New Jersey. Over the course of twenty-one days, the hydrogen-filled airship travels 20,651 miles (33,234 kilometers) and stops in several international cities.

October 24–29

Stock prices plummet in the Wall Street crash, causing widespread panic. The crisis marks the end of the Roaring Twenties and the beginning of the decade-long Great Depression.

November 7

The Museum of Modern Art, which consists of six rented rooms on the twelfth floor of the Heckscher Building in Manhattan, opens to the public.

1929

1.
The first Tintin cartoon debuts in Belgium.

2.
Victims of the Saint Valentine's Day Massacre in a Chicago garage.

3.
The Barcelona Chair, designed by Ludwig Mies van der Rohe.

4.
A woman sits at the scanning end of a color television system while her image is received at the opposite end of the machine.

5.
The *Graf Zeppelin* flies above curious onlookers.

6.
Front page of a newspaper dated October 30, 1929, announcing panic after the stock market crash.

7.
A postcard of the Plaza Hotel includes the Heckscher Building at left, site of MoMA's first galleries.

January 31
President Harry Truman orders development of the hydrogen bomb following the Soviet Union's detonation of the first nuclear bomb in 1949. Albert Einstein delivers a speech in response, warning the public of the dangers of nuclear war and the threat of mutual destruction.

February 8
Frank McNamara, Ralph Schneider, and Matty Simmons, founders of the Diners Club credit-card company, make the first credit-card charge, at Major's Cabin Grill in New York City.

February 9
During a speech to the Republican Women's Club in West Virginia, Senator Joseph McCarthy warns of "enemies from within" and accuses the U.S. Department of State of employing 205 known Communists.

February 19
Seventeen Modern American Painters: The School of New York opens at the Yale University Art Gallery. In his preface to the exhibition catalogue, Robert Motherwell introduces the term "School of New York."

April 27
The first Group Areas Act is passed in South Africa, making apartheid a lawful form of racial segregation and discrimination.

June 27
Following the North Korean People's Army surprise crossing of the thirty-eighth parallel into South Korea, President Harry Truman orders U.S. military forces to aid in South Korea's defense against the Communist invasion.

October 2
Peanuts, the long-running comic strip by Charles M. Schulz, makes its first appearance, in eight newspapers across America.

October 13
The film *All about Eve* premieres in New York to widespread critical acclaim and goes on to win six Academy Awards, including Best Picture.

1950

1.
Albert Einstein delivers a speech at Princeton University about the perils of nuclear weapons.

2.
Senator Joseph McCarthy speaks about Communist infiltration of the government at a U.S. Congressional hearing.

3.
South Africans protest new laws that restrict their civil rights.

4.
Three American soldiers load a howitzer artillery gun during the Korean War.

5.
The first published *Peanuts* cartoon.

6.
Ann Baxter and Bette Davis, playing Eve Harrington and Margo Channing, in a scene from *All about Eve*.

January 31
Ham the Chimp is rocketed into outer space by the United States. His flight lasts a total of sixteen minutes and thirty-nine seconds.

February 9
The Beatles make their debut at the Cavern Club in Liverpool, England. They develop a massive following and will play 292 shows at the club over the next two and a half years.

April 11
Bob Dylan makes his first professional appearance, at Gerdes Folk City in New York's West Village.

April 12
The USSR sends the first human being into space; Yury Gagarin orbits Earth for two hours. Less than a month later, Alan B. Shepard becomes the first American astronaut in space.

April 17
In an attempt to overthrow Premier Fidel Castro, a group of Cuban exiles launches an invasion of Cuba, with support from the American government. The unsuccessful mission is named after the invaders' landing point, the Bay of Pigs.

May 4
The first Freedom Riders depart from Washington, D.C., with the intent of traveling to New Orleans on public buses. Although a recent law banned segregation on bus and transit facilities along interstate routes, the interracial activists are met with violence on their journey.

August 13
East Germany begins construction of the Berlin Wall. The barrier separates East and West Berlin, with armed guards in towers preventing emigration from one half of the divided city to the other.

October 2
The Art of Assemblage opens at The Museum of Modern Art, focusing on art constructed from found objects and other unconventional materials.

1961

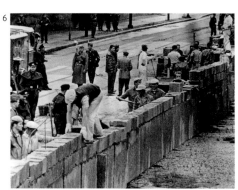

1.
U.S. Air Force personnel examine Ham the Chimp following his successful trip into space.

2.
The Beatles perform at the Cavern Club in Liverpool, England.

3.
A poster promotes a concert series featuring Bob Dylan at Gerdes Folk City in the Village.

4.
Yury Gagarin, the first man to orbit Earth.

5.
Freedom Riders wait to board a bus in Birmingham, Alabama.

6.
Workers lay bricks during construction of the Berlin Wall.

January 1

Soviet Union leader Mikhail Gorbachev introduces a program of economic and political restructuring called Perestroika.

February 13

Michael Jackson, while traveling on his "Bad Tour," purchases Neverland Valley Ranch in California for $17 million.

May 15

Following nine years of military conflict, foreign troops withdraw from Afghanistan, ending the Soviet War.

July

The *Freeze* exhibition, organized by artist Damien Hirst, opens in a warehouse in London. Featuring works by Hirst and fellow students from Goldsmiths College of Art, the show launches the careers of a group quickly labeled "Young British Artists" or "YBAs."

September 26

Salman Rushdie's controversial novel *The Satanic Verses* is published. Nine days later, it is banned by the Indian government, and the Iranian leader Ayatollah Ruhollah Khomeini eventually issues a *fatwa* calling for Rushdie's death.

September 29

After a thirty-two-month hiatus following the *Challenger* disaster, NASA resumes space shuttle flights with the launch of *Discovery*.

October 5

The October Riots begin in Algiers, as thousands protest against the Algerian government, resulting in hundreds of deaths and injuries. Although democratic reform is eventually introduced, the conflict ultimately leads to the Algerian Civil War.

1988

1.
Mikhail Gorbachev and Ronald Reagan talk in Red Square, Moscow.

2.
Michael Jackson performs in East Rutherford, New Jersey, as part of his "Bad Tour."

3.
A convoy of armored vehicles crosses a bridge during the withdrawal of Soviet Army troops from Afghanistan.

4.
A poster by Gran Fury illustrates the anger directed at the U.S. government for its inaction in dealing with the AIDS pandemic.

5.
The space shuttle *Discovery* lifts off from NASA's Kennedy Space Center on Merritt Island, Florida.

6.
A woman walks by rubble left in the aftermath of violent rioting in Algiers.

December 1

The first World AIDS Day is observed in an effort to raise awareness of the pandemic and to mobilize global efforts to stop the spread of HIV.

December 2

Benazir Bhutto is sworn in as prime minister of Pakistan, becoming the first female head of government in an Islamic state.

December 31

Pan Am flight 103, en route to New York from London, is blown up over Lockerbie, Scotland. Although Libyan involvement is strongly suspected, no one is brought to trial until the year 2000.

>> 2013

7.

8.

7.
Benazir Bhutto makes a public appearance in Punjab, Pakistan, during her election campaign.

8.
Policemen overlook the wreckage of Pan Am flight 103 in Lockerbie, Scotland.

1913

Checklist of the Exhibition

Giacomo Balla
(Italian, 1871–1958)

Swifts: Paths of Movement + Dynamic Sequences
1913 (plate 12)
Oil on canvas, 38⅛ × 47¼ in.
(96.8 × 120 cm)
Purchase

Umberto Boccioni
(Italian, 1882–1916)

Unique Forms of Continuity in Space
1913 (cast 1931) (plate 13)
Bronze, 43⅞ × 34⅞ × 15¾ in.
(111.2 × 88.5 × 40 cm)
Acquired through the Lillie P. Bliss Bequest

Sonia Delaunay-Terk
(French, born Russia, 1885–1979)
Blaise Cendrars
(French, born Switzerland, 1887–1961)

La Prose du Transsibérien et de la petite Jehanne de France (Prose of the Trans-Siberian and of the Little Jeanne of France)
1913 (plate 2)
Illustrated book with pochoir, sheet: 6 ft. 9⅝ in. × 14¼ in.
(207.4 × 36.2 cm)
Publisher: Éditions des Hommes Nouveaux, Paris
Printer: unknown
Edition: 150
Purchase

Marcel Duchamp
(American, born France, 1887–1968)

Bicycle Wheel
1951 (third version, after lost original of 1913) (plate 3)
Metal wheel mounted on painted wood stool,
51 × 25 × 16½ in.
(129.5 × 63.5 × 41.9 cm)
The Sidney and Harriet Janis Collection

Juan Gris
(Spanish, 1887–1927)

Grapes
October 1913 (plate 6)
Oil on canvas, 36¼ × 23⅝ in.
(92.1 × 60 cm)
Bequest of Anna Erickson Levene in memory of her husband, Dr. Phoebus Aaron Theodor Levene

Erich Heckel
(German, 1883–1970)

Siblings
1913 (published 1921) (plate 17)
Woodcut, sheet: 24³⁄₁₆ × 18½ in.
(61.4 × 47 cm)
composition (irreg.):
16⁵⁄₁₆ × 12¹⁄₁₆ in. (41.5 × 30.7 cm)
Publisher: J. B. Neumann, Berlin
Printer: Fritz Voigt, Verlin
Edition: 40

Woman Kneeling near a Rock
1913 (published 1921) (plate 16)
Woodcut, sheet (irreg.):
24⅜ × 20³⁄₁₆ in. (61.9 × 51.2 cm)
composition (irreg.):
19³⁄₁₆ × 12⅝ in. (50.3 × 32 cm)
Publisher: J. B. Neumann, Berlin
Printer: Fritz Voigt, Berlin
Edition: 40

Ernst Ludwig Kirchner
(German, 1880–1938)

Street, Berlin
1913 (plate 18)
Oil on canvas, 47½ × 35⅞ in.
(120.6 × 91.1 cm)
Purchase

Oskar Kokoschka
(Austrian, 1886–1980)

Self-Portrait
1913 (plate 19)
Oil on canvas, 32⅛ × 19½ in.
(81.6 × 49.5 cm)
Purchase

Roger de La Fresnaye
(French, 1885–1925)

The Conquest of the Air
1913 (plate 1)
Oil on canvas,
7 ft. 8⅞ in. × 6 ft. 5 in.
(235.9 × 195.6 cm)
Mrs. Simon Guggenheim Fund

Mikhail Larionov
(Russian, 1881–1964)

Rayonist Composition
c. 1912–13 (plate 10)
Oil on cardboard,
20 × 17⅛ in. (50.2 × 43.5 cm)
Gift of Mr. and Mrs. Marvin Sackner

Stanton Macdonald-Wright
(American, 1890–1973)

Still Life Synchromy
1913 (plate 15)
Oil on canvas, 20 × 20 in.
(50.8 × 50.8 cm)
Given anonymously

1929

Kazimir Malevich
(Russian, born Ukraine,
1878–1935)

Samovar
1913 (plate 9)
Oil on canvas, 35 × 24½ in.
(88.5 × 62.2 cm)
The Riklis Collection of
McCrory Corporation

Franz Marc
(German, 1880–1916)

The World Cow
1913 (plate 20)
Oil on canvas, 27⅞ × 55⅝ in.
(70.7 × 141.3 cm)
Gift of Mr. and Mrs. Morton
D. May, and Mr. and
Mrs. Arnold H. Maremont
(both by exchange)

Henri Matisse
(French, 1869–1954)

The Blue Window
Summer 1913 (plate 5)
Oil on canvas, 51½ × 35⅝ in.
(130.8 × 90.5 cm)
Abby Aldrich Rockefeller
Fund

Piet Mondrian
(Dutch, 1872–1944)

*Gemälde no. II / Composition
no. IX / Compositie 5
(Composition in Brown
and Gray)*
1913 (plate 11)
Oil on canvas, 33¾ × 29¾ in.
(85.7 × 75.6 cm)
Purchase

Pablo Picasso
(Spanish, 1881–1973)

Glass, Guitar, and Bottle
Early 1913 (plate 4)
Oil, pasted paper, gesso, and
pencil on canvas, 25¾ × 21⅛ in.
(65.4 × 53.6 cm)
The Sidney and Harriet Janis
Collection

Card Player
Winter 1913–14 (plate 7)
Oil on canvas, 42½ × 35¼ in.
(108 × 89.5 cm)
Acquired through the Lillie P.
Bliss Bequest

Olga Rozanova
(Russian, 1886–1918)

The Factory and the Bridge
1913 (plate 8)
Oil on canvas, 32¾ × 24¼ in.
(83.2 × 61.6 cm)
The Riklis Collection of
McCrory Corporation

Morgan Russell
(American, 1886–1953)

*Creavit Deus Hominem
(Synchromy Number 3:
Color Counterpoint)*
1913 (plate 14)
Oil on canvas, mounted
on cardboard, 11⅞ × 10¼ in.
(30.2 × 26 cm)
Given anonymously

Jean (Hans) Arp
(French, born Germany
[Alsace], 1886–1966)

Two Heads
1929 (plate 25)
Painted wood, 47¼ × 39¼ in.
(120 × 99.7 cm)
Purchase

Jean (Hans) Arp
Walter Cyliax
(German, 1899–1945)

*Kunsthaus Zürich, Abstrakte
und Surrealistische Malerei
und Plastik (Kunsthaus
Zürich, Abstract and Surrealist
Painting and Sculpture)*
1929 (plate 62)
Lithograph, 50½ × 35⅝ in.
(128.3 × 90.5 cm)
Special Purchase Fund

Herbert Bayer
(American, born Austria,
1900–1985)

*DWB Jahresversammlung
(DWB Annual Meeting)*
1929 (plate 60)
Letterpress, 4³⁄₁₆ × 5¹³⁄₁₆ in.
(10.6 × 14.8 cm)
Jan Tschichold Collection,
Gift of Philip Johnson

*Signal, H. Berthold AG Berlin,
Probe Nr. 276*
1929 (plate 58)
Cover: letterpress; interior:
letterpress and offset lithograph,
11¾ × 8⁵⁄₁₆ in. (29.8 × 21.1 cm)
Printer: H. Berthold AG, Berlin
Jan Tschichold Collection,
Gift of Philip Johnson

Francis Bruguière
(American, 1879–1945)

Untitled
c. 1928–29 (plate 36)
Gelatin silver print, 10⅝ × 7⅝ in.
(24.4 × 19.3 cm)
David H. McAlpin Fund

Johannes Canis
(German, 1895–1977)

*Fortschritt-Stuhl
(Progress Chair)*
1928–29 (plate 56)
Letterpress, 9⅞ × 7⅞ in.
(25.1 × 20 cm)
Jan Tschichold Collection,
Gift of Philip Johnson

Henri Cartier-Bresson
(French, 1908–2004)

France
1929 (printed 1986) (plate 35)
Gelatin silver print,
9⁷⁄₁₆ × 12⁹⁄₁₆ in. (24 × 32 cm)
Gift of the photographer

John Collins
(American, 1888–1991)

*Advertisement for
Shur-On Optical Company*
c. 1929 (plate 54)
Gelatin silver print,
7¼ × 9¼ in. (18.5 × 23.4 cm)
Gift of Bernard Leeb

Salvador Dalí
(Spanish, 1904–1989)

Illumined Pleasures
1929 (plate 21)
Oil and collage on composition
board, 9⅜ × 13¾ in.
(23.8 × 34.7 cm)
The Sidney and Harriet Janis
Collection

Walter Dexel
(German, 1890–1973)

Technische Vereinigung Magdeburg (Technical Association of Magdeburg)
1928–29 (plate 59)
Lithograph, 4⅛ × 5¾ in.
(10.5 × 14.6 cm)
Jan Tschichold Collection,
Gift of Philip Johnson

Bauten der Technik: das Licht im Dienste der Werbung, Ausstellung am Adolf-Mittag-See (The Art of Construction: Light in the Service of Advertising, Exhibition at Adolf Mittag Lake)
1929 (plate 42)
Lithograph, 38 × 23½ in.
(96.5 × 59.7 cm)
Printer: W. Pfannkuch & Co.,
Magdeburg
Special Purchase Fund

Die Sport Ausstellung (The Sport Exhibition)
1929 (plate 61)
Photolithograph, 33⅛ × 23½ in.
(84.1 × 59.7 cm)
Printer: W. Pfannkuch & Co.,
Magdeburg
Special Purchase Fund

Kultur Film Bühne, Stadthalle (Culture Film Theater, Stadthalle)
1929 (plate 45)
Letterpress and lineblock,
33¼ × 23⅜ in. (84.5 × 59.4 cm)
Printer: W. Pfannkuch & Co.,
Magdeburg
Special Purchase Fund

Theo van Doesburg
(Christian Emil Marie Küpper;
Dutch, 1883–1931)

Simultaneous Counter-Composition
1929–30 (plate 63)
Oil on canvas, 19½ × 19½ in.
(49.5 × 49.5 cm)
The Riklis Collection of
McCrory Corporation

Simultaneous Counter-Composition
1929–30 (plate 64)
Oil on canvas, 19¾ × 19⅝ in.
(50.1 × 49.8 cm)
The Sidney and Harriet Janis
Collection

Max Ernst
(French, born Germany,
1891–1976)

Birds above the Forest
1929 (plate 26)
Oil on canvas, 31¾ × 25¼ in.
(80.6 × 64.1 cm)
Katherine S. Dreier
Bequest

Walker Evans
(American, 1903–1975)

Third Avenue "L," Light Patterns, New York
1929 (printed 1979 by
Joel Snyder) (plate 40)
Gelatin silver print,
7⅜ × 4¹⁵⁄₁₆ in.
(18.8 × 12.6 cm)
Gift of Joel Snyder

Theodore Lux Feininger
(American, born Germany,
1910–2011)

From the Bauhaus Roof
c. 1929 (plate 38)
Gelatin silver print,
14⅜ × 11⁷⁄₁₆ in.
(36.6 × 29.1 cm)
Gift of Philip Johnson

W. Grancel Fitz
(American, 1894–1963)

Cellophane
1928 or 1929 (plate 37)
Gelatin silver print,
9³⁄₁₆ × 7⁹⁄₁₆ in. (23.3 × 19.3 cm)
John Parkinson III Fund

Alberto Giacometti
(Swiss, 1901–1966)

Gazing Head
1928–29 (plate 22)
Bronze, 15½ × 14½ × 2½ in.
(39.3 × 36.8 × 6.3 cm)
Florene May Schoenborn
Bequest

Florence Henri
(American, 1893–1982)

Windmill Composition, No. 76
c. 1929 (plate 41)
Gelatin silver print,
10¹⁄₁₆ × 14³⁄₁₆ in.
(25.6 × 36.1 cm)
John Parkinson III Fund

Gustav Klutsis
(Latvian, 1895–1938)

Rabotnitsa anglee (The Female Worker of England)
1929 (plate 51)
Letterpress, 8³⁄₁₆ × 11⅜ in.
(20.9 × 28.9 cm)
Jan Tschichold Collection,
Gift of Philip Johnson

El Lissitzky
(Russian, 1890–1941)

Stroitel'stvo Moskvy. Ezhemesiachnyi zhurnal Moskovskogo oblastnogo ispolnitel'nogo komiteta Soveta R., K. i K. deputatov, no. 5 (Building Moscow: Monthly Journal of The Moscow Soviet of Workers, Peasants, and Red Army Deputies, no. 5)
1929 (plate 53)
Illustrated book with photo-mechanical reproductions,
page: 11⅞ × 9¹⁄₁₆ in.
(30.1 × 23 cm);
book: 11⅞ × 9¹⁄₁₆ × ³⁄₁₆ in.
(30.1 × 23 × 0.4 cm)
Publisher: Moskovskii Sovet
Rabochikh Krest'ianskikh
i Krasnoarmeiskikh
Deputatov, Moscow
Printer: unknown
Gift of The Judith Rothschild
Foundation

USSR Russische Ausstellung (Russian Exhibition)
1929 (plate 49)
Gravure, 49⅞ × 35⅝ in.
(126.7 × 90.5 cm)
Purchase

El Lissitzky
Jan Tschichold
(Swiss, born Germany,
1902–1974)

Foto-Auge (Photo-Eye)
1929 (plate 50)
Illustrated book with photo-mechanical reproductions,
page: 11⁹⁄₁₆ × 7⅝ in.
(29.3 × 19.4 cm);
book: 11⅝ × 8¹⁄₁₆ × ½ in.
(29.5 × 20.5 × 1.2 cm)
Publisher: Fritz Wedekind
& Co., Stuttgart
Printer: unknown
Gift of The Judith Rothschild
Foundation

René Magritte
(Belgian, 1898–1967)

The Palace of Curtains, III
1928–29 (plate 23)
Oil on canvas, 32 × 45⅞ in.
(81.2 × 116.4 cm)
The Sidney and Harriet Janis
Collection

Man Ray
(American, 1890–1976)

Place Vendôme
1929 (plate 44)
Gelatin silver print,
11¼ × 9 1/16 in. (28.5 × 23 cm)
Gift of James Thrall Soby

Joan Miró
(Spanish, 1893–1983)

*Portrait of Mistress Mills
in 1750*
Winter–spring 1929 (plate 24)
Oil on canvas, 46 × 35¼ in.
(116.7 × 89.6 cm)
James Thrall Soby Bequest

László Moholy-Nagy
(American, born Hungary,
1895–1946)

Play
c. 1929 (plate 39)
Gelatin silver print,
14⅝ × 10 11/16 in.
(37.1 × 27.1 cm)
Given anonymously

Johannes Molzahn
(German, 1892–1965)

*Wohnung und Werkraum
(Dwelling and Workplace)*
Poster for Deutsche Werkbund
Exhibition in Breslau
1929 (plate 57)
Photolithograph, 23⅝ × 33 in.
(60 × 83.8 cm)
Printer: Druckerei
Schenkalowsky, A.G., Breslau
Purchase

Gerald Murphy
(American, 1888–1964)

Wasp and Pear
1929 (plate 34)
Oil on canvas, 36¾ × 38⅝ in.
(93.3 × 97.9 cm)
Gift of Archibald MacLeish

Georgia O'Keeffe
(American, 1887–1986)

Farmhouse Window and Door
October 1929 (plate 32)
Oil on canvas, 40 × 30 in.
(101.6 × 76.2 cm)
Acquired through the
Richard D. Brixey Bequest

Aleksandr Rodchenko
(Russian, 1891–1956)

*Biznes. Sbornik literaturnogo
tsentra konstruktivistov
(Business: Collection
of the Literary Center of
Constructivists)*
1929 (plate 52)
Illustrated book with 1 photo-
mechanical reproduction,
page: 8⅞ × 5 15/16 in.
(22.5 × 15.1 cm);
book: 8⅞ × 6 × ½ in.
(22.6 × 15.2 × 1.2 cm)
Publisher: Gosudarstvennoe
izdatel'stvo, Moscow
Printer: unknown
Gift of The Judith Rothschild
Foundation

Chauffeur
1929 (plate 55)
Gelatin silver print,
11¾ × 16½ in. (29.8 × 41.8 cm)
Mr. and Mrs. John Spencer
Fund

Park of Culture and Rest
1929–32 (plate 43)
Gelatin silver print,
8 15/16 × 6⅛ in. (22.8 × 15.5 cm)
Gift of the Rodchenko family

Pierre Roy
(French, 1880–1950)

Daylight Savings Time
1929 (plate 27)
Oil on canvas, 21½ × 15 in.
(54.6 × 38.1 cm)
Gift of Mrs. Ray Slater Murphy

Vladimir Stenberg
(Russian, 1899–1982)
Georgii Stenberg
(Russian, 1900–1933)

*Chelovek s Kinoapparatom
(The Man with the Movie
Camera)*
1929 (plate 48)
Lithograph, 39½ × 27¼ in.
(100.5 × 69.2 cm)
Arthur Drexler Fund
and purchase

Alfred Stieglitz
(American, 1864–1946)

Equivalent
1929 (plate 28)
Gelatin silver print, 3⅝ × 4⅝ in.
(9.2 × 11.8 cm)
Alfred Stieglitz Collection.
Gift of Georgia O'Keeffe

Equivalent
1929 (plate 29)
Gelatin silver print,
4 11/16 × 3 11/16 in. (11.9 × 9.3 cm)
Alfred Stieglitz Collection.
Gift of Georgia O'Keeffe

Equivalent
1929 (plate 30)
Gelatin silver print,
4 11/16 × 3⅝ in. (11.9 × 9.2 cm)
Alfred Stieglitz Collection.
Gift of Georgia O'Keeffe

Equivalent
1929 (plate 31)
Gelatin silver print,
4 11/16 × 3 11/16 in. (11.9 × 9.3 cm)
Alfred Stieglitz Collection.
Gift of Georgia O'Keeffe

Helen Torr
(American, 1886–1967)

Basket of Vegetables
1928–29 (plate 33)
Charcoal on paper, 14 × 18⅛ in.
(35.6 × 45.8 cm)
Gift of Alice C. Simkins
in memory of Alice Nicholson
Hanszen

Unknown
(German)

*"FILM UND FOTO"
(International Exhibition of
the German Industrial
Confederation, Stuttgart 1929)*
1929 (plate 46)
Offset lithograph, 33 × 23⅛ in.
(84 × 58.5 cm)
Gift of The Lauder Foundation,
Leonard and Evelyn Lauder
Fund

Dziga Vertov
(Russian, 1895–1954)

*Chelovek s Kinoapparatom
(The Man with the Movie
Camera)*
1929 (plate 47)
35mm film, transferred to
DVD, black and white, silent,
65 minutes (approx.)
Gosfilmofond (by exchange)

1950

Otl Aicher
(also known as Otto Aicher;
German, 1922–1991)

*Kurs freitags: Physik des
Alltags (Friday Lecture:
Physics of Everyday Life)*
1949–51 (plate 84)
Photolithograph,
16¼ × 16¼ in. (41.3 × 41.3 cm)
Gift of the artist

*Musik des Barock
(Baroque Music)*
1949–51 (plate 89)
Photolithograph,
16¼ × 16⁵⁄₁₆ in. (41.3 × 41.4 cm)
Gift of the artist

*Der europäische Familienzwist:
Kurs montags (The European
Family Quarrel: Monday
Lecture)*
c. 1950 (plate 90)
Photolithograph,
16 × 16 in. (40.6 × 40.6 cm)
Gift of the artist

Jazz
c. 1950 (plate 85)
Photolithograph,
16 × 16¼ in. (40.6 × 41.3 cm)
Gift of the artist

*Kurs freitags: Vom Rundfunk
zur Funknachrichtentechnik
(Friday Lecture: From Broadcast
to Radio Communications
Technology)*
c. 1950 (plate 87)
Photolithograph, 16¼ × 16 in.
(41.2 × 40.6 cm)
Gift of the artist

*Kurs montags: Geologie unserer
Heimat (Monday Lecture:
Geology of Our Homeland)*
c. 1950 (plate 82)
Photolithograph,
16 × 16 in. (40.6 × 40.6 cm)
Gift of the artist

*Massenmensch und
Persönlichkeit: Kurs dienstags
(Mass Society and Personality:
Tuesday Lecture)*
c. 1950 (plate 88)
Photolithograph,
16¼ × 15⅞ in. (41.3 × 40.2 cm)
Gift of the artist

*Rosen und Orchideen,
Vortrag 17. Dez. (Roses and
Orchids, Lecture Dec. 17)*
c. 1950 (plate 83)
Photolithograph,
16¼ × 16⅛ in. (41.3 × 40.9 cm)
Printer: F. Walcher
Gift of the artist

*Vortrag über Sartres
"Das Sein und das Nichts"
(Lecture on Sartre's
"Being and Nothingness")*
c. 1950 (plate 86)
Photolithograph, 16¼ × 16 in.
(41.4 × 40.8 cm)
Gift of the artist

Louise Bourgeois
(American, born France,
1911–2010)

Quarantania, III
1949–50 (cast 2001) (plate 77)
Bronze
58¼ × 12¾ × 2 in.
(148 × 32.4 × 5.1 cm)
Gift of the artist

Jean Dubuffet
(French, 1901–1985)

*Corps de Dame
(Body of a Lady)*
June–December 1950 (plate 72)
Ink on paper, 10¾ × 8⅜ in.
(27.2 × 21.3 cm)
The Joan and Lester Avnet
Collection

*Corps de Dame
(Body of a Lady)*
June–December 1950 (plate 73)
Ink on paper, 10⅝ × 8⅜ in.
(27 × 21.3 cm)
The Joan and Lester Avnet
Collection

*Corps de Dame
(Body of a Lady)*
June–December 1950 (plate 74)
Ink on paper, 12¾ × 9⅞ in.
(32.3 × 24.9 cm)
The Joan and Lester Avnet
Collection

The Jewish Woman
October 1950 (plate 75)
Oil on canvas, 45¾ × 35 in.
(116.2 × 88.7 cm)
Gift of Pierre Matisse

Alberto Giacometti
(Swiss, 1901–1966)

The Chariot
1950 (plate 76)
Painted bronze on wood base,
57 × 26 × 26⅛ in.
(144.8 × 65.8 × 66.2 cm);
base: 9¾ × 4½ × 9¼ in.
(24.8 × 11.5 × 23.5 cm)
Purchase

Philip Guston
(American, born Canada,
1913–1980)

Loft 1
1950 (plate 80)
Ink on paper, 17 × 22 in.
(43.2 × 55.9 cm)
Gift of Edward R. Broida

Red Painting
1950 (plate 70)
Oil on canvas, 34⅛ × 62¼ in.
(86.4 × 158.1 cm)
Bequest of the artist

Ellsworth Kelly
(American, born 1923)

*Automatic Drawing:
Pine Branches VI*
1950 (plate 79)
Pencil on paper, 16½ × 20¼ in.
(41.9 × 51.4 cm)
Gift of the artist

Study for "La Combe II"
1950 (plate 81)
Ink and pencil on paper,
25½ × 31½ in. (64.8 × 80 cm)
Purchased with funds
given by Jo Carole and
Ronald S. Lauder

Franz Kline
(American, 1910–1962)

Chief
1950 (plate 65)
Oil on canvas,
58⅜ in. × 6 ft. 1½ in.
(148.3 × 186.7 cm)
Gift of Mr. and Mrs. David M.
Solinger

Willem de Kooning
(American, born
the Netherlands, 1904–1997)

Woman, I
1950–52 (plate 71)
Oil on canvas,
6 ft. 3⅞ in. × 58 in.
(192.7 × 147.3 cm)
Purchase

Jackson Pollock
(American, 1912–1956)

Number 7, 1950
1950 (plate 68)
Oil, enamel, and
aluminum paint on canvas,
23¹⁄₁₆ in. × 8 ft. 9¾ in.
(58.5 × 268.6 cm)
Gift of Sylvia Slifka in
honor of William Rubin

1961

Ad Reinhardt
(American, 1913–1967)

Number 107
1950 (plate 66)
Oil on canvas, 6 ft. 8 in. × 36 in.
(203.2 × 91.4 cm)
Given anonymously

Mark Rothko
(American, born Russia
[now Latvia], 1903–1970)

No. 10
1950 (plate 67)
Oil on canvas,
7 ft. 6⅜ in. × 57⅛ in.
(229.6 × 145.1 cm)
Gift of Philip Johnson

David Smith
(American, 1906–1965)

Twenty-Four Greek Y's
1950 (plate 78)
Painted steel, 42¾ × 29⅛ × 6 in.
(108.6 × 73.9 × 15.2 cm)
Blanchette Hooker Rockefeller
Fund

Bradley Walker Tomlin
(American, 1899–1953)

*Number 9: In Praise
of Gertrude Stein*
1950 (plate 69)
Oil on canvas,
49 in. × 8 ft. 6¼ in.
(124.5 × 259.8 cm)
Gift of Blanchette Hooker
Rockefeller

Lee Bontecou
(American, born 1931)

Untitled
1961 (plate 112)
Welded steel, canvas,
black fabric, rawhide,
copper wire, and soot,
6 ft. 8¼ in. × 7 ft. 5 in. × 34¾ in.
(203.6 × 226 × 88 cm)
Kay Sage Tanguy Fund

George Brecht
(American, 1926–2008)

Keyhole
c. 1961 (plate 122)
Ink on paper in artist's
frame and metal escutcheon
mounted on wood, overall
(frame): 6 11/16 × 5 9/16 × 13/16 in.
(17 × 14.2 × 2.1 cm),
overall (wood with metal
escutcheon): 4¾ × 3⅝ × 13/16 in.
(12 × 9.2 × 2.1 cm)
The Gilbert and Lila Silverman
Fluxus Collection Gift

Exit
1961 (object realized c. 1962–63)
(plate 123)
Metal sign mounted on painted
wood, 3 9/16 × 11⅛ × ⅞ in.
(9 × 28.2 × 2.2 cm)
The Gilbert and Lila Silverman
Fluxus Collection Gift

Water Yam
1963 (actions on selected cards
from 1961) (plate 121)
Cardboard box with offset label,
containing 69 offset cards,
overall (box): 5⅞ × 6 5/16 × 1¾ in.
(15 × 16 × 4.5 cm)
The Gilbert and Lila Silverman
Fluxus Collection Gift

Harry Callahan
(American, 1912–1999)

Chicago
1961 (plate 131)
Gelatin silver print,
15¾ × 10¼ in. (40 × 26 cm)
Purchase

Chicago
1961 (plate 132)
Gelatin silver print,
15 11/16 × 10 5/16 in. (39.8 × 26.2 cm)
Gift of Susan and Peter
MacGill

César
(French, 1921–1998)

The Yellow Buick
1961 (plate 117)
Compressed automobile,
59½ × 30¾ × 24⅞ in.
(151.1 × 77.7 × 63.5 cm)
Gift of Mr. and Mrs. John
Rewald

Christo
(Christo Javacheff; American,
born Bulgaria, 1935)

Package 1961
1961 (plate 111)
Fabrics and ropes on wood,
33 × 52 × 8 in.
(83.8 × 132.1 × 20.3 cm)
Gift of Christo and Jeanne-
Claude in honor of
Agnes Gund

Jim Dine
(American, born 1935)

Six White Rainbows
1961 (plate 100)
Oil on canvas, 6 panels,
overall: 6 ft. ½ in. × 40½ in.
(184.1 × 102.7 cm)
Mary Sisler Bequest

*These Are Ten Useful Objects
Which No One Should Be
Without When Traveling*
1961 (plates 101–10)
Portfolio of 10 drypoints with
gouache additions, various
plate dimensions; sheet (each):
12 15/16 × 10 1/16 in. (32.9 × 25.6 cm)
Publisher: unknown
Printer: Pratt Graphics Center,
New York
Edition: 6
John B. Turner Fund

Dan Drasin
(American, born 1942)

Sunday
1961 (plate 130)
35mm film, transferred to DVD,
black and white, sound,
17 minutes
Courtesy New Yorker Films
and Dan Drasin

Lee Friedlander
(American, born 1934)

Philadelphia, Pennsylvania
1961 (plate 137)
Gelatin silver print,
8 11/16 × 13 1/16 in. (22 × 33.1 cm)
Purchase

Richard Hamilton
(British, 1922–2011)

Glorious Techniculture
1961–64 (plate 94)
Oil and collage on panel,
48⅜ × 48⅜ in. (122.9 × 122.9 cm)
Enid A. Haupt Fund and
The Sidney and Harriet Janis
Collection (by exchange)

Dick Higgins
(American, born England,
1938–1998)

Graphis 89, for a Drama
1961 (plate 124)
Ink on paper, 13⅞ × 16¾ in.
(35.2 × 42.5 cm)
The Gilbert and Lila Silverman
Fluxus Collection Gift

Dennis Hopper
(American, 1936–2010)

Double Standard
1961 (plate 138)
Gelatin silver print,
16 × 23¹³⁄₁₆ in. (40.7 × 60.5 cm)
Samuel J. Wagstaff, Jr. Fund

Jasper Johns
(American, born 1930)

Painting Bitten by a Man
1961 (plate 114)
Encaustic on canvas mounted
on type plate, 9½ × 6⅞ in.
(24.1 × 17.5 cm)
Gift of Jasper Johns in memory
of Kirk Varnedoe, Chief Curator
of the Department of Painting
and Sculpture, 1989–2001

Donald Judd
(American, 1928–1994)

Relief
1961 (plate 113)
Oil on board and wood,
with tinned-steel baking pan,
48⅛ × 36⅛ × 4 in.
(122.2 × 91.8 × 10.2 cm)
Gift of Barbara Rose

Simpson Kalisher
(American, born 1926)

Untitled
1961 (plate 135)
Gelatin silver print,
8⅞ × 13½ in. (22.6 × 34.3 cm)
Purchase

Untitled
1961 (plate 136)
Gelatin silver print,
9³⁄₁₆ × 13⁷⁄₁₆ in. (23.3 × 34.1 cm)
Purchase

Yves Klein
(French, 1928–1962)

Blue Monochrome
1961 (plate 118)
Dry pigment in synthetic
polymer medium on cotton over
plywood, 6 ft. 4⅞ in. × 55⅛ in.
(195.1 × 140 cm)
The Sidney and Harriet Janis
Collection

Roy Lichtenstein
(American, 1923–1997)

Girl with Ball
1961 (plate 93)
Oil on canvas, 60¼ × 36¼ in.
(153 × 91.9 cm)
Gift of Philip Johnson

Jackson Mac Low
(American, 1922–2004)

Drawing-Asymmetries,
nos. 5, 7, 10, 21
1961 (plates 125–28)
Ink on paper (no. 5, ink and
colored ink on paper),
sheet (each): 8⁹⁄₁₆ × 11⅞ in.
(21.7 × 30.2 cm)

Kenneth Noland
(American, 1924–2010)

Turnsole
1961 (plate 120)
Synthetic polymer paint
on canvas, 7 ft. 10⅛ in. ×
7 ft. 10⅛ in. (239 × 239 cm)
Blanchette Hooker
Rockefeller Fund

Claes Oldenburg
(American, born Sweden,
1929)

Pastry Case
1961 (plate 96)
Painted plaster sculptures
in glass-and-metal case,
14½ × 10¼ × 10⅝ in.
(37 × 26 × 26.9 cm)
Mary Sisler Bequest

*Store Poster, Torn Out
Letters Newspaper Pie Cup
Cakes and Hot Dog*
1961 (plate 97)
Cut-and-pasted paper and
printed paper, watercolor,
and crayon on paper
20 × 26 in. (50.8 × 66.1 cm)
Purchased with funds
provided by Marie-Josée
and Henry R. Kravis

The Store
1961 (plate 98)
Letterpress poster, composition:
26⁹⁄₁₆ × 20⁵⁄₁₆ in. (67.4 × 51.6 cm);
sheet: 28¼ × 22¹⁄₁₆ in.
(71.8 × 56 cm)
Publisher: the artist in
cooperation with Green Gallery,
New York
Printer: Manhattan Press,
New York
Edition: unknown
Mary Ellen Meehan Fund

Robert Rauschenberg
(American, 1925–2008)

First Landing Jump
1961 (plate 91)
Cloth, metal, leather, electric
fixture, cable, and oil paint on
composition board, with auto-
mobile tire and wood plank,
7 ft. 5⅛ in. × 6 ft. 8⅞ in.
(226.3 × 182.8 × 22.5 cm)
Gift of Philip Johnson

Robert Ryman
(American, born 1930)

Untitled
1961 (plate 115)
Oil on unstretched linen,
10¾ × 10¼ in. (27.3 × 26 cm)
Mrs. Frank Y. Larkin and
Mr. and Mrs. Gerrit Lansing
Funds

Lucas Samaras
(American, born Greece, 1936)

Untitled
1960–61 (plate 116)
Wood panel with plaster-covered
feathers, nails, screws, nuts,
pins, razor blades, flashlight
bulbs, buttons, bullets, and
aluminum foil, 23 × 19 × 4 in.
(59 × 48.2 × 10.2 cm)
Larry Aldrich Foundation
Fund

Wayne Thiebaud
(American, born 1920)

Cut Meringues
1961 (plate 99)
Oil on canvas, 16 × 20 in.
(40.6 × 50.6 cm)
Larry Aldrich Foundation
Fund

Cy Twombly
(American, 1928–2011)

The Italians
January 1961 (plate 119)
Oil, pencil, and crayon on
canvas, 6 ft. 6⅝ in. × 8 ft. 6¼ in.
(199.5 × 259.6 cm)
Blanchette Hooker
Rockefeller Fund

1988

Andy Warhol
(American, 1928–1987)

Water Heater
1961 (plate 95)
Casein on canvas, 44¾ × 40 in.
(113.6 × 101.5 cm)
Gift of Roy Lichtenstein

Robert Watts
(American, 1923–1988)

Mechanical for artist's self-
published *Safepost/K.U.K.
Feldpost/Jockpost* postage stamps
1961 (plate 129)
15 cut-and-pasted gelatin
silverprints in artist's frame,
overall (frame): 15 ⅛₆ × 21 ⅛₆ × ⅜ in.
(38.3 × 53.5 × 1 cm)
The Gilbert and Lila Silverman
Fluxus Collection Gift

Tom Wesselmann
(American, 1931–2004)

Great American Nude, 2
1961 (plate 92)
Synthetic polymer paint,
gesso, charcoal, enamel, oil,
and collage on plywood,
59⅝ × 47½ in. (151.5 × 120.5 cm)
Larry Aldrich Foundation
Fund

Garry Winogrand
(American, 1928–1984)

Untitled
1961 (plate 133)
Gelatin silver print,
9 ⅛₆ × 13 ⅞₆ in. (23.1 × 34.1 cm)
Purchase and gift of
Barbara Schwartz in memory
of Eugene M. Schwartz

Untitled
1961 (plate 134)
Gelatin silver print,
8¾ × 13 ⁵⁄₁₆ in. (22.3 × 33.9 cm)
Purchase and gift of
Barbara Schwartz in memory
of Eugene M. Schwartz

Ashley Bickerton
(British, born 1959)

*Tormented Self-Portrait
(Susie at Arles)*
1987–88 (plate 151)
Synthetic polymer paint,
bronze powder and lacquer
on wood, anodized aluminum,
rubber, plastic, Formica,
leather, chrome-plated steel,
and canvas, 7 ft. 5⅜ in. ×
68¾ in. × 15¾ in.
(227.1 × 174.5 × 40 cm)
Purchase

Melvin Edwards
(American, born 1937)

Cup of?, from the Lynch
Fragment series
1988 (plate 149)
Welded steel, 12⅞ × 6¾ × 9½ in.
(32.7 × 17 × 24 cm)
Purchase

Sekuru Knows, from the
Lynch Fragment series
1988 (plate 150)
Welded steel, 14⅞ × 11 × 7¼ in.
(37.9 × 28 × 18.3 cm)
Purchase

Adam Fuss
(British, born 1961)

Untitled
1988 (plate 147)
Gelatin silver print,
54⅞ × 49 ⅛₆ in.
(139.4 × 124.6 cm)
Polaroid Foundation
Fund

General Idea
(Canadian artist group,
active 1969–1994)

AIDS (Wallpaper)
1988 (plate 154)
Screenprinted wallpaper,
dimensions vary upon
installation
Publisher: the artists
Edition: 3
Gift of Richard Gerrig and
Timothy Peterson in
celebration of the Museum's
reopening

Peter Halley
(American, born 1953)

Final Attributes
1988–90 (plate 153)
Screenprint, composition:
21 ⁵⁄₁₆ × 24½ in. (54.1 × 62.2 cm);
sheet: 30 ¹¹⁄₁₆ × 38 ⁹⁄₁₆ in.
(78 × 98 cm)
Publisher: The Spring Street
Workshop, New York
Publisher: Edition Schellmann,
Munich
Printer: Studio Heinrici Ltd.,
New York
Edition: 50
John B. Turner Fund

Mona Hatoum
(British, of Palestinian origin,
born Lebanon, 1952)

Measures of Distance
1988 (plate 145)
Video, color, sound,
15 minutes, 26 seconds
Purchase

Jenny Holzer
(American, born 1950)

*LAMENTS: THE NEW
DISEASE CAME…*
1988–89 (plate 142)
Ink transfer and pencil
on transparentized paper
in artist's frame, frame:
7 ft. 1½ in. × 33⅛ in. × 1¼ in.
(216.2 × 84.1 × 3.2 cm)
Purchase

*LAMENTS: THE KNIFE
CUT RUNS AS LONG…*
1988–89 (plate 143)
Ink transfer and pencil
on transparentized paper
in artist's frame, frame:
7 ft. × 32⅛ in. × 1¼ in.
(213.4 × 81.6 × 3.2 cm)
The Judith Rothschild
Foundation Contemporary
Drawings Collection Gift

Jeff Koons
(American, born 1955)

Pink Panther
1988 (plate 152)
Porcelain, 41 × 20½ × 19 in.
(104.1 × 52 × 48.2 cm)
Gift of Werner and Elaine
Dannheisser

Glenn Ligon
(American, born 1960)

*Untitled (There is a
consciousness we all have…)*
1988 (plate 144)
Synthetic polymer paint and
pencil on 2 sheets of paper,
30 × 44¾ in. (76.2 × 111.1 cm)
Gift of Jan Christiaan Braun
in honor of Agnes Gund

Brice Marden

(American, born 1938)

Couplet IV
1988–89 (plate 146)
Oil on linen, 9 ft. × 60 in.
(274.3 × 152.4 cm)
Fractional and promised
gift of Kathy and Richard S.
Fuld, Jr.

Allan McCollum

(American, born 1944)

*Collection of Thirty
Drawings (No. 14)*
1988 / 1990 (plate 141)
Pencil on board in artist's
frame, overall: 39⅜ in. × 11 ft.
(100 × 335.3 cm)
Purchase

Annette Messager

(French, born 1943)

My Vows
1988–91 (plate 139)
Photographs, colored graphite
on paper, string, black tape, and
pushpins over black paper or
black synthetic polymer paint,
overall: 11 ft. 8¼ in. × 6 ft. 6¾ in.
(356.2 × 200 cm) (approx.)
Gift of The Norton Family
Foundation

Allen Ruppersberg

(American, born 1944)

Preview
1988 (plates 155–64)
Series of 10 lithographs,
composition (each):
21⁵⁄₁₆ × 13³⁄₁₆ in. (54.1 × 33.5 cm);
sheet (each): 22¹⁄₁₆ × 13¹³⁄₁₆ in.
(56 × 35.1 cm)
Publisher and printer:
Landfall Press, Inc., Chicago
Edition: 30
John B. Turner Fund

Kiki Smith

(American, born
Germany, 1954)

All Souls
1988 (plate 140)
Screenprint on 36 attached
sheets of handmade Thai
paper, composition and sheet,
overall: 71¼ in. × 15 ft. 1⅛ in.
(181 × 460 cm)
Publisher: unpublished
Printer: the artist, New York
Riva Castleman Endowment
Fund

David Wojnarowicz

(American, 1954–1992)

Weight of the Earth, Part I
1988 (plate 148)
14 gelatin silver prints,
overall: 39 × 41¼ in.
(99.1 × 104.8 cm)
The Family of Man Fund

Aaron Curry

(American, born 1972)

Deadhead
2012
Painted steel, 11 ft. 5 in. ×
13 ft. 8¾ in. × 6 ft. 9¼ in.
Courtesy of the artist and
Michael Werner Gallery,
New York

Thing
2012
Painted steel,
9 ft. 11 in. × 6 ft. 3 in. × 40½ in.
Courtesy of the artist and
Michael Werner Gallery,
New York

Boo
2012 (plate 168)
Painted steel,
17 ft. 9½ in. × 47¾ in. × 40½ in.
Courtesy of the artist and David
Kordansky Gallery, Los Angeles

Katharina Grosse

(German, born 1961)

Untitled
2011
Acrylic on fiberglass,
11 ft. 6 in. × 22½ in. × 4⅜ in.
(350 × 570 × 11 cm)
Courtesy of Gallery Mark Müller,
Zurich, and Galerie nächst St.
Stephan/Rosemarie
Schwarzwälder, Vienna

Untitled
2011
Acrylic on canvas,
6 ft. 7¼ in. × 53⅛ in.
(201.3 × 134.9 cm)
Courtesy of Galerie nächst
St. Stephan/Rosemarie
Schwarzwälder, Vienna

Untitled
2011
Acrylic on canvas,
7 ft. ¼ in. × 57⅞ in.
(214 × 147 cm)
Courtesy of Galerie nächst
St. Stephan/Rosemarie
Schwarzwälder, Vienna

Sarah Sze

(American, born 1969)

Untitled
2012
Mixed mediums,
dimensions variable
Courtesy of the artist and
Tanya Bonakdar Gallery,
New York

Acknowledgments

JODI HAUPTMAN

Curator, Department of Drawings,
The Museum of Modern Art

The partnership between The Museum of Modern Art and the High Museum of Art has deepened in preparation for this exhibition, and I remain grateful to the individuals in both New York and Atlanta who have continued to work unflaggingly to ensure the ongoing success of this multi-exhibition project. The collaborative spirit of our institutions' directors—Glenn D. Lowry of The Museum of Modern Art and Michael E. Shapiro, Nancy and Holcombe T. Green, Jr., Director of the High Museum of Art—has informed this chapter in an already voluminous history between our two museums. Their objectives both for the project as a whole and for this installment have been shepherded into being by their senior staffs: Ramona Bronkar Bannayan, Senior Deputy Director for Exhibitions, Collections, and Programs at MoMA, and at the High, David Brenneman, Director of Collections and Exhibitions and Frances B. Bunzl Family Curator of European Art, and Jody Cohen, Senior Manager of Exhibitions and Special Initiatives.

The multifaceted nature of such a partnership relies on the keen organizational skills and good judgment of a team of colleagues. At MoMA, I deeply appreciate the efforts of Maria DeMarco Beardsley, Coordinator, Exhibition Program; Patty Lipshutz, General Counsel; Nancy Adelson, Deputy General Counsel; Peter Reed, Senior Deputy Director for Curatorial Affairs; James Gara, Chief Operating Officer; Jan Postma, Chief Financial Officer; Diana Pulling, Chief of Staff; and, at the High, of Philip Verre, Chief Operating Officer; Rhonda Matheison, Chief Financial Officer; Amy Simon, Manager of Exhibitions; Laurie Kind, Images and Rights Coordinator; Elizabeth Riccardi, Assistant to the Director of Collections and Exhibitions; Toni Pentecouteau, Executive Assistant to the Director; and Leslie Petsoff, Assistant to the Chief Operating Officer.

In order to show the breadth of artistic activity that occurred during each of *Fast Forward*'s key moments, I have depended on my colleagues in every one of the Museum's

curatorial departments. MoMA colleagues who have shared their deep knowledge of our collections and generously lent to the exhibition include: in the Department of Painting and Sculpture, Ann Temkin, The Marie-Josée and Henry Kravis Chief Curator; Anne Umland, Curator; Cora Rosevear, Associate Curator; Lilian Tone, Assistant Curator; Lily Goldberg, Loan Assistant; Cara Manes, Collection Specialist; in the Department of Prints and Illustrated Books: Christophe Cherix, The Abby Aldrich Rockefeller Chief Curator of Prints and Illustrated Books; Deborah Wye, Chief Curator Emeritus; Starr Figura, Associate Curator; Sarah Suzuki, Associate Curator; Gretchen Wagner, The Sue and Eugene Mercy, Jr. Assistant Curator; Katherine Alcauskas, Collection Specialist; Jeff White, Preparator; in the Department of Photography: Sarah Meister, Curator; Dan Leers, former Beaumont and Nancy Newhall Curatorial Fellow; Tasha Lutek, Cataloguer; Marley Lewis, Research Assistant; in the Department of Film: Rajendra Roy, Chief Curator; Anne Morra, Associate Curator; Kitty Cleary, Circulating Film Library; in the Department of Architecture and Design: Barry Bergdoll, The Philip Johnson Chief Curator; Juliet Kinchin, Curator; Aidan O'Connor, Curatorial Assistant; Paul Galloway, Cataloguer; Pamela Popeson, Preparator; in the Department of Media and Performance Art: Sabine Breitweiser, Chief Curator, and Erica Papernik, Assistant Curator. My colleagues in the Department of Drawings — Connie Butler, The Robert Lehman Foundation Chief Curator; Luis Pérez-Oramas, Estrellita Brodsky Curator of Latin American Art; Christian Rattemeyer, Associate Curator; Kathleen Curry, Assistant Curator; Esther Adler, Assistant Curator; Geaninne Gutiérrez Guimarães, Curatorial Assistant; Ingrid Langston, Curatorial Assistant; Beatriz Olivetti, Curatorial Assistant; David Moreno, Preparator; John Prochilo, Department Manager; and Karen Grimson, Department Assistant — deserve special thanks for contributing daily support and thoughtful input as well as important loans.

For helping relay this rich material to our visitors, whether in the galleries or on the Web, educators at both museums deserve our thanks: at the High, Patricia Rodewald,

Eleanor McDonald Storza Director of Education; Julia Forbes, Shannon Landing Amos Head of Museum Interpretation; Virginia Shearer, Associate Chair of Public Programs; Erin Dougherty, Manager of Family Programs and New Audience Initiatives; Lisa Hooten, Head of School Programs; and Nicole Cromartie, Coordinator of Museum Interpretation; and at MoMA, Wendy Woon, The Edward John Noble Foundation Deputy Director for Education; Sara Bodinson, Director, Interpretation and Research; and Stephanie Pau, Associate Educator.

Our communications teams have conveyed this exhibition's complex subject matter to the press and the public with clarity and style. We are grateful to: Susan Clark, Director of Marketing and Communications; and Jennifer Bahus, Senior Manager of Advertising and Promotions, both at the High; and Kim Mitchell, Chief Communications Officer, and Margaret Doyle, Director of Communications, at MoMA. For building new museum memberships around this project, thanks are also due to Meagan Johnson, Director of Membership at MoMA, and Catherine Fink, Senior Manager of Membership and Guest Relations; Jennifer McNally, Member and Guest Relations Manager; and Jodi O'Gara, Manager of Group Sales, all of the High.

We extend appreciation to the development and finance teams who have secured the funding and sponsorships that make such a large-scale endeavor possible: Michael Margitich, Senior Deputy Director, External Affairs; Lisa Mantone, former Director of Development; and Hallie Hobson, Associate Director of Development at MoMA, and Kimberly Watson, Director of Advancement; Woodie Wisebram, Senior Development Manager; and Ruth Richardson, Manager of Individual Support, at the High.

I have been exceedingly lucky to rely once again on Jerome Neuner, Director, Exhibition Design and Production at MoMA, for his always-imaginative solutions in presenting these unparalleled objects. His installation concepts were realized elegantly by Jim Waters, Exhibition Designer at the High. Contributing extensively to the project's overall look were Angela Jaeger, Senior Manager

of Creative Services, and Ewan Green, Graphic Designer, both at the High.

The considerable task of mobilizing almost 160 works was managed smoothly and efficiently by our Registration Departments. At MoMA, Rob Jung, Manager; Sarah Wood, Assistant Manager; Steve West, Assistant Manager; Brandi Pomfret-Joseph, Senior Registrar Assistant; and Liz Desjardins, Registrar Assistant, arranged for us to view many of these objects in storage. Kathy Hill, Registrar, Collections, organized the cross-country shipment of these masterpieces with professionalism and care. Stefanii Ruta-Atkins, Head Registrar; Cheryl Miller, Associate Registrar, Collections; and Jennifer Schauer, Department Coordinator, also lent their expertise. Peter Perez, Foreman, Frame Shop, ensured that each work looked its very best. And Jeri Moxley, Manager, Collection and Exhibition Technologies, facilitated fluid transmission of checklists and data between the two museums. At the High, Frances Francis, Senior Registrar; Rebecca Parker, Associate Registrar, Exhibitions; Brian Kelly, Chief Preparator; Gene Clifton, Senior Preparator, Fabrication; and Cayse Cheatham, Edward Hill, Justin McNeight, and Caroline Prinzivalli, Preparators, all made sure that the works were safely received and beautifully installed in Atlanta, as did the High's Kevin Streiter, Manager of Facilities and Logistics, and Al Holland, Chief of Security.

The tremendous skill and thoughtfulness of our conservators allowed us to send these works to Atlanta with confidence. Anny Aviram, Conservator, led the way, while James Coddington, Chief Conservator; Karl Buchberg, Senior Conservator; Lynda Zycherman, Sculpture Conservator; Scott Gerson, Associate Conservator; Brenna Campbell, Mellon Fellow; and Cindy Albertson, Kress Fellow, all provided insight and hands-on attention.

The research efforts required by a project of this scale are both expansive and specific, and I have relied on Milan Hughston, Chief of Library and Museum Archives, and his entire staff, especially Jennifer Tobias, Librarian, for their invaluable assistance. I have also been fortunate to count on interns Emma Sokoloff, Rebecca Wolff, and

Diana Sibbald for excellent research files. Sarah Zabrodski, who joined the project as an intern, became a key member of our team as a Research Assistant; I profoundly appreciate the calm thoroughness with which she secured myriad rights and references, and the creativity and concision with which she composed this book's time line.

An important facet of this collaboration was the exchange between Kathy Thornton-Bias, President, and Brian Bergeron, Assistant Creative Director, at MoMA, and Sylvia Roberts, Head of Retail Operations, and Patricia Sampson, Manager of Museum Shops and Visual Merchandising, at the High. Their innovative outlooks yielded new retail products to share with visitors to the exhibition.

I have once again been privileged to work with an extraordinary group of individuals in producing this catalogue. In MoMA's Department of Publications, I have the highest respect for Christopher Hudson, Publisher; Kara Kirk, former Associate Publisher; David Frankel, Editorial Director; and Marc Sapir, Production Director. Nancy Grubb, Editor, expertly guided this book and enhanced our prose. Margaret Bauer, Designer, created a striking and elegant structure for complex material, enlivening the layout with compelling detail. Nerissa Dominguez Vales, Production Manager, sure-handedly attended to every visual and logistical detail. Input from the High's publications staff, particularly Rachel Bohan, Associate Editor, and Heather Medlock, Print Production Coordinator, was also beneficial. The quality of this book's photography — much of it made especially for this purpose — is a testament to the talents of Erik Landsberg, Head of Collections Imaging; Robert Kastler, Production Manager; and Roberto Rivera, Production Assistant, all at MoMA.

During the course of this project, we have also relied on collaborators beyond MoMA and the High. I am extremely grateful to Kathy and Richard S. Fuld, Jr., for their generosity, and to Avril Peck for her kind cooperation. Dan Drasin made his wonderful film included in the 1961 section available to us, and many other artists represented here offered invaluable assistance. We are deeply grateful to Aaron Curry, Katharina Grosse, and Sarah Sze for their participation in the exhibition

and for inspiring us with their efforts. We also thank their studios, gallerists, and fabricators, who expertly facilitated the process: Gordon Veneklasen and Justine Birbil of Michael Werner Gallery; Mark Rossi, fabricator at Hand-Made; Rosemarie Schwarzwälder of Galerie nächst St. Stephan; Kathleen Knitter and Karola Matschke at Katharina Grosse's studio; and Emily Ruotolo and Ethan Sklar of Tanya Bonakdar Gallery.

It has been a pleasure, once again, to work with Michael Rooks, Wieland Family Curator of Modern and Contemporary Art — our committed counterpart on this project and curator of the section devoted to 2013. He took on the organization of that section with great enthusiasm, carefully considering the diversity of contemporary artistic practices. Samantha Friedman, Assistant Curator at MoMA, has again been an exemplary colleague. With an extraordinary ability to draw connections between objects, whether in form, subject, or approach, she has made these chronological slices visually compelling, dynamic, and astute. Her contributions to the catalogue are equally perceptive and will enlighten readers regarding the innovations and inventions at work during these key moments. I could not have had a wiser or more insightful partner.

Finally, one of the benefits of looking at slices in time has been the realization that our present, like the history represented here, does not unfold in a neat sequence but instead is characterized by events that occur at the same time, conflicting ideas that emerge simultaneously, activities that overlap or clash. Thus, one important lesson has been *not* to order, *not* to arrange, but to revel in the messy simultaneity. On that count, I thank my family for consistently providing that variety — even that disorder — in all its richness.

Photo Credits

In reproducing the images contained in this publication, the Museum obtained the permission of the rights holders whenever possible. In those instances where the Museum could not locate the rights holders, notwithstanding good-faith efforts, it requests that any contact information concerning such rights holders be forwarded so that they may be contacted for future editions.

AFP/Getty Images: fig. 5, p. 170; fig. 3, p. 174; fig. 6, p. 174; fig. 8, p. 175. © Estate of Otl Aicher: plates 82–90. Albright-Knox Art Gallery/Art Resource, NY: fig. 1, p. 82. Reprinted with permission of Alcatel-Lucent USA Inc.: fig. 4, p. 171. Courtesy of Alexander Gray Associates: plates 149, 150. Photograph © The Art Institute of Chicago: fig. 3, p. 84. © 2012/ Artists Rights Society (ARS), New York: plate 51. © 2012 Artists Rights Society (ARS), New York/ADAGP, Paris: plates 6, 10, 26, 27, 72–75, 118, 139. © 2012 Artists Rights Society (ARS), New York/ADAGP, Paris/Estate of Marcel Duchamp: fig. 3, p. 21; and plate 3. © 2012 Artists Rights Society (ARS), New York/DACS, London: plate 94. © 2012 Artists Rights Society (ARS), New York/Pro Litteris, Zurich: plate 19. © 2012 Artists Rights Society (ARS), New York/SIAE, Rome: plate 12. © 2012 Artists Rights Society (ARS), New York/ VG Bild-Kunst, Bonn: fig. 3, p. 44; fig. 3, p. 171; and plates 25, 39, 49, 50, 53, 58, 60, 62–64, 121–23. Associated Press: fig. 2, p. 170; fig. 5, p. 171; fig. 2, p. 172; fig. 1, p. 173; fig. 1, p. 174. © 2012 Ashley Bickerton: plate 151. © 2012 Lee Bontecou: plate 112. © 2012 Louise Bourgeois Trust: plate 77. Mike Bruce: plate 169. © 2012 The Estate of Harry Callahan: plates 131, 132. © 2012 Henri Cartier-Bresson/Magnum Photos, courtesy Fondation Henri Cartier-Bresson, Paris: plate 35. Text © Miriam Cendrars: plate 2. © 2012 César (César Baldaccini)/Artists Rights Society (ARS), New York/ADAGP, Paris: plate 117. Jennifer Chbeir, Los Angeles: plate 166. Courtesy of the artist and Cheim & Read: plate 147. © 2012 Christo: plate 111. © Aaron Curry: plates 167–69. © 2012 Salvador Dalí,

Gala-Salvador Dalí Foundation/Artists Rights Society (ARS), New York: fig. 1, p. 42, and plate 21. © 2012 The Willem de Kooning Foundation/Artists Rights Society (ARS), New York: fig. 3, p. 84; and plate 71. © Estate of Walter Dexel: plates 42, 45, 59, 61. © 2012 Jim Dine/Artists Rights Society (ARS), New York: plates 100–110. © 2012 Estate of Honoria Murphy Donnelly/ Licensed by VAGA, New York, NY: plate 34. Courtesy of Dan Drasin: plate 130. © 2012 Walker Evans Archive, The Metropolitan Museum of Art: plate 40. Denis Farley: plate 167. © 2012 Estate of Theodore Lux Feininger: plate 38. © 2012 Lee Friedlander: plate 137. © Galleria Martini & Ronchetti, Genoa, Italy: plate 41. Gamma-Keystone via Getty Images: fig. 2, p. 171; fig. 1, p. 172. Gamma-Rapho via Getty Images: fig. 7, p. 175. © 2012 General Idea: plate 154. Getty Images: fig. 4, p. 170; fig. 7, p. 170; fig. 3, p. 172; fig. 4, p. 172; fig. 6, p. 172; fig. 3, p. 173. © Giacometti Estate/ Licensed by VAGA and ARS, New York, NY © 2012 Succession Alberto Giacometti, Paris/ADAGP, Paris: plates 22, 76. © Katharina Grosse and VG Bild-Kunst, Bonn 2012: plates 170, 171 a+b, 172. © 2012 The Estate of Philip Guston: plates 70, 80. © 2012 Peter Halley: plate 153. © 2012 Mona Hatoum, Courtesy Video Data Bank: plate 145. © 2012 Erich Heckel/Artists Rights Society (ARS), New York/VG Bild-Kunst, Germany: plates 16, 17. © Hergé/Moulinsart 2012: fig. 1, p. 171. © 2012 C. Herscovici, Brussels/Artists Rights Society (ARS), New York: plate 23. © Ken Heyman; The Getty Research Institute, Los Angeles (980063); artwork © 2012 Estate of Allan Kaprow: fig. 1, p. 104. © 2012 Dick Higgins: plate 124. © 2012 Jenny Holzer/Artists Rights Society (ARS), New York: fig. 3, p. 142, and plates 142, 143. © The Dennis Hopper Trust, Courtesy of The Dennis Hopper Trust & Tony Shafrazi Gallery, New York: plate 138. © 2012 Jasper Johns/ Licensed by VAGA, New York, NY: plate 114. © 2012 Judd Foundation/Licensed by VAGA, New York, NY: plate 113. © Simpson Kalisher: plates 135, 136. © 2012 Ellsworth Kelly: plates 79, 81. © 2012 The Franz Kline Estate/Artists Rights Society (ARS), New

York: fig. 1, p. 82; fig. 2, p. 83; and plate 65. © 2012 Jeff Koons: plate 152. Kunstmuseum Basel, Martin P. Bühler: fig. 2, p. 18. © L&M Services B.V. The Hague 20120204: fig. 2, p. 13, and plate 2. © Estate of Roy Lichtenstein: plate 93. © 2012 Glenn Ligon: plate 144. © 2012 The Estate of Jackson Mac Low: plates 125–28. © 2012 Man Ray Trust/Artists Rights Society (ARS), New York/ADAGP, Paris: plate 44. © 2012 Brice Marden/ Artists Rights Society (ARS), New York: plate 146. © 2012 Succession H. Matisse, Paris/Artists Rights Society (ARS), New York: plate 5. © 2012 Allan McCollum: plate 141. © Estate of Robert R.McElroy/Licensed by VAGA, New York, NY; courtesy Oldenburg van Bruggen Studio, New York; artwork © 2012 Claes Oldenburg: fig. 2, p. 105. Photograph © The Metropolitan Museum of Art. Image Source: Art Resource, New York: fig. 1, p. 13; fig. 2, p. 83. Michael Ochs Archives via Getty Images: fig. 2, p. 173. © 2012 Successió Miró/Artists Rights Society (ARS), New York/ADAGP, Paris: plate 24. © 2012 Mondrian/Holtzman Trust c/o HCR International Washington, D.C.: plate 11. © 2012 Morgan Art Foundation Ltd./Artists Rights Society (ARS), New York: fig. 2, p. 14. © 2012 The Museum of Modern Art/Artists Rights Society (ARS), New York: plates 28–31. Courtesy The Museum of Modern Art, Department of Imaging Services: fig. 3, p. 44; fig. 1, p. 170; fig. 3, p. 171; fig. 7, p. 171, and plates 18, 22, 23, 28–32, 37, 39, 42–46, 48, 50, 51, 53, 55–62, 69, 82, 84, 87–90, 92, 119, 120, 132–35, 137, 139, 143, 148; Peter Butler: fig. 2, p. 13, and plates 52, 98, 121, 122, 124–28, 129, 156, 157, 159–64; Robert Gerhardt: fig. 2, p. 141, and plates 16, 17; Thomas Griesel: plates 5, 10, 15, 19, 24, 64, 73, 77, 78, 80, 81, 86, 96, 97, 101–8, 110, 115, 118, 138, 142, 146, 147, 152; Kate Keller: fig. 1, p. 18, and plates 1, 6, 7, 11–13, 49, 70, 76, 93, 154; Paige Knight: 34, 63, 94, 95, 99, 140, 149, 150; Jonathan Muzikar: plates 2, 8, 20, 27, 35, 38, 40, 79, 100–114, 116, 123, 131, 153; Mali Olatunji: plates 3, 75, 109; John Wronn: fig. 3, p. 142, and plates 4, 14, 21, 25, 26, 33, 36, 41, 54, 65–68, 71, 72, 74, 83, 85, 91, 117, 136,